One of the most listened-to doctors in America, DR. DREW PINSKY is a practicing physician who is board certified in internal and addiction medicine. He is the executive producer and host of the hit VH1 reality series *Celebrity Rehab with Dr. Drew, Celebrity Rehab Presents Sober House,* and *Sex Rehab with Dr. Drew.* On radio, he is the host of the nationally syndicated program *Loveline.* He is the author of *Cracked: Putting Broken Lives Together Again* and *When Painkillers Become Dangerous.* Pinsky lives in Southern California with his wife, Susan, and their teenage triplets.

DR. S. MARK YOUNG holds the George Bozanic and Holman G. Hurt Chair in Sports and Business Entertainment at the University of Southern California's Marshall School of Business, where he heads the entertainment business program. An expert in the psychology and economics of celebrity, he has won several international research awards as well as honors for teaching, and is a distinguished faculty fellow at the Center for Excellence in Teaching. The author of five books, he lives in Southern California with his wife, Sarah, and their two children.

THE MIRROR EFFECT

DR. DREW PINSKY

AND DR. S. MARK YOUNG

WITH JILL STERN

THE MIRROR

EFFECT

HOW CELEBRITY NARCISSISM IS ENDANGERING OUR FAMILIES —AND HOW TO SAVE THEM

HARPER

NEW YORK · LONDON · TORONTO · SYDNEY

HARPER

A hardcover edition of this book was published in 2009 by HarperCollins Publishers.

FIRST HARPER PAPERBACKS EDITION PUBLISHED 2010.

Designed by Jaime Putorti

Library of Congress Cataloging-in-Publication data is available upon request.

ISBN 978-0-06-158234-9 (pbk.)

10 11 12 13 14 DIX/RRD 10 9 8 7 6 5 4 3 2 1

To our spouses, Susan Pinsky and Sarah E. Bonner
Thank you for your unyielding support

and

To our children, Paulina, Douglas, and Jordan Pinsky and
Nathaniel and Kaylee Young
Be compassionate, be broad-minded,
and don't be swept away by the herd

CONTENTS

THE MIRROR

EFFECT

She's tried singing, acting, modeling, even writing a book but, in the end, she's most famous for being famous. She seems to glide through a glamorous world of prestige and privilege, where the usual rules don't apply. When she violated her probation after being arrested for drunk driving, neither her celebrity nor her parents' wealth was enough to keep her out of jail, at least for four days.

She's a fixture on the club scene and a favorite of the paparazzi. Increasingly erratic in her job performance, she's now better known for her highly publicized hookups, drunk-driving arrests, consecutive stints in rehab, and apparent fondness for cocaine than she is for the acting skills that made her famous in the first place. Her dysfunctional parents are in the tabloids almost as much as she is. With her fame-seeking family encroaching on her limelight, everyone's waiting to see what she'll do next to get attention.

She's a supermodel. She wears couture and dates rock stars and millionaires. Only a teenager when she became the darling of the high-fashion set, she's credited with popularizing heroin chic—the pale, languid, druggy look

increasingly prevalent among models so emaciated that they are barely a size 0. However, highly publicized photos of her snorting cocaine, and a succession of romances with drugged-out rock stars, fueled the buzz that she should be in rehab rather than on the runway. Her public apology and promise to work on "various personal issues" stopped short of admitting she had a drug problem, but likely helped to salvage her career. Her employers and admirers were quick to forgive and forget, as her jet-setting lifestyle and reign as a style icon retained their pride of place in both fashion magazines and the tabloids.

From cute preteen, to highly sexualized teen pop star, to crotch-flashing paparazzi magnet, she has often traded on her sexuality to capture attention. At seventeen, her naughty schoolgirl look and provocative lyrics made her a platinum recording artist with the best-selling single of the year. By the time she was twenty-one, Forbes *magazine named her the most powerful celebrity in the world. Her career was derailed by allegations of drug and alcohol abuse, unsuccessful visits to rehab, volatile relationships, and outright bizarre behavior. Five havoc-filled years later, a very public breakdown landed her in a psychiatric hospital and cost her custody of her children. Though a carefully engineered "comeback" seems to spell her return from the brink, it raises the question: Can she stay healthy if she stays in the limelight?*

■ ■ ■

If you read *People* or *US Weekly*, regularly check gossip sites like TMZ.com, or watch entertainment news shows or even reality TV, you're sure to have recognized each of the people described here. Without hearing their names, or their career highlights, you still know exactly who they are. Celebrities today are as likely to be recognized for their bodies, rap sheets, and rehab stints as they are for their talents or résumés.

That's because the behavior of today's celebrities is much more dramatically dysfunctional than it was a decade ago. The personal lives of these figures—many of them young, troubled, and troubling—have become the defining story lines of our entertainment culture, played out in real time and held up for our amusement, scrutiny, and judgment. Celebrity gossip, branded as "entertainment news," details stories of excessive partying, promiscuity, divalike tantrums, eating disorders, spectacular meltdowns, and drug and alcohol abuse, behaviors that have become more open, more dramatic, and more troubling than in previous generations.

The media still reports on all the traditional celebrity gossip staples: Who's lost or gained weight; who's getting married, divorced, or cheated on; who wore what designer to which event; who's got a new hairstyle (or, these days, a new nose or smoother forehead). Tabloids specialize in the business of making the mundane appear glamorous. In recent years, however, a new breed of extreme, salacious, unflattering dirt, courtesy of the no-holds-barred reporting on cable TV and the Internet, has redefined celebrity reporting and audience expectations.

Never before has it been as possible to feel like an insider in the culture of celebrity as it is today. We all have 24/7 access to the intimate lives of the stars, courtesy of the celebrity media machine. We can gawk at so-called candid photos of celebrities by flipping through *US Weekly, In Touch, Life & Style, Star*, or *People* at the supermarket checkout, or follow breaking gossip as it's streamed to our home or office computers, BlackBerries, or cell phones. (In big cities, it's even available onscreen in taxis.) We're privy to a constant parade of sometimes private, often unflattering moments from the lives of our favorite stars, captured by paparazzi with high-tech video cameras or fans with cell-phone cameras, all of it posted on TMZ or YouTube.

Emboldened by the de facto relaxing of libel standards online, bloggers and paparazzi feed us their stories live and up close, with no apparent regard for fact-checking, especially when the reporter witnessed the action firsthand (or even captured it on video). Instead of relying on official press releases or credible inside sources, even mainstream media outlets have become increasingly willing to tackle previously taboo topics in their struggle to keep pace with the new media.

From footage of a dazed-looking Britney Spears strapped to a gurney, to TMZ video of Heath Ledger's body being removed from his apartment by paramedics, no secret is too private, no tragedy too personal, to be considered off-limits. Life-threatening eating disorders, addictions to drugs and alcohol, self-harming behaviors like cutting or overdoses, trips to rehab and public relapses, sex tapes, and outrageous diva behavior are irresistible celebrity fodder, for both the audience who consumes it and the media outlets that exploit it. And such behavior only seems to add to the celebrities' fame, with little or no negative consequences for their public reputation.

If that weren't enough, the cable TV networks have filled their schedules with literally hundreds of reality TV shows, in which past, current, and aspiring stars potentially trade their dignity for a chance to play by the new rules. And those who want to do more than passively observe the antics of the rich and famous can audition to compete for our own fifteen minutes of fame on any of the hundreds of reality television shows. Or we can add our voices to the cultural chatter by anonymously passing judgment on celebrity behavior on Web sites like PerezHilton, Gawker, PopSugar, or TheSuperficial. And those who find tracking celebrities not intimate enough can even use the same media to report on *themselves*—blogging about their love and sex lives, parenting woes, political

views, or even the most minute details of their daily lives. Those who crave the video spotlight can accept the challenge to "Broadcast Yourself" (YouTube's trademarked slogan) and channel their inner rock star, TV star, even amateur porn star.

As those online platforms have evolved, it's clear that they've given real people a forum to mimic those outsized, troubling behaviors they learn from celebrity gossip media. The Internet serves as an all-access, unmonitored version of unrated TV, on which lines between fantasy and reality are increasingly blurred. Our children, teens, and young men and women now absorb dozens of hours of gossip from the media each week, much of it featuring this celebrity bad behavior. And more and more they are imitating what they see, if only to attract attention from an audience of their peers. Teens are posting sexy, even explicit, photos and videos of themselves online. They are inviting, and engaging in, provocative conversations with strangers through social networking sites like MySpace and Facebook and in online chat rooms. (Chris Hansen's recent "To Catch a Predator" series for *Dateline NBC*, a runaway ratings hit, was based on the widespread risk of teenagers being contacted over the Internet for sexual liaisons with strangers.) The Web allows vulnerable young people to project any persona they can imagine in the hope that people might notice them, fall in love with them or, just possibly, make them as famous in real life as they already are in their private fantasies.

■ ■ ■

In the past, most celebrities worked hard to keep their more reckless or dangerous private behavior under wraps, concerned that excessive drinking, drug abuse, and other vices might tarnish their public profile and thus their careers. Today, things have changed. Tabloid coverage may seem to be the most immediate path to

building one's career, and the most publicity-hungry celebrities and wannabes are only too willing to expose their unhealthy behavior in order to keep the cameras, and the public's attention, riveted on their lives. The troubles of real-life characters like Anna Nicole Smith are exploited by the celebrity news business, with no concern for the example they set or even the celebrities' own personal safety. And the public, increasingly unsure where entertainment ends and exploitation begins, consumes such imagery without thinking twice. When Anna Nicole, who lived her outrageous life on camera, was found dead in her Florida hotel room, her death felt less like a tragic loss of a deeply troubled soul than the inevitable last installment of a shamelessly exploitative miniseries.

It's easy for any of us to fall into a pattern of following the love life of an actress we like, or the missteps of a rock star we find cool, as if they were the leads in a soap opera we can't bear to miss. But it's also easy to forget that these figures are real people, and that behavior that may seem merely wild or outrageous to us may actually be dangerous and troubling, a sign that those real people are going through a desperate time. And, as our exposure to the stars' unrestrained behavior increases in its graphic intensity and intimacy, a disturbing phenomenon occurs. As we study the photos in magazines, absorb hours of "entertainment" and reality programming on TV, and stare at our computer screens, we absorb the images, and our perception of what is normal begins to change.

When stars are recorded indulging in high-risk behavior—drinking heavily, taking drugs, refusing rehab, losing huge amounts of weight in short amounts of time, making and releasing "private" sex videos—they are doing what psychological professionals consider "modeling" that behavior: that is, broadcasting an image that serves as a model for viewers of the broadcast. And when impressionable fans soak up those images in the absence of responsible

mitigating commentary, it becomes easy for such viewers to impose their own desire for vicarious thrills, rebellion, or vindication onto such acts, and to mirror them in their own behavior.

We call this the Mirror Effect: the process by which provocative, shocking, or otherwise troubling behavior, which has become normalized, expected, and tolerated in our media culture, is increasingly reflected in our own behavior. In this book, we'll examine the inherent danger when the line between fantasy and reality becomes blurred; when the public becomes accustomed to seeing celebrity dysfunction or acting out portrayed as sexy, compelling, and dramatic; and when these corrosive behaviors are increasingly mirrored in our lives and those of our children.

■ ■ ■

After years of interacting daily with famous people, I cannot dismiss these behaviors as harmless or tolerable. I'm alarmed to see how widely such dysfunctional behavior has come to be accepted as glamorous, even desirable. While some may view the outrageous conduct of our entertainers as the inevitable byproduct of talent, creativity, and celebrity itself or a sign of today's relaxed social mores, I want to identify it for what it is: a danger sign of the insidious group of traits that are clinically defined as *narcissism*.

Many celebrities display unmistakable symptoms of classically narcissistic behavior, from high levels of specific personality traits to dangerous and self-destructive behavior. As we'll discuss at greater length in chapter 4, the word *narcissism* can be misleading: It's often taken to mean self-love but, in fact, narcissism has more to do with self-*loathing* than self-love. Celebrity narcissists aren't egomaniacs with high self-esteem. Rather, they are traumatized individuals who are unable to connect in any real way with other people. They are driven to attain fame, with its constant stream of

attention, flattery, and empowerment, because they need the steady trickle of adoring recognition to take the place of any kind of real self-love or self-respect. As one of the most famous celebrities in the world has said privately (and darkly), he considers himself "a piece of shit around whom the whole world revolves."

As I've studied celebrity behavior in the course of my work, one thing that has become clear to me is that celebrities don't become narcissists. Rather, narcissists are driven to become celebrities. Viewed through this lens, the dramatically compelling celebrity soap opera we follow daily no longer seems quite so amusing; rather, it seems like cause for dismay. When you understand the danger of narcissistic behavior, which happens to be rampant among celebrities, but which is rooted in family and early childhood experiences, you will understand why the current preoccupation with celebrity has troubling implications for modern society. And why it's important to recognize, and positively channel, the narcissistic traits we all share.

■ ■ ■

It was an act of nature that brought me together with my coauthor, social scientist Mark Young, and set us on the path to writing this book. One morning, during my morning run, I came across a large tree that had fallen across the road just a few houses away from mine. As I tried to drag it out of the way, Mark came out of his house to investigate. We introduced ourselves, first as neighbors and then as professionals, and thus began a fruitful friendship and collaboration.

For more than twenty-five years, I have co-hosted the syndicated radio show *Loveline* (a version of which also ran on MTV for four years). Today, I also host a daytime radio show, *Dr. Drew Live*. On television, I treat celebrity addicts on the VH1 series *Celebrity*

Rehab, and work with adolescents and their families on MTV's *Sex . . . with Mom & Dad.* As an addiction medicine specialist, I treat patients at a rehab facility in Los Angeles.

Mark holds the George Bozanic and Holman G. Hurt Chair in Sports and Entertainment Business at the Marshall School of Business at the University of Southern California and is trained to conduct research in social and organizational psychology. At the time we met, he was studying the entertainment industry, while developing an MBA curriculum aimed at grooming the next generation of entertainment business professionals.

My time on *Loveline* has given me a unique view of both celebrity and adolescent behavior. Thousands of celebrity guests have appeared on the show and many of them have shared their personal and psychological struggles with me and asked for guidance. On the air, I've taken hundreds of thousands of calls from adolescents seeking practical answers to the problems they deal with every day. At the hospital, I've treated thousands of addicts, both celebrities and everyday people.

Over the years, as I treated more and more celebrities, I noticed an increase in the frequency and intensity of acts of unregulated behavior. And, increasingly in recent years, I have also seen signs that my nonfamous patients were mirroring such behavior. I gradually became convinced that narcissistic personality traits were at the root of many challenging personality characteristics, and that they played a key part in the psychiatric issues that drove this behavior.

Because of the nature of our work, Mark and I often talked about celebrities: how to deal with their issues, how to interpret their shared psychological traits, and how to understand the allure they held, particularly for Mark's students, most of whom hoped someday to work with celebrities in the sports or entertainment

industries. One day, I suggested that Mark might enhance his understanding of how to manage and work with celebrities if he had access to celebrity culture from an insider's perspective. So, I invited him to join me at the *Loveline* studio each night. For many months he sat and talked with the celebrities appearing on the show and with their entourages: the friends, family, agents, and publicists who accompanied them. He also spent time with celebrities on television and movie sets and at innumerable entertainment industry events.

When I asked Mark what he thought of these experiences, he admitted that he found most of the celebrities to be friendly, accomplished people, and that he'd become quite fond of many of them. As a group, however, they often behaved in ways that unnerved and puzzled him. I knew what he meant. I have a lot of friends who would be considered celebrities, and sometimes their behavior makes my heart ache for them. Practicing medicine in a psychiatric environment taught me long ago that otherwise lovely people may behave in obnoxious ways when driven by forces they have not acknowledged and therefore cannot manage.

When I told Mark my theory that extreme narcissistic issues were the root cause of most celebrity meltdowns and misbehavior, he responded immediately. His students were highly motivated professionals, but many of them admitted to admiring celebrities and, increasingly, his students were showing high levels of certain traits associated with narcissism, most notably a heightened sense of entitlement. Mark had also seen psychological studies of young people that backed up his own anecdotal impressions. Some of the students at USC, he said, were so sure they were about to become famous that they retained agents just in case. He described the rise of "USCene," a gossipy blog (now defunct) that reported on and photographed USC students, effectively creating campus celebri-

ties. Like most gossip blogs, it featured candid photos, the more provocative the better, and message boards that invited unfiltered commentary from viewers. The undergraduate population at USC, at least among participants in this blog, was modeling itself on the celebrity lifestyle.

■ ■ ■

Many of today's celebrity story lines are powerful enough to trigger behavioral pathology among their audience, especially among its most vulnerable members. The media is full of accounts of celebrities wrestling with dysfunctional behavior, usually in four specific areas: body image, hypersexuality, substance abuse and addiction, and harmful acting out. Anyone who follows celebrity gossip even casually can name half a dozen widely admired celebrities who have had cosmetic surgery or eating disorders; who have released a sex tape; who have been arrested for DUI or possession of controlled substances; or who have played out an ugly breakup on the world stage. More explicitly than ever, the tabloids and gossip sites reveal which stars abuse drugs and alcohol, engage in divalike behavior or explosive aggression, or undergo dramatic swings in their body weight and physical condition. Especially when it comes to young celebrities, this kind of behavior is portrayed as tragically glamorous, dramatically alluring, and, most alarmingly, normal and expected.

Adolescents in particular are at high risk for mirroring such dangerous behavior. Among teens and college students, eating disorders are commonplace: As many as 3.7 percent of all female adolescents suffer from anorexia, up to an additional 4.2 percent suffer from bulimia. Nearly half (46 percent) of teens aged fifteen to nineteen have had sex at least once, and one in four teens has a sexually transmitted disease. Approximately 10.8 million teens

(more than 28 percent of the total population for that age group) admit to consuming alcohol. Around 10 percent of twelfth graders use the prescription drug Vicodin for nonmedical reasons. Nearly as many eighth graders have used marijuana. Bullying and more serious forms of aggression and acting out are causing increasing concern among educators and parents from grammar school through college. And the bar for teen entitlement has been reset to a mind-boggling level.

In short, the levels of narcissistic behavior in our culture appear to be at all-time highs.

■ ■ ■

As an educator and a doctor respectively, and as parents ourselves, Mark and I were concerned about how the current entertainment landscape might affect our children. The more we talked about it, the more we felt we needed to analyze these troubling aspects of celebrity culture and consider what society could do to guard against their harmful influence.

My training leads me to evaluate a patient's symptoms in detail before I arrive at a diagnosis. As a social scientist, Mark studies research data in much the same way, identifying and interpreting patterns that point to new conclusions. When I told Mark that I saw the growth of celebrity narcissistic behavior as an increasingly troubling cultural virus, he suggested that we study it at the point of transmission. If I were right, if celebrities as a group do tend to suffer from unhealthy levels of narcissism that drive their worst behavior, a scientific study of celebrity personality would give us a way to confirm and quantify that theory. In reviewing research on celebrity, neither of us could find a single systematic scientific analysis of celebrity personality. As far as we could tell, no one had undertaken to collect data from celebrities, and no empirical

studies of their personality traits or behavior had ever been published.

The barrier wall of fame, of course, would have blocked most curious researchers from attempting such a study. However, my work in radio and television, and Mark's network of connections in the entertainment industry, give us access to stars of all kinds. It may seem surprising, but when we began approaching celebrities about participating in a study of narcissism and celebrity, most of them were eager to participate. Over the course of approximately two years, we administered a well-known psychological survey tool called the *Narcissistic Personality Inventory* (NPI) to two hundred celebrities from all fields of entertainment. The NPI assesses the scale of narcissism for a respondent, based on their answers to forty questions tailored to measure levels of specific narcissistic traits.

Most of the celebrities we surveyed had been guests on *Loveline:* comedians, actors, musicians, reality TV participants. Some of them are considered A list, some B list, or C list, but they were all famous enough to feature regularly in the tabloids, on entertainment news shows, and on Internet gossip sites. We also surveyed a group of MBA students. Since previous studies had found links between MBA students' aspirations to corporate leadership and the traits of narcissism, we expected that our study would allow us to place the general population, MBA students, and celebrities all on the sliding scale of narcissism.

The results of our study, published in the October 2006 edition of the *Journal of Research in Personality*, confirmed our instinct. They showed that narcissism is not a byproduct of celebrity, but a primary motivating force that drives people to *become* celebrities. This study, along with additional, previously unpublished research, original interviews, and a detailed review of the entertainment

press, gave us a springboard to continue our analysis of celebrity narcissism, and of its effects on the vulnerable and increasingly wide audience it influences. This book is the result.

The prospect of narcissism playing an increasingly dominant role in our culture is a sobering one. People with narcissistic personality disorder (NPD) have difficulty maintaining relationships, are more likely to have mood disturbances, gravitate toward high drama, and have a much higher likelihood of using drugs and alcohol to excess. That may sound like just another day in the tabloid life of Britney Spears, Lindsay Lohan, or Paris Hilton, but it also sounds like the story of too many regular people who call in to my radio shows every day seeking advice; who offer themselves up as reality show contestants competing for their chance to perform in front of an audience; or who post shocking photos, stories, and videos of themselves on the Internet.

Our work suggests that contemporary culture has become fixated on a group of stars whose narcissistic tendencies appear to be approaching personality-disorder levels. This theory raises disturbing questions, especially for those of us who worry about the examples these celebrities are setting for our children. The celebrity lifestyle has become a subject of aspiration for the rest of us. We have created entire industries to help us wear what the stars wear, drink what they drink, party like they party. Reality TV shows us how to act the way they act. And Web sites like YouTube and MySpace have encouraged millions of people to launch their own online pseudo-selves, to promote their own personal dramas until they seem as compelling as any played out in Hollywood.

What does our insatiable hunger for such celebrity stories tell us about ourselves? Before we can understand its adverse effects, we must start by realizing that celebrities, as a general rule, are driven to seek fame and attention because they suffer from un-

healthy levels of highly narcissistic traits. Our willingness to accept, admire, and even emulate these stars' behavior—without understanding or acknowledging its underpinnings in narcissism—is causing damage to our relationships, our families, and the fabric of society.

When we see celebrities "get away with" outrageous behaviors, it tends to reinforce our sense that they are "special," and makes their status look even more desirable. Witnessing such behavior also tends to provoke our own narcissistic impulses, causing us to feel envy, and tempting us to act like the celebrities we admire. Many of these behaviors can be detrimental, or even dangerous, in and of themselves. But for anyone who has experienced childhood trauma—the fundamental source of pathological narcissism—surrendering to such impulses can lead even mildly narcissistic people to spiral out of control, with devastating results.

The same instincts that drive us to want to mimic these celebrities, however, can also compel us to try to tear down the very idols we create. This urge to destroy what we cannot have often takes the shape of indulging in "harmless" gossip about celebrities whose behavior makes us uncomfortable. This, in turn, fuels the tabloid madness—delivering constant new episodes of the latest celebrity train wrecks in progress.

If we want to understand this behavior, the way to start is by exploring its roots—in the specifics of the psychological phenomenon known as narcissism. But there's another point that's equally important to understand: that the link between celebrity misbehavior and the behavior of everyday people (even vulnerable teenagers) is more complex than simple cause and effect. Narcissistic celebrities whose hypersexuality, body image issues, substance abuse, or other extreme behaviors are paraded in the public square are certainly "modeling" behavior to their fans, making it seem

more normal and appropriate, and encouraging others to emulate it themselves. Yet not everyone—not even every young, impressionable teenager—will be influenced by such modeling. Those who are susceptible will be so because their own family lives have made them especially vulnerable to narcissistic examples.

The phenomenon we call the Mirror Effect has troubling implications for society at large. For parents who have begun seeing signs of such behavior in their children, it also suggests that a look in the mirror may be the first step in addressing the problem. To paraphrase Shakespeare: The fault may not be in the stars but in ourselves.

Modern Celebrity:
From Marilyn to Miley

NEW YORK, NEW YORK, 1962

When Marilyn Monroe arrived at Madison Square Garden to perform at a gala Democratic Party fund-raiser and birthday salute to President John F. Kennedy, her reputation as a temperamental, sexy, vulnerable, and troubled star preceded her. Her erratic behavior on the set of her latest film, Something's Got to Give, *had compromised the production, and her producers had failed to keep her in Hollywood. The rumor that she was having an affair with JFK had become widely circulated, and she was ill with a high fever. However, nothing was going to prevent Marilyn from making her appearance at this historic event. When Peter Lawford introduced her, the crowed roared as she shrugged out of her white ermine stole, revealing a flesh-colored, sequined gown, so form-fitting she had literally been sewn into it. She minced across the stage and into the spotlight. Despite her unsteady appearance and disjointed performance, her oppressively sexy, nightclub-style version of "Happy Birthday, Mr. President" was mesmerizing. JFK's nearly speechless reaction only added to Marilyn's legend, as the entire nation was riveted by this early, and very public, collision of sex, politics, and Hollywood.*

COLLEGE PARK, MARYLAND, 1974

By the mid-1970s, Elvis Presley was deep in the throes of a dependence on prescription drugs. It should have been apparent to any observer, as evidenced by his dramatic weight gain and puffy face, his inability to remember lyrics, his slurred speech, and his rambling diatribes during his shows. According to Jerry Hopkins, author of Elvis: The Final Years, *"It was a bad time for Elvis. Everything seemed to be coming apart."*

The King was in rough shape when he arrived to play a concert at the University of Maryland. When Elvis arrived at the venue, he fell out of the limousine to his knees. As his band looked on in horror, he staggered up the stairs to the stage. Grabbing the microphone for balance and slurring his words, he swayed on his feet as he rambled his way through a two-hour show. Elvis ended his performance with a tirade against the rumors that he was "strung out" on drugs, imploring his fans to take his word, rather than that of movie magazines, gossip columnists, or reporters. Five months later he was hospitalized to treat an enlarged colon, the press was told. Years later, his private physician, Dr. George Nichopoulos, confirmed that the main reason for the hospitalization was to allow Elvis to undergo drug detoxification.

LOS ANGELES, CALIFORNIA, 1999

By the time Robert Downey, Jr., dressed in an orange prison jumpsuit, appeared in a Malibu courtroom to answer to his third parole violation in as many years, the gifted actor, musician, and physical comedian had become as famous for his addictions as for his talent. His fans and detractors knew all the details of his downward spiral. The multiple arrests, imprisonments, and stints in rehab had all made tabloid headlines; the entertainment press dissected each comeback and fall with mingled horror and relish. There was the arrest for speeding and drunk driving, along with possession of heroin, crack cocaine, and an unloaded gun. There was the bizarre incident when

he was found passed out in a bed at his neighbor's house and arrested for being under the influence of drugs. His continued drug use caused him to violate his parole continually. Downey didn't deny he had a problem. "It's like I have a loaded gun in my mouth and my finger's on the trigger," he told the judge. "And I like the taste of the gunmetal." Downey was sentenced to the California Substance Abuse Treatment Facility and state prison in Corcoran. A year later, he was released on bail and went to work on the popular series Ally McBeal. *However, neither a year in prison, nor a critically acclaimed role on a hit series, were motivation enough to curb his self-destructive tendencies. On a break from working on the show he was arrested again, at a posh resort in Palm Springs, California, when police found cocaine and Valium in his room after receiving an anonymous 911 call.*

■ ■ ■

Three very different stars; three snapshots of the kind of celebrity conduct that has spread to epidemic proportions in today's celebrity landscape. When I look at the behavior of Marilyn, Elvis, and Robert Downey, Jr., and the actions of the people around them during their careers, I see a pattern that has only been amplified in today's world.

After her death, Marilyn Monroe's addiction to opiates and other pharmaceutical drugs was well documented, as was her over-sexualized behavior, her penchant for nudity, and her constant preoccupation with her image. But while she was alive, she sought stability in her relationships, marrying men like Joe DiMaggio, whom she considered a "decent" man, and Arthur Miller, the bookish American playwright. Despite her carefully maintained persona as a ditzy blonde, Marilyn cared deeply that she be perceived as a talented actress. She was ambitious in her career, and longed for a family to enhance her lonely personal life.

Her childhood was traumatic. She never knew who her father was, and her mother was institutionalized for mental illness. Marilyn spent much of her young life in foster homes and with family friends. She was sexually abused at a young age, married for the first time at sixteen, and divorced four years later. Arriving in Hollywood at the age of twenty, she used her sexuality to seduce agents, producers, directors, and the American public. Increasingly addicted to barbiturates, pain-killers, and alcohol, Marilyn nevertheless built a successful career, making thirty films in her sixteen-year career, and along the way establishing herself as a Hollywood icon.

Elvis Presley depended on the people around him to hide his sense of shame; in return, he was exploited by them. Introduced to prescription drugs during his time in the U.S. Army, he grew increasingly dependent on them throughout the 1960s, though his habit remained hidden from the public until the early 1970s. By then, sadly, he was habitually sick or high, and eventually his fans got used to seeing him that way. In the end, he was no longer able to perceive how ill he had become, which is why he continued to get up in front of people and behave so erratically. Society's collective denial of his illness and addiction was so profound that it took twenty years for Elvis's personal physician to be penalized for being too liberal in his prescribing of drugs, despite the fact that, at the time of his death, Elvis had as many as ten different prescription drugs in his system.

Elvis spent his career surrounded by enablers, but they didn't take the same care to hide his problems as the Hollywood handlers who shaped Marilyn Monroe's image. Whether their acceptance of his increasing substance abuse was symptomatic of the changing standards of behavior in the rock 'n' roll lifestyle of the 1970s, or a testament to his inner circle's reluctance to challenge their leader, Elvis's dysfunctional behavior was more amplified than Marilyn

Monroe's indiscretions a decade earlier. And yet, even as his career peaked, then began its precipitous fall, Elvis's performances were broadcast to a vast public, through radio and records, movies and television, in a media synergy that Marilyn never experienced.

The son of an avant-garde filmmaker and an actress, Robert Downey, Jr., was born in Greenwich Village in New York City. He moved frequently during his childhood, living in Paris, California, Connecticut, and London. At seventeen, he dropped out of high school in California and moved back to New York to pursue an acting career. From the mid-1980s through the 1990s he worked with respected directors like Oliver Stone, Robert Altman, and Richard Attenborough, and stars like Kevin Kline, Michael Douglas, Halle Berry, and Penelope Cruz. In 1992, his portrayal of Charlie Chaplin in Attenborough's *Chaplin* even garnered him an Academy Award nomination for best actor. However, by the late '90s his escalating drug and alcohol problem had become an inextricable part of his persona, and his friends and handlers seemed helpless to control him. The public was divided, some decrying him as a common addict, others excusing his outrageous behavior as the price of creative genius.

These days Downey's story sounds a note of redemption, with a second marriage, a revived movie career, and years of sobriety. However, his earlier downward spiral illustrates the blunt reality that recovery from addiction almost always includes a series of relapses and progressive consequences. In the end, the fact that he was unwilling, or unable, to hide his increasingly dangerous and destructive behavior may be what saved him.

■ ■ ■

In 1991, I started working in the field of addiction medicine at Las Encinas Hospital in Southern California. Las Encinas has been

known as one of the nation's most prominent psychiatric hospitals since the 1930s and 1940s. It's also one of the places where Hollywood went, and still goes, to get dried out and cleaned up. Since I've worked there, I've treated people from all walks of life, from everyday people to many of the biggest stars of the past five decades. To the doctors and staff at the hospital, even the biggest of these celebrities are simply patients. Still, I'd be lying if I didn't admit that, over time, the famous people who have become patients have become increasingly challenging to treat.

I remember the first time I truly recognized that treating celebrities could pose a special set of challenges. In the early 1990s, a major film star who was a severe alcoholic entered treatment at the hospital. She made it quite clear that she expected to be treated as a celebrity first and a patient second. And we complied. She demanded a special room, which we had to repaint before she would move in. The CEO of the hospital got personally involved in her case, even making sure there were always fresh flowers in her room. We made special allowances for her, letting her opt out of certain groups. She did poorly in treatment. I quickly perceived that treating celebrities as special in any way could have catastrophic consequences for their recovery.

Such behavior is common among celebrities in trouble. When Britney Spears was considering going into treatment, a story made the rounds of rehab centers that she had asked that an entire wing of a hospital be closed to the public while she was in residence. More and more frequently, I'm finding that even nonfamous rehab patients arrive at our clinic expecting such special treatment. One of the hardest things I must convey to my patients, famous or not, is that their rehab cannot be successful until they realize that they're *not* special.

Las Encinas isn't the only place I've seen stars behaving badly.

Having hosted innumerable celebrity guests on my radio shows, I've witnessed outrageous celebrity behavior both on and off the air. Yet I still get upset whenever I hear one of these individuals characterized as obnoxious or crazy in the press. Having grown friendly with many of these guests, I can see the pain or illness that underlies their behavior, and it is heart-wrenching for me to watch what they are doing to themselves, and how the public reacts.

My time at Las Encinas has convinced me that Hollywood itself has undergone something of a transition, at least when it comes to the personalities of those who come to us for treatment. When I treated movie stars from the 1940s, '50s, and '60s, they often presented as vain or self-preoccupied, but still deeply sensitive and caring. As a young doctor, I was often conscious of the fact that my patients wanted to make *me* feel good about the job I was doing. Typically, these patients were being treated for alcohol or drug addiction. While their substance abuse was obviously an issue, their struggles with it had been carefully guarded and weren't really reflected in their public image. These were people who had maintained long careers and lasting relationships, and I observed very little obvious chaos in their personal lives. In fact, I was frequently surprised by how chronic and severe their problems were, given how well-kept and together they seemed on the surface.

As these old-time Hollywood stars gradually died out, I started treating a younger generation. These patients were the stars of the 1990s, and they gloried in the sex and drugs and rock 'n' roll lifestyle. They were sick, but they weren't jaded: As their friends overdosed and died—John Belushi, River Phoenix, Kurt Cobain, Chris Farley—they realized that it might not be enough just to ease up on the partying. Maybe they needed to admit that they had a problem, not just their alcohol or drug habits, but something deeper that was driving the magnitude of their substance abuse.

After spending nearly two decades working to understand addictions and the underlying psychological conditions that can complicate and undermine treatment, I've become attuned to alarming trends among my celebrity patients. Beyond any doubt, the trajectory of dysfunctional celebrity behavior has escalated. The addictions are more extreme, the behaviors are more intense and attention seeking, and the senses of entitlement have reached toxic levels. I have also noted an alarming increase in how many such patients reveal that they suffered childhood traumas, and the fallout in their lives is clear: These patients are disturbingly lacking in empathy, unable to maintain healthy relationships, and frequently unwilling to do the hard work necessary to maintain recovery.

I'm also sensitive to how the extreme behavior of celebrities is often misrepresented in the press. The celebrities who lose control of their lives and end up in rehab are often portrayed as not really sick, or not actually pursuing genuine treatment; the media presents their unhealthy behavior as gossip fodder, as entertainment. Yet, in truth, most of the people I see are very sick indeed. Moreover, the public response to celebrities in distress is increasingly lacking in empathy. Online commenters and talk-show callers often assume a finger-wagging attitude toward celebrities, scorning their behavior as "spoiled," dismissing each new breakdown as "just another publicity stunt," and demanding that they be held accountable for their behavior.

Because of *Loveline*, I've met many of the celebrities whose behavior regularly lands them in the tabloids, or on the more sensational entertainment shows. They often confide in me, sharing their personal stories and asking my advice. It's clear to me that many of them are suffering from significant mental health issues. Almost without exception, such a conversation changes my perspective on these celebrities immediately. Instead of seeing their

behavior as a way to attract media attention and stay in the spotlight, I recognize that it usually has roots in a troubled past, and likely signals that the patient is headed for hard times. As reporting on celebrity behavior becomes ever more ruthless and mean-spirited, I am struck by this disconnect between how a celebrity's behavior is portrayed in the media and the very real problems that underlie their actions.

It's easiest to understand the scope of what I have been observing if you imagine the trajectory of celebrity behavior as a bell curve. In the past, such behavior was clustered in the center of the curve: A few outliers displayed extreme pathological behavior, but most troubled celebrities managed to maintain a certain level of control over their lives. Today, the shape of the distribution has shifted, with more and more individuals falling into the region of extremely problematic behavior.

Now, for every Marilyn Monroe there is a Paris Hilton, an Anna Nicole Smith, a Lindsay Lohan. For every Elvis Presley, there is a Tommy Lee, Scott Weiland, or Kiefer Sutherland. And, remember, the behavior in question isn't limited to drinking, drug use, or other forms of hard partying. Though a certain amount of vanity has always gone hand-in-hand with celebrity—no one ever claimed that Marilyn and Elvis weren't preoccupied with their appearance—today's celebrities take it to a new level, and at a much younger age. Influenced by the demands of their career, by overbearing parents, or simply by their own insecurities, even teenage stars have increasingly resorted to body reshaping or image-changing plastic surgery, turned to prescription medications to lose weight, or fallen into debilitating eating disorders, such as anorexia and bulimia.

■ ■ ■

It's impossible to talk about the new generation of badly behaved celebrities without examining the four young women considered by some the "Four Horsewomen of the Apocalypse": Paris Hilton (a socialite and heiress who achieved celebrity without the burden of performing); Nicole Richie (Paris's friend since kindergarten, and the adopted daughter of singer Lionel Richie); Lindsay Lohan (a child star, teen sensation, talented actress, and poster child for the perils of growing up in the spotlight); and Britney Spears (a multiplatinum recording artist who became at least as famous in 2006 and 2007 for her bizarre behavior as she was for her singing career). More than anyone else in Hollywood today, these young women have set a new bar for outrageous behavior on the celebrity circuit. Moving in and out of one another's orbits, they have invited intense media scrutiny for most of this decade, turning their lives into minor epics of dysfunction.

In 2002, the radio station I worked for asked me to introduce a band at a concert they were sponsoring. This gig sticks in my mind, not because of any of the performances, but because it was the first time I came face to face with a celebrity who was, in the well-known phrase, *famous for being famous*.

As I was waiting backstage for the show to begin, I started hearing whispers about one of the other presenters, a young woman who'd just begun showing up on the Hollywood scene. From what I could gather, she'd had bit roles in a few unremarkable films, but the producers and other event organizers at the concert—all women—didn't seem interested in her as an actress. What they all wanted was to meet "Paris the heiress." They were excited about being in the same orbit as this beautiful, rich socialite, though their excitement was definitely tinged with envy. Paris Hilton was already on her way to becoming a celebrity, despite her lack of any special quality or talent beyond simple beauty. By virtue of hered-

ity, and an unrelenting determination to be noticed, she had been elevated over thousands of other young, attractive, fame-seeking women in Los Angeles. Paris was exploiting a new formula for fame, and I remember thinking that she was unlike any of the celebrities I had met before.

I had my next glimpse into what made this new breed of celebrity tick in late November 2003, when Paris's friend Nicole Richie came to *Loveline* to promote *The Simple Life*, one of the first celebrity reality shows. Paris was also supposed to be a guest, but she failed to show. When Mark naively asked why, Nicole explained, "Well, because of the tape. She's in hiding." The week before, Paris's ex-boyfriend, Rick Salomon, had attempted to sell a tape of the couple having sex that had been filmed several years before, when Paris was only nineteen. Threatened legal action stopped him from going any further, but by then the gossip machine was working overtime to keep the story, and Paris, in the news.

■ ■ ■

From 2003 on, a series of minidramas, often with Paris at the center, and always in the picture, kept Paris and her cohorts in the public eye. Even before her sex tape hit the Internet, Paris was no stranger to public exposure. The New York and LA gossip pages began tracking her adventures (often with her sister Nicky in tow) in the early 2000s, while Paris dabbled in modeling and established a reputation on the party circuit. However, it was *The Simple Life* that cemented the image of Paris and Nicole as shallow, entitled rich girls with more attitude than brains. The 2005 breakup and subsequent reunion of the BFFs kept the show on the air and in the entertainment news for five seasons.

On the other hand, Lindsay Lohan, who'd been in front of the cameras since she was an infant, was generating tabloid headlines

simply by virtue of going through puberty until a feud with Paris catapulted her into the tabloid maelstrom of boyfriend stealing, are-they-or-aren't-they-friends speculation, and one particularly angry encounter when Paris's friend Brandon Davis famously ranted about Lindsay, forever enshrining the term *firecrotch* in the gossip lexicon. The feud continued for a few months, until peace was declared in late 2006 at what the *New York Post* dubbed the "Bimbo Summit"—a weekend Paris, Britney, and Lindsay spent partying together in Las Vegas.

The Summit was a circus of outrageous behavior and, for many, the first time these starlets' antics came into focus. Britney, on hiatus from her singing career, had just announced her intent to divorce husband Kevin Federline. Leaving her one-year-old and two-month-old sons at home, she joined Paris and Lindsay for a girls' weekend out. Britney lost no time in grabbing the tabloid spotlight with a series of outrageous paparazzi encounters, including the first of her infamous crotch-flashing episodes. At first, Britney may have been surprised by the mayhem she caused among the paparazzi, and worried about damage to her image; pleading on her blog for forgiveness from her fans, she conceded that she "probably did take my newfound freedom a little too far." Nevertheless, over the next few months, she continued to put herself in compromising situations, partying hard and allowing the paparazzi to get several more revealing photos, sparking a wider trend for titillating the public with "upskirt" shots and other celebrity wardrobe malfunctions.

■ ■ ■

Public nudity and divaish acting out weren't the famous four's only troubling behaviors. Drug and alcohol use among the Paris/Nicole/Lindsay crowd was fairly open from the start.

In 2006, Paris Hilton was photographed with pot, and in June 2007, she was arrested for driving with a suspended license while on probation for alcohol-related reckless driving. Despite a tearful breakdown in the courtroom, she was sent to Lynwood's Century Regional Detention Facility home for twenty-three days. Upon her release, she appeared on *Larry King Live* in a carefully scripted attempt to rehab her image by claiming, among other things, that she never used drugs. It wasn't long, however, before Paris was back in the news, her makeover short-circuited by an Internet video of her allegedly smoking pot, talking about mushrooms, and joking about her drug use.

When I met Nicole on *Loveline* in 2003, she impressed me as a lovely and sweet girl who had somehow been sidetracked down a very dangerous path. She had admitted to smoking marijuana at age thirteen, and says she was injecting heroin by age nineteen. Her bad-girl reputation was solidified by a series of arrests and drug-related incidents. In 2003, she was arrested for DUI and charged with possession of heroin, while driving with a suspended license. In late 2006, she was arrested for driving the wrong way down an LA freeway, and received her second DUI when she failed a field sobriety test, admitting to using marijuana and Vicodin before the incident. In summer of 2007, a newly pregnant Nicole was sentenced to four days in jail; she was released after serving just eighty-two minutes. Nicole has since said that her daughter, Harlow, has saved her life. The ability to connect deeply with her child, while maintaining her relationship with Harlow's father, is a positive sign for Nicole. It may be that motherhood has fulfilled her in such a way that she no longer seeks to numb and regulate her feelings with drugs, alcohol, or other self-harming behaviors.

By her late teens, child star Lindsay had blossomed into a beautiful young woman, but just as she was poised to emerge as a

bona fide movie star, reports of her out-of-control partying and substance abuse began to surface. Rumored to be a habitual cocaine user, Lindsay was as likely to be seen out at Hollywood hotspots with her mother, Dina, who partied as much as she did, as she was with Nicole and Paris. Lindsay's reputation as a wild girl soon threatened to overshadow her credibility as an actor and derail her career. In May 2006, she was arrested for DUI when she crashed her Mercedes convertible into a curb in Beverly Hills. Toxicology reports concluded she had almost twice the legal limit of alcohol and traces of cocaine in her bloodstream. After repeatedly failing to show up for work on the set of *Georgia Rule* in the summer of 2006, she received a memo from the producer, James Robinson, calling her "irresponsible and unprofessional" and blaming her "all-night heavy partying" for her "so-called 'exhaustion.'" Posted on The Smoking Gun's Web site, the letter soon made headlines in the press, fueling the stories about Lindsay's out-of-control spiral, which was rumored to include bulimia, heavy drug use, and frequent hookups with others in her party circuit.

In January 2007, Lindsay checked into rehab at the Wonderland Center in Los Angeles for a month, beginning a cycle of rehab pit stops and out-of-control partying. In July 2007, police in Santa Monica spotted her SUV chasing another vehicle at high speed. After failing a field sobriety test, she was taken into police custody, where a search turned up cocaine in her pants pocket; she was arrested for drunk driving and cocaine possession. In August, she returned to rehab, checking into the Cirque Lodge Treatment Center in Utah for close to two months. Her treatment was far from private, however, as paparazzi continued to stalk her for photos, and stories about her rehab romances remained tabloid staples. Estranged from her parents, caught up in a cycle of meaningless relationships, and in the grip of her addiction, Lindsay's physical

and mental well-being, as well as her career, were in obvious jeopardy. However, I do believe that her attempts at treatment were sincere and meaningful and expect that one day she will achieve a sustained sobriety.

Although those in Britney Spears's inner circle knew that she'd been drinking and using drugs since her early teens, at first Britney didn't have as much of a public reputation for drug and alcohol abuse as the other three. Her grueling recording and video schedule, and back-to-back pregnancies, may have kept her from participating in the Hollywood nightlife in which the other three indulged. There's no doubt, however, that drugs and alcohol played a part in accelerating her psychological decline and likely precipitated her headline-making breakdown, which spanned nearly all of 2007. In fact, the trajectory of Britney's actions from 2004 to 2008 shows just how acceptable outrageous celebrity had become. Although she was in and out of rehab three times during a seven-day period in 2007, Britney remained deeply in denial about having a problem with drugs or alcohol, posting a letter on her blog claiming she was just blowing off steam and insisting that it was "actually normal for a young girl to go out after a huge divorce." The reality is that Britney would never have been admitted to a drug treatment facility without evidence of a substance abuse problem; regulatory standards would likely have prevented her admission and would certainly have prevented any attempt at readmission.

It wasn't until early 2008, when Britney was finally committed to a psychiatric ward, lost control of her finances, custody of her children, and was remanded into the custodial care of her father, that people began to acknowledge that Britney's wild acting out was actually evidence of a life-threatening illness.

■ ■ ■

It isn't just female celebrities who publicly push the limits of unhealthy behavior. Andy Dick has made a second career out of public intoxication, and Disney star Shia LaBeouf's transition from child actor to action star was marked by arrests for trespassing, driving under the influence, and a spectacular car crash.

Drug abuse is widely accepted as a byproduct of the rock 'n' roll lifestyle, with regular tabloid updates on rehabbing rock stars like Steven Tyler of Aerosmith, Steven Adler of Guns N' Roses, Scott Weiland of Stone Temple Pilots, and Pete Doherty of the Libertines and Babyshambles. Violence is such an ingrained part of rap culture that many of its biggest stars—Tupac, Notorious B.I.G., DJ Jam Master Jay, and D12's Proof—are as well-known for their brutal deaths as they are for their rhymes.

Some of the most celebrated bad boys in entertainment, like Colin Farrell, Kid Rock, Eminem, and Tommy Lee, have made news for both displays of physical aggression and highly aggressive sexual behavior. Over the past ten years, male politicians have also escalated their sexual acting out, from President Bill Clinton and New Jersey Governor Jim McGreevey to New York Governor Elliot Spitzer and former Democratic presidential candidate John Edwards. And Johnny Knoxville, Steven "Steve-O" Glover, Bam Margera, and their gang have made careers out of acting like a bunch of destruction-bent adolescents on MTV's *Jackass* and on spinoffs like *Wildboyz* and *Viva La Bam*.

As celebrity behavior has become increasingly unregulated in all arenas—sex, substance abuse, entitlement, exploitation—our preoccupation with celebrities and their private lives has exploded. Today, the constant stories of celebrity misbehavior offer a steady diet of amplified, vicarious thrills for a society that's increasingly obsessed with the famous. Such behavior is unhealthy: It derives from toxic extremes of vanity, entitlement, superiority, exploita-

tion, and impulses for self-harm. Yet our culture no longer seems to regard it as cause for alarm or dismay. Instead, our mass media happily transmits salacious celebrity images into our homes 24/7, to an audience with a seemingly insatiable appetite. The way the media highlights and portrays this behavior, and the nature of our response as consumers of popular culture, is at least as troubling as the individual behavior of any celebrity plunging into the abyss.

■ ■ ■

Famous people, by definition, are famous because we pay attention to them, but only recently have the offscreen antics of so many entertainers come to rival their scripted roles for sheer dramatic impact.

Decades ago, it was a star's talent that captured, and held, an audience's attention. A star's persona was a commodity to be carefully maintained and protected. From the early 1900s to the mid-1950s, the Hollywood studio system was a tightly controlled movie-making machine. Stars were little more than well-paid employees who could be rented or sold to other studios for profit. The studio heads signed them to five- to seven-year contracts and, in return, the studios assumed legal control of their identities. The studios had the power to suspend actors without pay and fire them without notice. Stars who refused to be loaned out to another studio, or complained about poor scripts, ran the risk of suspension or worse.

Under the studio system, aspiring stars had every aspect of their lives managed by the studio that signed them. They were given new names, image and physical makeovers, and fictionalized life stories that were published in fan magazines. Actors were typecast in order to make films easily identifiable to the audience, and the studios decided the roles the actor would perform. Realizing

that the way stars acted outside the studio walls could affect their popularity with fans, the studios used in-house publicity departments to script the stars' lives. Cary Grant, Rock Hudson, Tab Hunter, Roddy McDowell, and Tony Perkins were all cast as leading men, even though they were gay or bisexual. Joan Crawford, Clara Bow, Jean Harlow, Frances Farmer, and Lana Turner were all held up as glamorous ideals, with no mention of the sex scandals and/or alcohol abuse that created chaos in their personal lives.

For the earliest movie stars, their screen image was everything. Living up to it in the eyes of the fans was the only way to continue their careers. Women wanted to be as cool and glamorous as Lauren Bacall, or as charming and sophisticated as Olivia de Havilland. Men wanted to be as handsome and virile as Cary Grant, or as affable and sincere as Jimmy Stewart. Some mainstream magazines, such as the *Saturday Evening Post,* covered entertainment, and magazines like *Photoplay* and *Movie Digest* provided fans with their dose of studio-sanctioned celebrity gossip.

Even eighty years ago, stars engaged in their share of sensational behavior, some of it foreshadowing the escapades of celebrities today. Exhibitionism among Hollywood starlets, for instance, is nothing new. In the 1940s, Carmen Miranda reportedly lost her 20th Century Fox contract when her boss, Darryl F. Zanuck, reviewed the stills from a studio photo session that showed her leaping into the air, revealing that she wore no underwear. As Patrick McGilligan recounts in his biography *Alfred Hitchcock: A Life in Darkness and Light,* Tallulah Bankhead caused a similar stir on the set of the 1943 film *Lifeboat* by refusing to wear underwear during filming. The cast was required to repeatedly climb in and out of the boat using a small ladder and, in so doing, Bankhead flashed her costars repeatedly. A cameraman protested she was ruining shots every time she spread her legs. When a journalist from a la-

dies' magazine visited the set, she was so appalled by Bankhead's shenanigans that she complained to the publicity department. Confronted with the problem, Hitchcock, who reportedly admired the star's larger-than-life personality and lack of inhibition, famously responded, "Should I call wardrobe, makeup, or hairdressing?"

Rumors of such behavior sometimes leaked out, but most of what went on—affairs, illegitimate children, unusual sexual proclivities, substance abuse—was kept under wraps, at least until the star passed away. In the days of top-down studio control, actors and actresses were schooled in how to interact with their fans, and the paparazzi were instructed to keep a respectful distance. Actresses were expected to be classy and glamorous. Actors were to behave as gentlemen—and, at the risk of being blackballed or losing lucrative studio contracts, to hide it when they didn't. This wasn't as difficult as it appears today. The stars' behavior was less dramatic, their capacity for forging real and stable relationships was greater and, just as significantly, consumers didn't *want* to see their favorite stars' idealized images tarnished. The audience was far less prone to the envy and aggressive outbursts of fans today.

Once the star system disintegrated in the 1950s, Hollywood responded to the scandal of the McCarthy years, and the desires of the audience, with a carefully designed fantasy world of Disney productions and frothy melodramas. At the same time, the burgeoning age of rock 'n' roll created an increasingly influential teen audience that found their craving for rebellion reflected onscreen in the antiheroes of James Dean and Marlon Brando, the censor-defying sexiness of Elvis, and the blatant sexuality of Marilyn Monroe. Rumors of sexual transgressions and addiction were published in the lurid smear magazines like *Confidential*, *Uncensored*, and *Exposed*, but fans pointedly ignored these whispers, preferring

to remain steadfastly infatuated with the manufactured images of the stars.

■ ■.■

In the 1960s and '70s, the film industry responded to hippies, free love, and the counterculture movement by creating movies and stars that expressed the wilder side of those generations, exploring sexual freedom and drug use. Stars flirted with a rawness that not all audiences were ready to accept. Dennis Hopper, Peter Fonda, Warren Beatty, and Jack Nicholson reigned as the bad boys of Hollywood. Reports of the stars' misbehavior in their private lives became more commonplace, but in the era of free love and experimentation such antics were taken in stride.

The mid-seventies also saw the dawn of an increase in coverage of the personal lives of celebrities—a trend that continues unabated today. In 1974, *People* magazine was spun off from *Time* as a way to give readers more intimate details of famous (and nonfamous) people's lives. Announcing the magazine's launch, managing editor Richard Stolley said: "We're getting back to the people who are causing the news and who are caught up in it, or deserve to be in it. Our focus is on people, not issues."

People was a success. For a society politically exhausted in the aftermath of the Vietnam War, confronted by shifting roles in the nuclear family brought about by the feminist movement, and economically deflated by recession on the home front, freedom from heavy issues, and the notion of escapism, had a powerful allure.

■ ■ ■

By the 1980s and '90s, the hippies of the 1960s and the me generation of the 1970s had become adults and parents, without losing their "If it feels good, do it" mantra. In the early 1980s, celebrity

coverage was split between the red carpet (glossy accounts of the glamorous aspects of celebrity life) and the gutter (tabloid reports of celebrity scandal, which increasingly hinted at addiction, relationship problems, and embarrassing personal revelations). Shows like *Entertainment Tonight* mainly focused on celebrity-friendly pieces, featuring interviews and light celebrity gossip; Robin Leach's *Lifestyles of the Rich and Famous* took viewers inside celebrities' homes, paving the way for current shows like MTV's *Cribs* and VH1's *The Fabulous Life of*. . . . On the other hand, tabloid news shows like *A Current Affair, Hard Copy*, and *Inside Edition* (followed a little later by *Extra, Access Hollywood*, and *The Insider*) focused on more scandalous stories, like Drew Barrymore's metamorphosis from ET's adorable friend to overdosing rehab patient.

A childhood star from a celebrated Hollywood family, Drew presented a spectacle that was irresistible to the tabloid press. In her memoir, *Little Girl Lost*, Drew reveals that she started smoking when she was nine years old. "It wasn't long before I began thinking, 'Well, if I smoke cigarettes, I can drink,' " she writes. "It was an easy step. . . . I was also a club hopper at ten, as much as someone that age can be. . . . After a while, though, I started thinking, 'Well, this is getting boring now, so let's try something even better. If I can drink, I can smoke pot. There's nothing to it. . . .' Eventually that got boring, too, and my addict mind said to me, 'Well, if smoking pot is cute, it'll also be cute to get into the heavier stuff, like cocaine.' My usage was gradual. But what I did kept getting worse and worse, and I didn't care what anybody else thought about me."

A decade earlier, Drew might have been able to downplay her problems in the press, and her fans might have chosen to look away from such troubling revelations. In those days, a beleaguered

star could still reasonably expect a measure of privacy. However, the increasing competition among the various corners of the entertainment media was already fostering a more relentless, unblinking approach to celebrity reporting. As a result, in these years, consumers flipping through a tabloid magazine or watching an entertainment news show were increasingly confronted with candid reports of famous people in unflattering, often disturbing, situations. The behavior of troubled celebrities, which pointed to very real problems with substances or other serious issues, began to seem common among the rich and famous. As such dysfunctional behavior was accepted as par for the course, the coverage showed a lack of concern for the actual well-being of the stars themselves.

The 1990s saw the emergence of a new generation of celebrities who seemed to thrive on courting tabloid attention, and an equal appetite among consumers eager to follow every detail of a celebrity's most outrageous exploits, often choosing stars they loved to follow (or loved to hate) as avidly as sports fans follow their favorite teams. Madonna had been pushing the sexual envelope with her performances since the mid-eighties, but from 1990 to 1992 she upped the ante with her erotic video for "Justify My Love," her Blond Ambition tour (in which she mimicked masturbation onstage), and her book *Sex*, a collection of erotic photographs that sold half a million copies. In a different corner of the entertainment universe, Howard Stern, the provocative New York radio DJ, rode his obsession with sex, strippers, and breast implants into national stardom, capped by his bestselling autobiography *Private Parts* (1993) and the 1997 hit film of the same name.

Actress Angelina Jolie, who emerged in the mid-nineties, was one celebrity who appeared untroubled by pushing the boundaries of outrageous behavior. In fact, she seemed to relish demolishing them. For Angelina no subject was off-limits, from her multiple

tattoos and her episodes of cutting to her heroin use, bisexuality, and dalliances with S&M. Her chaotic personal life was well-documented in the tabloids: her feud with her father, her extremely close relationship with her brother—so close, in fact, that she felt compelled to deny rumors of an incestuous love affair in 2000—and her controversial romances. In 1995, she married her first husband, Johnny Lee Miller, wearing a white shirt with his name painted in her blood on the back. They were divorced a year later. In 2000, she became the fifth wife of Billy Bob Thornton, a man twenty years her senior. The two wore vials of each other's blood around their necks at the ceremony. (That marriage ended in 2002.) Angelina's tempestuous lifestyle perfectly suited the new era of tabloid reporting and set a new standard for supply and demand. Before long it was clear that the public was more interested in her personal life than in her considerable professional achievements, and no one seemed inclined to question what her bizarre behavior might imply.

By the early 2000s—thanks to the rapidly multiplying opportunities for exposure on cable TV and the Internet—the celebrity firmament was dotted with an endless and practically interchangeable array of celebrities, mainly young women, whose lives were intimately documented. These celebrities accumulated hordes of fans and detractors alike, who scoured gossip sources for new dirt on their favorites and most hateds, and used it to engage in the sport of building those celebrities up and tearing them down, rooting for their redemption or breathlessly awaiting their demise in the ultimate "train wreck."

A perfect example is Miley Cyrus, perhaps better known to her young fans as her alter ego, Hannah Montana, on the Disney show of the same name. In her role as Hannah, Miley was the star of a hit TV show, filled arenas on concert tours, and made millions on

merchandising deals. She was arguably on her way to becoming one of the most successful and popular performers of the decade. Her fans were devoted to her image: a squeaky clean average teen who was extremely close to her parents. Yet, as Miley enters adolescence, she has flirted with some questionable behavior. Provocative self-portraits have found their way on to the Internet; she and her friend Mandy Jiroux were accused of mocking fellow Disney teen stars Demi Lovato and Selena Gomez on their *Miley and Mandy Show* videos on YouTube; and an increasing stream of gossip and photos about her alleged boyfriends, including a twenty-year-old model, began adding uncomfortable shadings to her public image.

When a provocative photograph of an apparently topless Miley wrapped in a bedsheet, taken by famed photographer Annie Leibovitz, appeared in *Vanity Fair* in April 2008, it created a scandal that threatened her lucrative image. Her fans, and their parents, reacted with a wave of outrage that may also have been fueled by envy and aggression. Disney immediately jumped to her defense with a barrage of spin, claiming the young singer and actress had been "deliberately manipulated." Leibovitz defended the photographs, calling them "very beautiful," and claiming they'd been misinterpreted. Miley herself issued a statement apologizing for the incident. "I took part in a photo shoot that was supposed to be 'artistic' and now, seeing the photographs and reading the story, I feel so embarrassed. I never intended for any of this to happen and I apologize to my fans who I care so deeply about," she said at the time. Critics painted Cyrus and her parents as seizing an opportunity to boost her profile and tweak her image as an innocent girl, and accused the magazine of exploiting America's tween sweetheart in a bid to sell magazines.

Fans have generally excused such missteps as inevitable fallout when a teenage star grows up in the spotlight, and Miley has so far remained as popular as ever with the eight-to-twelve-year-old crowd. Yet, when I see Miley's behavior, I think there's reason for concern about her. I'm worried that she hasn't gone through normal teenage milestones. I see a fifteen-year-old who often pretends she is a grown-up, a young girl who wants everyone to think she's capable of talking, thinking, and acting like an adult, even though she's still very much a child. If Miley's parents are not extremely vigilant, and she's not allowed to experience the types of social frustrations that are necessary for any teenager's healthy development, I worry that she could end up trapped in a permanent state of adolescence, her persona stalled in the idealized fusion of child star and adoring audience, even as she tries to mature.

■ ■ ■

The admired but aloof Hollywood idol, with a carefully crafted persona and tightly controlled mystique, has largely been replaced by new celebrities whose primary career motivation has less to do with their craft than with a desperate need to hang on to the spotlight by any means necessary. Their very celebrity has become their most compelling role, the entertainment media their enablers. By casting them in real-life minidramas, the new media universe invites these celebrities to act as if they can do anything and get away with it. And the media walks away with maximum profits: more magazines sold, higher ad rates on TV, more exposure on the Internet.

This interdependence between celebrities and the media is a dangerous bargain. The more a celebrity attracts the attention of the media, the more famous he or she becomes. The more dys-

functionally the celebrity behaves, the more interest he or she generates from the tabloids. The more the audience finds out, the more we want to know. And the cost of it all—to the vulnerable celebrities on one side of the mirror, and the impressionable viewers on the other—is impossible to estimate.

The Rise of the Celebrity-Industrial Complex

It was an archetypal tale of triumph and tragedy: the girl who wanted to be Marilyn Monroe. She was raised by a single mother, married, divorced, and became a mother herself by the time she was nineteen. Leaving her past behind, she became a Playboy Bunny, a successful model, and the wife of a billionaire sixty-three years her senior. When her husband died of pneumonia, she engaged in a bloody battle with his family over his $1.6 billion estate.

Anna Nicole Smith's beauty sparked her modeling career, but it was her rags-to-riches story and her erratic, over-the-top personality that led producers to build a reality television show around her. In 2002, 4 million people tuned in to the E! Entertainment network to see the show, which traced the everyday travails of a woman critics derided as a "human train wreck." At the time, it was the most highly rated debut for a reality program on cable television. For two seasons, the audience tuned in to watch Anna's unaccountable behavior—her slurred words, her unfocused affect, her immature personality. When each episode was over they speculated about the obvious causes of it all: what drugs Anna Nicole was taking, how much she was drinking, whom she was sleeping with, and which members of her entourage were helping or hurting her. When the show ended, the public remained fascinated and unable to look away, demanding every detail of her downward spiral.

She left the country and gave birth to a daughter. Three days later, her son, who was staying with her in the hospital, died of an accidental drug overdose. Three weeks after that, she married her companion and lawyer, Howard K. Stern, in a shipboard ceremony and posed for People *magazine as a new family. Despite the spin—that she had found new happiness— Anna Nicole was heartbroken. She attempted to isolate herself, but the issue of the paternity of her daughter yanked her back into the spotlight. Six months after her son's death, she was found unconscious in a Florida hotel room and was rushed to a nearby hospital, but the interaction of so many different drugs in her system and sepsis from a drug injection site on her buttocks ultimately claimed her life. The cameras stayed with her even in death, with the paparazzi documenting the removal of her body from the hospital and her arrival at the morgue. And the celebrity media soon turned its attention to the latest updates on the legal fight over where she should be buried.*

Anna Nicole's saga was as fascinating to her fans after her death as it had been in her well-documented life. For the next seven months, a major custody battle for her newborn daughter was played out in a Florida court-room, and in real time on the Court TV network. The media circus was made even more carnival-like by the judge, whose tearful histrionics on the bench made it appear that he relished his role in the third and final act of Anna Nicole's reality show.

■ ■ ■

Behind her larger-than-life image as a ditzy blonde Marilyn wan-nabe, the reality is that Anna Nicole Smith was a deeply troubled and seriously ill individual. She was a drug addict, enabled by hangers-on and sycophants. She was so invested in her addictions that she left the country in order to keep using, and she died of a drug injection abscess in her gluteus muscle. The story of her life is devastatingly pathetic, and yet we consumed it for our own en-

tertainment. To feed our cultural fixation with her erratic behavior, we cast her as a cartoon character and devalued her as a real person.

In the months before her death, I remember telling people how sick I thought she was, and that she needed help or was going to die. Time and time again, the response I got was: "What are you talking about?" The primitive gratification of watching someone else torch out is hard to resist, and people didn't want to acknowledge what they were participating in as they watched this troubled young woman destroy herself before their eyes.

Anna Nicole epitomized the dangerous illusion of modern celebrity. A stripper turned model, she became famous without education or developed talent. Her fame stemmed solely from her love of the camera, her surgically enhanced looks, and her complicity in encouraging a voyeuristic audience. She was kept in the public eye by media and management machines that profited from her very existence. Most people either saw Anna Nicole as a real celebrity—a small-town girl made good who lived a life of glamour—and loved her for it, or they jeered at her as a caricature. But few could look away.

Anna Nicole's tumultuous existence was perfect fodder for what Maureen Orth identified in her 2004 book, *The Importance of Being Famous*, as the "Celebrity-Industrial Complex: the media monster that creates the reality we think we see, and the people who thrive or perish there." As Orth points out, we now live in a world of extremes: "extreme media presence, extreme stories, extreme recognition." Dominated by the rapacious programming needs of cable TV, the Internet, and the newsstand—all three interests often owned by huge media conglomerates, resulting in a crosspromotional gossip frenzy—the Celebrity-Industrial Complex demands a constant flow of immediate and sensational celebrity

news. The tragic life and death of Anna Nicole fed the media monster, as an eager public looked on, with a troubling lack of regard for the sad, sick human being at the center of the storm.

■ ■ ■

Journalist Michael Hirschorn has described celebrity as "a state of pure fabulousness, in which one's aura is projected across the land, inspiring envy, fantasy, endless curiosity." The trajectories of stars like Marilyn, Anna Nicole, or Britney certainly play to that endless curiosity; the media seized upon each of these vulnerable starlets to feed our constant appetite for entertainment news. They are also the stories of individuals who apparently were predisposed to pursue certain kinds of behavior, acting in ways that could be dangerous, but that inevitably led to more attention. Often coming from chaotic families, prone to mental health crises, and susceptible to addiction, such figures have a hard time finding stability in relationships and often drift into bizarre behavior, incapacitating drug dependency, psychiatric breakdown, and even death.

That may sound like a worst-case scenario. However, anyone who follows celebrity news knows that such stories, which should be cautionary tales, are increasingly common. And no medium is as powerful at telling those stories than the glossy magazines.

The magazine industry has gone through tremendous change in the past decade. In the 1990s, the celebrity magazine world was dominated by two glossies: *People* and *Entertainment Weekly*. These magazines, characterized by tame feature stories, short reviews, and artfully shot (and Photoshopped) images, lived or died by their cover stories, which were designed to promote a studio's latest blockbuster or an actor's breakthrough role. In the early 2000s, however, things began to change. The magazines started focusing on the personal lives of a handful of stars and star couples: Brad

Pitt and Jennifer Aniston, Brad Pitt and Angelina Jolie, Jennifer Aniston and Vince Vaughn, Ben Affleck and Jennifer Lopez, Jessica Simpson and Nick Lachey, Britney Spears and Kevin Federline. The magazines slavered over these story lines, which cast the stars in immediately identifiable roles in weekly minidramas: the all-American hunk, the exotic temptress, the adorable wronged wife, the funny-but-not-as-attractive guy who catches her on the rebound.

The business of celebrity gossip also took a darker turn around this time. In 2000, *US* magazine, originally a monthly, became *US Weekly* and immediately threatened *People* with its more tabloid-gossip approach. In quick succession came a swarm of new competitors: *In Touch* (2002), *Life & Style* (2004), and the relaunched tabloid *Star* (2004), transformed by former *US Weekly* editor Bonnie Fuller. These magazines weren't afraid to dig up dirt, publish unflattering photos, or deconstruct the glamour of the celebrity lifestyle. Other magazines, like *OK!*, whose editor is a former celebrity publicist, responded by carving out a niche for more star-friendly coverage, working with celebrities and their management to offer a positive slant, no matter what the story.

The competition changed the nature of the celebrity magazine business. Editors had to decide whether they wanted to fight for celebrity exclusives, spending top dollar and providing flattering coverage in order to get the best stories, or to forgo future favor-trading in order to break gossipy and possibly unflattering stories that were more likely to shock fans and bolster sales. Celebrities, too, quickly learned to play the game, countering unauthorized stories with more flattering portrayals in the celebrity-friendly press.

In this competitive new landscape, the magazines worked overtime to chase the latest dish—the more intimate the better, even if

there was nothing to the story but an ambiguous photo and a huge helping of speculation. If Jennifer Aniston was snapped at the grocery store, headlines would blare "Jen Woos Vince with Romantic Dinner." If two stars were photographed kissing hello, even in passing, the mags would put them in the middle of a torrid affair.

By 2005, a spate of celebrity pregnancies gave the paparazzi a new target, as any famous young woman leaving the house in a baggy T-shirt or loose dress triggered a wave of speculation about whether she was hiding the elusive "baby bump."

As the competition heated up, the magazines pushed their coverage into areas they'd rarely touched in the past. Where once the magazines had respected the celebrities' zones of privacy, now they began trafficking in stories and outright rumors of all kinds of troubling private behavior. The magazines ran stories about celebrities' struggles with body image and eating disorders:

Mary-Kate Olsen Battles Anorexia (*Us Weekly*, 2004)

Tyra Banks Fights Back: You Call This Fat? (*People*, 2007)

Lindsay Lohan Blogs About Her Sister's Breasts (*Star*, 2008)

about drug abuse:

Kate Moss Loses Ad Deal Amid Drug Reports (*People*, 2005)

Whitney: Mentor Paid for Rehab, Got Clean With Help of Courtney Love (*US Weekly*, 2006)

Amy Winehouse Caught on Tape Doing Drugs (*Star*, 2008)

about mental health crises:

Addiction and Despair: Owen Wilson's Secret Pain (*People*, 2007)

The Real Story: Britney's Mental Illness (*People*, 2008)

Brit's Fight to Get Well: Bipolar and Locked in Psych Ward, Spears Has No One to Trust as She Loses Control to Parents She "Hates" (*US Weekly*, 2008)

about highly sexual behavior:

John Mayer: I Once "Hooked Up" with a Fan (*People*, 2008)

Megan Fox Reveals Lesbian Fling (*Star*, 2008)

David Duchovny Enters Rehab for Sexual Addiction (*Star*, 2008)

and about the stars' divalike blowups:

Angry Actor on Line One: Upset He Couldn't Make a Late-Night Call, Russell Crowe Allegedly Pitches a Fit—and a Phone (*People*, 2005)

Naomi Campbell Charged with Assaulting a Police Officer (*US Weekly*, 2008)

Ali Lohan: A Diva Bigger Than Lindsay? (*Star*, 2008)

■ ■ ■

As the tabloids became increasingly popular and profitable, mainstream media couldn't ignore the allure of using celebrity (and, often, celebrity skin) to sell issues. Music magazines like *Rolling Stone, Blender*, and *Vibe* have long featured celebrities on the cover—the more scantily clad, the better—and the new generation of men's

magazines, like *Maxim*, have lured an increasing number of famous young women (from Sarah Michelle Gellar to Hillary Duff to Avril Lavigne) to pose provocatively for them. These days the trend has spread to news, fashion, home, health, even literary and cultural magazines. In the past few years, celebrities have increasingly graced the covers of magazines like *Domino*, *Women's Health*, even *Poets & Writers*. *The Atlantic*, one of the most culturally significant journals of reporting and opinion in American history, devoted a recent cover story to Britney Spears, with the headline "The Britney Show." And the trend took a self-conscious, though still disturbing, turn in February 2008, when *New York* magazine published a photo essay in which Lindsay Lohan and photographer Bert Stern recreated Marilyn Monroe's famous last sitting, an intimate all-nude pictorial Stern shot with an intoxicated Monroe six weeks before she died. If the whole exercise seemed gruesome on its face—like a death wish captured in soft focus—Lindsay shrugged off any criticism, calling the sitting "an honor."

Whether reported in the tabloids or the mainstream press, images of celebrities using drugs and alcohol have glamorized the sickness of addiction. Dangerous types of acting out—sex tapes, overdoses, breakdowns—have been defanged and repurposed as publicity hooks. Behavior that was once a publicist's nightmare is now guaranteed to put a celebrity on the cover of the supermarket tabloids, and keep the public hungry for more. Naomi Campbell keeps her diva profile high in the post-supermodel world with angry outbursts, including attacks on her assistant and a housekeeper. Glorifying her anger management problem to an unprecedented degree, she turned her public service at a New York sanitation facility into a high-fashion shoot for *W* magazine. Despite her history of drug and alcohol use and hard-partying image, twentysomething British singer and songwriter Lily Allen was

awarded the "Editor's Special Award" at the *Glamour* magazine "Women of the Year" awards ceremony in London. She celebrated the honor by becoming so drunk she had to be carried out of the party. And Tila Tequila publicly switches from girlfriend, to boyfriend, and back, keeping the paparazzi on the hook and the public titillated as she expands her entertainment empire.

For the audience, the tension in watching these dramas is cultivated by a media culture that purposely delivers opposing messages: On one hand, they imply that celebrities live lives we can only fantasize about. On the other, the media wants us to believe that celebrities are just regular folk: *US Weekly*'s popular feature "Stars . . . They're Just Like Us!" features celebrities doing everyday things like grocery shopping, taking their kids to school, getting their dry cleaning, and riding bicycles. The message is: "You see, they are nothing special. This could be you."

Today's celebrity magazines air the stars' dirty laundry and their personal struggles. They persuade the celebrities to open up about their problems with drugs and alcohol. They expect stars to discuss their relationships and talk about past abuse and bad childhoods and yet make no attempt to give readers a way to understand the import of these stories. They focus on celebrities' insecurities about their weight and their looks. And, as readers, we're gradually seduced into believing that being entertained by the real struggles of troubled individuals is harmless fun.

At the time we wrote this book, Nicole Richie had reinvented herself, leaving behind her life as a party girl and tabloid favorite for the role of new mother. She and her boyfriend, rocker Joel Madden, have been praised for their charitable ventures, and for now the media seems content with the idea that Nicole has overcome her difficulties and found a way to have it all. But should she encounter troubles down the line (and she surely may, as opiate

use is never just a phase) you can bet the press will quickly switch gears, forsaking human empathy for the thrill of the story. Readers and fans, envious of her recent good fortune, will choose to blame Nicole for her weakness, rather than rallying behind her to encourage her to get the treatment that can lead to sustained health. And that is how the cycle continues.

■ ■ ■

If Nicole, or any other star, makes a misstep, the paparazzi will make it a point to catch her in the act. When glossy magazines were purely fan magazines, celebrities and their handlers could count on glamorous photos to help perpetuate their star images. Today, your favorite star is just as likely to show up, sans makeup or retouching, in the "Stars Without Makeup" feature in *In Touch* as she is to make a flawless appearance on the red carpet. In the current market for celebrity photos, the artfully posed portraits of an earlier time have been supplanted by candid snaps, the more compromising or unflattering the better.

Named after the news photographer Paparazzo in Federico Fellini's film *La Dolce Vita*, the paparazzi (these days often called *stalkerazzi*) have injected themselves into every aspect of celebrity life. Faced with the chance of making hundreds of thousands of dollars for a single photo, they have become more aggressive and dangerous in their pursuit of the stars. Today's paparazzi swarm Hollywood in fast cars and on motorcycles. They lurk outside popular restaurants and celebrity hangouts like the Beverly Hills Hotel, Koi, STK, Nobu, Mr. Chow, or Kitson's and they descend on any celebrity heading in or out of the high-end shops lining LA's Robertson Boulevard. Armed with cell phones, two-way radios, and high-tech photo and video equipment, they prowl through LA as if they're on safari, trying to bag the big one. Their hottest shots

often appear on the Internet within hours, even minutes, of being taken.

Most of the audience has little or no sense of the symbiotic relationship that links certain celebrities, the tabloids, and the paparazzi. Every year, the tabloid editorial staffs usually pick about a dozen celebrities they feel are likely to provide an annual supply of drama. (This is no scientific process; one editor at a top tabloid told us he tends to choose "people I'd like to sleep with.") These celebs get a place on the tabloid calendar. And as long as their behavior keeps attracting attention, they stay there as staples for the year, with the rest of the space reserved for lower-tier celebrities who manage to create more fleeting drama on a week-by-week basis.

The photographers' side of the equation also influences the tenor of celebrity coverage. Photo services like Getty Images focus on the glamorous side of the business; their photographers have relationships with stars and their management, and they're the ones who get the call when a star wants a particular image captured and distributed. All those supposedly candid pictures of Paris, perfectly dressed and made up, emerging from a club or store? Completely set up. Heidi and Spencer caught in a romantic moment? Utterly staged. Flattering beach photos? Art directed *and* Photoshopped. Once the photos are taken and approved by celebrities or their management, they're distributed through the agency's Web site to be downloaded by magazine editors, Internet gossip sites, and other interested parties. A third party, who guarantees that the star's conditions are met and ensures exclusivity for the buyer, often brokers the biggest photos.

But there's another end to the spectrum, in which the more aggressive photo organizations, such as Jupitermedia, Corbis, X17, Bauer-Griffin, INF, Splash, Fame, and LDP Images, go hunting for

candid celebrity shots every day and night, in Hollywood and around the world. These photo agencies hire renegade freelancers who aggressively compete for truly candid shots that can be quickly sold to the tabloids. While their range is worldwide, the paparazzi tend to concentrate on Hollywood, where many stars live and have to conduct the ordinary business of their lives. The Web site TMZ, which thrives on this kind of photography, was named after the so-called *thirty-mile zone*, the center of the entertainment world in Hollywood and Los Angeles. One paparazzo says that he and his competitors actually concentrate their efforts in a *two*-mile radius of trendy shops, restaurants, and nightclubs in Hollywood. If a star doesn't want to be photographed, he insists, she won't come to that part of town. If she does, she's fair game.

When the paps are closing in on a newsmaking shot, they can be ruthless, and dangerous. Diana, Princess of Wales, of course, died in a Paris tunnel while being chased by paparazzi. At the last inquest into her death, it was revealed that after the crash, instead of aiding the victims, the photographers took pictures of the dying princess inside the wrecked car. The grief over Princess Di's death was worldwide and profound, but doesn't seem to have given the paparazzi second thoughts about the risks they take: A decade later, they're more aggressive than ever. The kind of car chase that led to Princess Di's death is commonplace today in Hollywood. Paparazzi on motorcycles or in cars chase celebrities down city streets and through red lights with no apparent thought for the safety of anyone who gets in the way. When Britney Spears was being transported to a hospital for psychiatric evaluation, there were so many paparazzi hanging off the sides of her ambulance that the vehicle could barely make it down the street.

■ ■ ■

Even as digital cameras, Internet downloads, and an increasingly competitive marketplace were changing the nature of the celebrity magazine business, another media development was bringing increasingly sexual imagery and a fresh torrent in the flood of celebrity-based news shows into American living rooms.

In the late 1990s, cable TV networks like MTV, VH1, Fox, and E! started breaking away from their traditional network season schedules, programming new shows in rapid cycles and bringing new faces into our homes virtually around the clock. Taking advantage of lower censorship standards than broadcast TV, they soon began changing the tone of basic cable programming, playing to a teen audience with outrageous, provocative, often highly sexualized content. Shows like E!'s *The Howard Stern Show* (1994), *E! True Hollywood Story* (1996), *Wild On!* (1997), and VH1's *Behind the Music* (1997) all gloried in the outrageously narcissistic behaviors of rock stars, movie stars, porn stars, and more.

Of course, MTV had paved the way for much of this, giving performers a highly visual, sexually charged arena in which to invent, and reinvent, their stage personae. By the late 1990s, the era of Madonna was giving way to a new generation of singers, clearly influenced by her example, but also younger and clearly less in control of their own images and careers. Two of these, ironically, were former Mouseketeers: Britney Spears and Christina Aguilera. In what was dubbed the MTV "Battle of the Vixens," Britney and Christina pushed the boundaries of good taste in a series of increasingly sexual and exploitative videos. In October 1998, seventeen-year-old Britney's first single, ". . Baby One More Time," climbed to the top of the *Billboard* chart and established her as an international sex symbol. In the video, Britney wore a sexy-schoolgirl outfit with a bare midriff and led her backup dancers through suggestive choreography. Britney was criticized for her perfor-

mance and the song's lyrics ("hit me, baby, one more time"), but protested that she herself was chaste (she was dating fellow former Mouseketeer and 'N Sync band member Justin Timberlake at the time, but vowed to remain a virgin until she married). She claimed her main goal was "just to make good music, and since I am so young, I can grow as an artist each time and hopefully be a legend or something, like Madonna."

A year older than Britney, Christina Aguilera had earned the nickname "the Diva" during her Mouseketeer days. In 1999 Christina took aim at Britney's pop idol status, responding to ". . . Baby One More Time" with "What a Girl Wants," a song with equally suggestive choreography and similarly bare midriff. Not to be up-staged, Britney countered in 2000 with "Oops! I Did It Again," in which she sported a skintight leather jumpsuit. Christina then teamed up with Lil' Kim, Mya, and Pink to do a bordello-inspired cover of "Lady Marmalade," Labelle's 1970s hit that appeared on the *Moulin Rouge* movie soundtrack.

Britney upped the ante again with "Slave 4 U" in 2001, taunt-ing her listeners to "leave behind my name and age." This time, Christina's response pushed things a little too far. In 2002 she re-leased the video "Dirrty," in which she stormed around a boxing ring in a scanty outfit, grungy-looking dreadlocks, and nose ring, grabbing her crotch, spitting on the floor, and grappling with another girl as a gang of sweaty men looked on. "Dirrty" seems to have been a tipping point with critics, who thought its self-indulgent sexuality went too far.

In 2003, the battle came to a head on the MTV Video Music Awards when both Britney and Christina performed with Ma-donna. Reprising Madonna's iconic live performance of "Like a Virgin," Christina and Britney joined a tuxedoed Madonna on-stage, dressed in lingerie versions of wedding gowns. Midway

through the performance, Madonna gave both girls a lingering kiss on the lips. The Britney-Madonna kiss got more screen time, and it stole the show, making headlines and creating a mini firestorm. Britney herself told *Access Hollywood* that she'd been nervous about the kiss, but that knowing her parents approved made her feel better. "Well, my mom liked it actually," she said. "I was like, 'Oh, my God, my mom . . . she's going to see this!' But no, she liked it! And my dad, weirdly enough, he thought it was fine, too. I mean, come on . . . it's Madonna. If you can kiss any girl in the world, that has to be her."

That these two video rivals were teenagers themselves was not lost on their audience, which consisted overwhelmingly of teenage girls. The subliminal message was that young women, even those who intended to be chaste, could garner attention and power by flaunting their sexuality. This questionable female-independence message was explicit in songs like "Slave 4 U": "All you people look at me like I'm a little girl," Britney sings. "Well, did you ever think it [might] be okay for me to step into this world?" In their 2000 hit, "Independent Woman," Destiny's Child sang, "Only ring your cell-y when I'm feelin' lonely/When it's all over please get up and leave."

When you watch these videos today, the choreography and costuming seem tame: Ten years ago belly-baring tops and low-rise jeans were edgy and scandalous, but they've long since found their way from MTV to the schoolyard. When Christina and Britney consciously subverted their wholesome Disney image, they were normalizing the sexualization of teenage girls in pop culture and paving the way for the antics of the next generation of young performers from Vanessa Hudgens to Miley Cyrus.

■ ■ ■

By the start of the twenty-first century, tabloids and shock TV were changing the fame agenda, and the audience was demanding total access to the stars. Puff pieces on the latest movies and CDs had given way to sensational, personal, often intrusive stories about the stars' private lives. And, as we learned more and more about those lives, our relationship to celebrity and fame began to shift. Awash in a culture of hypersexualized, body-conscious, entitled celebrity, we were no longer satisfied simply to admire the famous or to follow their travails. We began to believe we could *be* them. The magazines themselves told us the stars were "just like us." And before long two new phenomena—reality TV and the Internet—made it possible for us all to have the fifteen minutes Andy Warhol had promised us.

Broadcasting Yourself

This is the true story . . . of seven strangers . . . picked to live in a house . . . work together and have their lives taped . . . to find out what happens when people stop being polite . . . and start getting real.

——*The introduction to the MTV series* The Real World

As a reality show producer, there are many times when things will happen and you will look at an edit and think, 'Oh my gosh, this person is going to be devastated when they see this scene play out.' I think it's damaging to their reputation or who they think they are. And what happens is, they see the scene, and they call you and say, 'Oh my god! I loved that scene; it was amazing.' . . . They're not worried about their reputation because it's catapulting them into fame. Any attention is good attention.

——*L., reality TV producer*

Both reality television and the Internet have been around for more than a decade. However, in the past five years the explosion of reality TV programming, combined with the widespread accessibility of the Internet, have reshaped the landscape of fame and dramatically influenced the public's relationship with celebrity. Celebrity has become uncoupled from talent or performance; today, being famous seems like a game anyone can play. And the price of admission, apparently, is to indulge in the same unregulated, often troubling, behavior that dominates reality TV and the Internet.

The behavior modeled in those two venues can have different effects on different audiences. Some viewers take a celebrity's bad behavior as inspiration or license to act out in similar ways. Others may use it as an occasion to sit in self-righteous judgment, thereby shoring up their own weak self-esteem. Whatever the reaction, these two media are changing our relationship to celebrity in dramatic and potentially dangerous ways.

■ ■ ■

An important precursor of today's explosion of reality TV shows was *The Real World,* which debuted in 1992. The first season installed seven young people between the ages of seventeen and twenty-five in a Soho loft in Manhattan and rolled the cameras 24/7. One of the show's creators, Jon Murray, told Mark that the show was initially conceived to showcase the modern-day melting pot of youth culture, showing strangers from diverse backgrounds sorting out their differences and living together.

When *The Real World* premiered, no one knew if it was going to be a success. But from my radio experience I knew that the young audience at that time was craving a "really real," that is, authentic, mirror of their personal experiences. They wanted to be able to see their generation portrayed as they saw themselves. Teenagers were far more media savvy than they'd been in previous generations, and they'd become restless with traditional radio and TV programming, which they recognized as the product of an older generation trying to pander to their tastes. *The Real World* resonated with this audience, and over time it has provided an accurate, though amplified, reflection of the culture of young adults.

Early in the show's run, the cast members discussed, or hinted at, their housemates' more questionable behaviors in titillating confessionals, sharing their feelings with the camera (and us). Later,

this behavior became more explicit: Cast members were shown acting out sexually, drinking heavily, even referring to their drug use. The unacknowledged fallout of such open discussions was that adolescent viewers, who strongly identified with the show's characters, were at risk of relating to this behavior without analyzing it. Whether it was Ruthie passing out from drinking, prompting the roommates to call paramedics (season eight); Steven, Trishelle, and Brynn's hot-tub threesome (season twelve); Davis and Tyrie's rage-filled blowout (season eighteen); or Joey's alcoholic rampage, his denial that he had a problem, his angrily blaming his housemates for his drinking, and his ultimately leaving the house to go to rehab (season twenty), these behaviors were portrayed without framing commentary. Beyond the fleeting reactions of the housemates themselves, no one ever clarified that such behavior was part of a pathology, or even hinted that it was troubling. And how did the culture at large respond? With a resounding shrug. *After all*, we seemed to say, *kids will be kids*.

As someone who came of age in the era of sex, drugs, and rock 'n' roll rebellion that followed the sexual revolution, I can understand why so many parents today are so reluctant to second-guess such imagery. They don't understand that while youthful experimentation can be normal, it can quickly spill into pathology. And parents are not given the information they need to know the difference. When I am evaluating an adolescent, I know that signs of mental illness can be expressed through obsession with one's body, sexual acting out, volatile anger, or excessive drinking or drug use. Unfortunately, it is precisely those behaviors that were highly valued in the parents' youthful rebellions of the 1960s and '70s, and that are glamorized in magazines and on TV today.

The same sorts of behavior, from obsession with one's body to

sexual acting out to anger to excess drinking and drug use, are staples of reality show story lines today.

When callers on my radio shows bring up these types of behavior, I can explain why they are harmful and offer appropriate advice, often as a counterpoint to messages the caller has heard elsewhere in the culture. But when reality TV exploded, and viewers started watching such behaviors as entertainment, I became deeply worried. Reality was flooding a vulnerable audience with potentially damaging messages without offering any balancing commentary.

■ ■ ■

The success of *The Real World* marked a television watershed, but it was around the year 2000 that reality programming really exploded. The cable channels, and even the mainstream networks, jumped on the bandwagon, creating shows like *Who Wants to Marry a Multi-Millionaire, Big Brother, Survivor, The Amazing Race, The Simple Life,* and *America's Next Top Model.* There were many different types of reality show, and some generated spinoff after spinoff, but they all shared one hallmark: They exploited narcissistic behaviors for dramatic effect.

Competition shows like *Survivor, American Idol, America's Next Top Model, I'm a Celebrity . . . Get Me Out of Here!, The Apprentice, Project Runway, Dancing with the Stars, Hell's Kitchen,* and *Celebrity Circus* pit contestants in no-holds-barred battles for supremacy and financial reward. It's debatable whether talent has much to do with winning on these shows, but one thing is certain: They reward their contestants for being ruthless, exploitative, authoritarian, self-sufficient, and vain. It's hard to imagine anyone without a heavy reserve of narcissism carrying on after a dressing-down from one of their acerbic judges. Many of the shows, especially *Top*

Model and *Celebrity Fit Club*, focus on body image, following their contestants as they obsess over their weight and appearance, and then subject themselves to potentially withering critique. Nearly all of them highlight bad behavior, giving extra camera time to cast members who blow up, break down, or, alternatively, scheme and conspire to grasp every advantage. As Omarosa Manigault-Stallworth, the villain of *The Apprentice*, told *Time*, "When I was a good girl, there were no cameras on. The minute I started arguing, there was a camera shooting me from every angle." Even the judges, from Donald Trump to Janice Dickinson to Paula Abdul, join in the divalike behavior. These shows invite the audience to indulge its own narcissistic feelings of superiority, whether by jeering at the TV screen in their living rooms or by posting snide commentary on the shows' Web sites.

Dating competition shows like *The Bachelor, The Bachelorette, Joe Millionaire,* and *Mr. Personality* combine all of the traits above, with more emphasis on sex and treachery. The figure at the center of the competition—the prize, as it were—is always extremely attractive and charismatic, carefully coached to appear sincere and vulnerable. On television, such figures become idealized romantic idols, even if in real life they're vain, arrogant, and entitled. One talent agent I know was repeatedly called by one of his clients, a former star of *The Bachelor*, who wanted to know why he wasn't being offered leading man roles in films. Though he'd never acted, he saw himself as the star of a romantic blockbuster. While people were paying him thousands of dollars to show up at a restaurant or a shopping mall, he couldn't understand why his agent couldn't get him a movie role.

There were plenty of dating shows in the early years, offering endless variations on the basic cat-and-mouse game. Dating voyeur shows like *Blind Date, Room Raiders,* and *Next* featured nonce-

lebrities angling to hook up with sexy contestants—no promise of deeper relationships here—in a hot-tub stew of competition, outrageous behavior, and sexploitation. A series of surreal celebrity-bachelor shows, including *Flavor of Love, I Love New York, Rock of Love,* and *A Shot at Love with Tila Tequila* blended the house-of-misfit-toys absurdism of *The Surreal Life* with the spectacle of unconventional romance featuring such eccentric characters as rapper Flavor Flav, Poison lead singer Bret Michaels, and the so-called reality star known as New York. And parental boundaries were thrown out the window in the surprisingly robust subgenre of shows like *Meet My Folks, Date My Mom, Who Wants to Marry My Dad?,* and *Parental Control,* in which parents and children judged each other's dates for entertainment value.

Shows like *The Simple Life , The Surreal Life, Newlyweds: Nick and Jessica, Tommy Lee Goes to College, Hogan Knows Best,* and *Tori & Dean: Inn Love* invite audiences to laugh at celebrities in fish-out-of-water situations. Whether it's watching Paris and Nicole work on a dairy farm or Tommy Lee at marching band practice, the last laugh is usually on the audience: In most cases, the celebrities flaunt their narcissistic superiority, determined to prove that they're different from, that is, better than, the average folks who surround them. The audience might have enjoyed the spectacle of Paris and Nicole bungling the normal tasks they were assigned, but after an episode's worth of juvenile sabotage, stubbornness, and whining, Paris and Nicole just returned to their glamorous lives. Jessica and Nick weren't fish out of water, exactly, but Jessica's dumb-girl antics were a riff on the Paris-and-Nicole act, and the show somehow managed to make Jessica seem idiotic while preserving her glamorous aura. The point of these programs was to showcase celebrities being themselves, in other words, to document how narcissistic personalities cope with everyday life. They gave viewers an oppor-

tunity to indulge their own feelings of envy or superiority toward the celebrities, while flattering viewers by letting them in on the celebrities' little joke on the rest of the world.

A whole host of narcissistic traits—extreme self-importance, inflated sense of specialness, vanity, envy, and entitlement—come into play in diva shows like *Gastineau Girls, My Super Sweet 16, Real Housewives of Orange County, Kimora: Life in the Fab Lane,* and *Keeping Up with the Kardashians.* These shows offer hope to all narcissistic viewers who ever dreamed that fame, or even just ostentatious wealth, could be theirs simply by demanding it. The people who succeed on these shows appear to have little use for education, hard work, or the discipline of climbing a career ladder. Instead, they pout, throw tantrums, stomp their feet, manipulate friends, family, and coworkers, and otherwise act out, all while wallowing in the lap of luxury.

A similar narcissistic drive is the subtext of body-image shows such as *Dr. 90210, The Biggest Loser, The Swan, Look-a-Like, I Want a Famous Face,* and *Celebrity Fit Club.* These programs glorify the improvement of the body—by any means necessary. Unfortunately for most of the contestants, though, such extreme makeovers couldn't possibly solve the problems that may have driven them to the show in the first place. These shows may motivate some viewers to make positive changes in their lives, but for more vulnerable individuals their preoccupation with appearance, and the fantastic promise that internal struggles can be solved by external changes, risk triggering other harmful behavior, including eating disorders or other damaging habits.

The most malicious reality shows, however, are the train-wreck series: *The Anna Nicole Show, The Osbournes, Britney and Kevin: Chaotic, Breaking Bonaduce,* and *Hey Paula,* in which unstable individuals' lives and interpersonal chaos are served up as entertainment.

Several of these shows, especially *Anna Nicole* and *The Osbournes*, got huge attention when they debuted. Yet there was little public outcry about what their stars' behavior suggested about their own mental health. In many cases, the stars of these shows were deeply in trouble. It's appalling that their behavior was broadcast without acknowledging all the circumstances underlying their dysfunction. When *Celebrity Rehab* was created, I told VH1 producers that my goal was to do exactly the opposite of these shows: to *humanize* the celebrities we would feature, and to use the show to explain what really was behind the participants' outrageous and inconceivable behavior.

I was fortunate that VH1 was on board with my goals for the show. Perhaps my insistence on the importance of providing context to the sometimes unrestrained and incomprehensible behavior of addicts hit home with them, as VH1 had only recently completed the grueling experience of filming Danny Bonaduce's reality show, *Breaking Bonaduce*.

The producers certainly had some inkling of what they were getting into when they built a show around the former child actor: Bonaduce's long struggle with drugs, his police record, and his history of violence were no secret, and they were all red flags for an unstable personality. The producers were forced to walk a fine line as they decided how much "reality" they could present in the absence of full context of the behavior. The footage was often raw, and sometimes frightening. As viewers watched, Bonaduce hit bottom in real time—abusing drugs including steroids, harming himself, and unleashing violent and uncensored emotion on those around him.

In a *New York Daily News* interview, Bonaduce talks about what was really going on during filming—the downward spiral of his life

brought about by a return to abusing alcohol before the cameras even started rolling. "If I had known that I was going to implode," Bonaduce told the reporter, "I would never in a million years have done [the show]."

But by the time VH1 producers tried to pull the plug on filming, Bonaduce admitted that his regular cocktail of prescription drugs and alcohol had left him powerless to temper his behavior. "When VH1 said, 'We think you're probably going to die and we don't want to film you dying,'" said Bonaduce, "I said, 'What kind of TV show quits when the lead is going to die?' I thought the death of a B-lister on tape would be pretty cool . . . Plus I wouldn't have to muscle through this crap anymore, and I'd be James Dean. Anyone can die in a car crash. It takes a special guy to actually be the car crash."

In the end, Bonaduce didn't die and the producers ran with the raw, and in this case, unscripted reality. What emerged was a painful and eye-opening look at a troubled soul in the grip of personal demons. In the end, Bonaduce's decision to seek therapy for his addictions, psychological problems, and in the hopes of saving his marriage, revelations about his abusive childhood may have encouraged at-risk viewers who identified with certain of his behaviors to seek professional help. This type of audience response has been typical of the reaction to *Celebrity Rehab,* with new patients showing up for treatment and saying they had been motivated by seeing a celebrity they admired going through the process of rehab.

Most recently, the exploitative qualities of reality TV have been heightened in a host of next-generation shows, including *The Ashlee Simpson Show, Living Lohan,* and *Rock the Cradle,* in which the children or younger siblings of celebrities vie for their chance

at the spotlight, often at the manipulative direction of parents, who are clearly acting out their own narcissistic tendencies through their grandiose promotion of their families.

Even noncelebrity reality shows tend to exploit dysfunctional behavior. Family counseling shows like *Wife Swap, Nanny 911, Shalom in the Home,* and *The Baby Borrowers* all promise to shed light on common family struggles, and offer advice to those at home struggling with similar issues. Yet even these shows thrive on exploiting dysfunctional behavior—without ever exploring the complexities of the situations—and in so doing they allow viewers to sit in self-righteous judgment of these unfortunate families.

■ ■ ■

Whatever the genre, the formula for a successful reality show has long been clear: The more outlandish the behavior, the more successful the show. As Ellis Cashmore points out in his book *Celebrity/Culture,* "Reality television tended to turn its characters' vices into virtues, so that people who displayed ignorance, dishonesty or some other kind of depravity became praiseworthy."

Reality shows have influenced more than their viewers' notions that anyone could become a celebrity. They have promoted a new ethos of morality, in which superficial hooking up and intoxicated improprieties become rites of passage. The subtext of constant interpersonal drama speaks directly to the young viewers who personally relate to the conflicts being played out in each episode: *I am important. My problems are more important than yours. So watch me.*

Reality TV requires complicity from its audience. Viewers must willingly suspend disbelief to indulge in a fantasy that's portrayed as reality. How else can we explain the guilty pleasure of watching

pseudo-reality shows like the MTV series *The Hills*? When Mark asked his students at USC why they watched the show, they said they knew it was scripted, and admitted that the dialogue often seemed forced, but they insisted that parts of the show still resonated with their actual lives. And it's these small pieces of truth that make the show feel real and compel them to keep watching, even as they feel guilty about it. This goes a long way toward explaining the popularity of reality shows: Viewers can easily project themselves and their lives onto characters and situations that, however extreme, have a kernel of realness that triggers an emotional, and often narcissistic, response.

Anyone watching reality TV should keep in mind that it's not just the circumstances on these shows that make the cast members behave as they do. Nor, for that matter, is it a matter of personality, dysfunctional or not. One hidden element in every reality show is the influence of the producers, who manipulate the environment constantly to keep the contestants feeling unsettled and challenged, to encourage conflict and thus create drama. The result should really be called *hyper-reality* TV, since what it offers is a parade of reactions coaxed out of fragile people in extreme circumstances.

When we're watching a reality show, even one of the many that involve extreme circumstances—strangers locked in a house together, or stranded far from civilization, or engaged in ruthless competition under the guise of pursuing a relationship—it's easy to overlook the fact that we're also watching sick people struggle with very real problems. Having served as a consultant to several reality shows, I know what the producers are looking for in contestants. The standards regarding mental health are extremely fluid. In some cases, as long as the psychological evaluations indicate that contestants are unlikely to seriously harm themselves or others, they're

good to go. If they're psychologically disturbed enough to create some real drama, so much the better. As far as reality shows are concerned, emotionally healthy, stable people just don't make "good TV."

The purpose of drama has always been to examine the human emotional condition through allegory, and today reality TV purports to fill this role, but there are subtler, and more dangerous, forces at work here as well. After all, one of the hallmarks of narcissism is a lack of empathy, so it's highly unlikely that either participants in the shows or viewers with narcissistic tendencies could ever learn any real lessons about the human condition from these chaotic reality story lines. Certainly the cast members themselves tend to react to conflict in a typically narcissistic fashion, often with an immediate, intense, even violent response and the certainty that their point of view is the only perspective worth considering. While this may make for high-tension television, presenting such behavior as reality allows the audience to validate their own preexisting narcissistic responses and encourages them to mirror the behavior in their own lives.

The phenomenon of reality TV has certainly democratized fame, but by normalizing narcissistic behaviors on a public stage, it has also fueled narcissism among everyday people. Reality television has a great capacity for taking challenging, even tragic dysfunctions and making them seem glamorous and even beneficial. When night after night we watch the "real" people on these shows become famous for acting out, drinking, using drugs, engaging in hypersexual behavior, indulging in exhibitionism, flaunting their vanity and entitlement, or drawing attention through self-harming actions, it's easy to conclude that the road to fame is paved with bad behavior. And when we realize that few of these individuals ever suffer consequences for these actions, it only seems to prove

that celebrity offers special protections to the famous. That's a powerfully seductive message, particularly to vulnerable audience members predisposed to narcissistic thinking.

■ ■ ■

One of the earliest reality-show blockbusters, *Big Brother*, also became the first to exploit the power of the Internet to lure audiences by promising to make them part of the show. At first, the appeal was that the online content was only subject to a twelve-second delay before it was transmitted. The nightly ninety-minute shows were lightly edited to meet broadcast standards, but watching online gave the viewer the voyeuristic chance to witness behavior, like nudity or sex, that would be edited from the TV broadcast. Another aspect of the online episodes proved even more attractive.

What the *Big Brother* producers hit upon was a way to allow viewers to participate actively in a reality-show community via the Internet. Before long, the interactions of the people who visited the Web site were as interesting as the program itself. *Big Brother* also used the Internet to give the audience power over the outcome of the show by allowing them to vote off cast members. The audience now had two ways of participating in reality shows: Those who weren't lucky enough to become contestants could nevertheless indulge their judgmental side to knock down those who were. For the first time, narcissistic individuals had a direct way to act out their feelings toward the characters on one of their favorite shows.

This came at a time when other cultural trends had already begun weakening the boundaries between public and private, redefining the meaning of exhibitionism and creating new kinds of celebrity. President Bill Clinton exposed his private life to scru-

tiny: first willingly, as he took personal questions from MTV view-ers (boxers or briefs?), then less so when his behavior in office led to a blistering inquiry into his extramarital affairs. A flood of per-sonal tell-all memoirs, dubbed *reality literature* by some critics, be-came a growing trend. The talk shows of the 1980s and '90s, hosted by Geraldo Rivera, Sally Jesse Raphael, Maury Povich, Montel Wil-liams, Ricki Lake, Jenny Jones, and Jerry Springer, specialized in probing the deeply dysfunctional lives of their guests. For an audi-ence eager to experience a supposedly real moment of illicit behav-ior, reality TV transformed voyeurism into a mainstream hobby, and created modern-day celebrities out of ordinary individuals whose high levels of exhibitionism were perfect fodder for con-stant scrutiny and commentary.

Then the world went online. In its short life as a public phe-nomenon, the Internet has proven its enormous potential to trans-form our culture in ways we're only beginning to understand. It has already changed journalism, commerce, communication, re-search, and entertainment. It has been welcomed by some quarters of society for its ability to spread information quickly and demo-cratically, and scorned by others for the platform it offered to more insidious forces, from Internet scams to pornography.

In particular, when broadband Internet access became wide-spread, it gave young people the opportunity to project their own images, in words, music, photographs, and video, to unknown viewers the world over. In less than a decade, this has had enor-mous, and troubling, implications for young people who were vul-nerable to exploitation.

By the early 2000s, a handful of entrepreneurs recognized the potential to use this technology to create an entirely new form of communication and began creating what became known as social networking sites. First Friendster, then MySpace and Facebook, al-

lowed their members, at that time predominantly young women and men looking for connection, to create Web pages on which they could share personal information, photos, and running commentary about their lives. These unmonitored sites invited users to create new personae whose connection with their real lives were often tenuous at best, a high-tech version of what psychiatric professionals call a *pseudo-self*, a classic social coping mechanism among narcissists. And the perceived goal of these sites was to connect with others by "friending" them, thus establishing an ambiguous, but alluring, connection with strangers who might be hiding behind false fronts of their own.

Beyond the social networks, other platforms offered more specialized ways for vulnerable users to share their private worlds with strangers, often without any adult supervision. YouTube and Flickr allowed users to post video and still images (respectively) of whatever they wanted, making them accessible to anyone in the world. Twitter offered users the chance to share their experiences in brief instant messages up to 140 characters long, perfect for a generation already accustomed to IM'ing and text-messaging on their computers and phones. Some used webcams to broadcast their every move in real time on their own Web pages. By the mid-2000s it seemed like everyone had a blog, a kind of personal online journal for posting everything from photos to political commentary to a running chronicle of the bloggers' most intimate thoughts and feelings.

All these services have their legitimate purposes, but they can also feed the narcissism of adolescents and adults alike by allowing people to document their experiences in words, pictures, and videos solely for the purpose of broadcasting them to (often anonymous) others. The very act of creating an artfully crafted image of oneself, in words, photos, or video, and posting it for universal

consumption can make the poster feel suddenly important, gratified, glamorous, even powerful. Ultimately, these sites act as incubators for those who harbor narcissistic traits.

With its open invitation to broadcast to the world from the privacy of your bedroom, the Internet paved the way for voyeurs to evolve into exhibitionists. Blogs, webcams, and social networking sites present themselves as miraculous new avenues of self-expression, but they also encourage users to give free rein to their narcissistic side. They turn personal information into a commodity and give those on the Internet a rare opportunity to manipulate the opinions of others. Any average person can now become a cyber-celebrity: the star of his or her own documentary, broadcast through the ether to an anonymous audience who then validates his or her existence by offering encouraging or critical feedback. It's hard to imagine a more perfect venue for the narcissist.

In a June 2008 article in *Wired* magazine, Jason Tanz profiled Julia Allison, one of the most visible Internet celebrities who have blogged their way to notoriety in recent years. Of Allison, Tanz wrote: "She can't act. She can't sing. She's not rich. But thanks to a genius for self-promotion—plus Flickr, Twitter, and her blogs—she's become an Internet celebrity. . . . Allison has done it on her own and on the cheap, armed only with an insatiable need for attention and a healthy helping of Web savvy."

Julia Allison is young, attractive, and ambitious. She's a graduate of Georgetown University. No doubt she could have been successful in any number of ventures, but when she moved to New York City in 2004, she decided that her goal would be to brand herself, to "become a cult figure." Her strategy began with writing a dating column for *AM New York*, a free commuter newsletter. She then used the tip line on Gawker, a media-gossip site with millions of readers each month, to link to her articles. Allison upped

her visibility on the site by becoming a frequent commenter on stories, until the site's editors banned her for a level of "gratuitous self-promotion that makes even the most gratuitous self-promoters at Gawker blush."

Allison remained determined to become a Gawker regular, but once she could no longer spread her name around on their comments boards, she knew she had to take more drastic measures; she translated her online personality into real life, showing up at Gawker owner Nick Denton's Halloween party in a skimpy, low-cut costume accessorized with condom wrappers. Denton noticed the condom fairy and told his managing editor to run an item about her. The 800-word item was scathing, and a thinner-skinned individual might have given up on the idea of taking Manhattan by storm. Not Allison. Her next move was to befriend the Gawker writers, sending them personal anecdotes from her blog. As the writers started picking up her stories and readers began to comment, Allison continued revealing intimate information about herself, particularly the made-for-the-Internet drama of her love life, and then begged Gawker *not* to link to it. It was a brilliant stroke of reverse psychology, and it worked: After a few months, everyone who read Gawker knew who Julia Allison was.

Having achieved name recognition, and a following, though much of her audience loved to hate her for her spotlight-hungry antics, Allison continued her media onslaught with a job as a talking head for *Star* magazine, appearing on various news and talk shows to parse the latest celebrity dramas. She used Flickr and Twitter to amplify her cyberpresence, updating followers on her activities every few hours throughout the day.

Allison's online life eventually netted her—you guessed it!—a deal to develop her very own reality show. In June 2008, the Bravo network signed a series called *IT Girls*, which will follow Al-

lison and her partners as they launch an Internet start-up venture. As with most reality TV, whether the business succeeds or fails hardly seems to matter. Narcissists are largely undeterred by failure. Their protective mechanisms are always on hand to reassure them that the blame lies with others; before long, other helpful traits, like vanity, exploitativeness, superiority, and entitlement, will kick into gear and they're on to their next adventure.

Not every Internet celebrity has it quite as easy as Julia Allison. Another blogger's notorious oversharing cost her relationships and eventually drove her from her job (though it did land her a *New York Times Magazine* cover story). Emily Gould, a book editor turned Gawker writer and editor, says she left the media blog in despair after being deluged with criticism about her glib commentary on the site, and after her personal life overlapped once too often with her blogging personality. Gould told the *Times* just how all-consuming blogging about oneself can become: "The will to blog is a complicated thing, somewhere between inspiration and compulsion. It can feel almost like a biological impulse. You see something, or an idea occurs to you, and you have to share it with the Internet as soon as possible." That's the kind of language that often crops up when narcissists talk about their feelings: Because they're so detached from their emotions, they often seem bewildered by otherwise normal behaviors, and can truly feel driven by a mysterious force.

It's not just bloggers who use the Internet to achieve widespread notoriety. For anyone with a digital camera and an Internet connection, a rise from obscurity to celebrity can be just one short video away. Twenty-year-old Chris Crocker was an openly gay adolescent living in a small town, posting frustrated rants and performance art videos about his life on his MySpace page, when one of

his video posts went viral, making him an Internet icon and opening the door to a whole new level of celebrity.

Crocker's moment came in September 2007, after Britney Spears opened the MTV Video Music Awards with a disoriented and sluggish performance. The event had been billed as her comeback, and when she fell short the critics savaged her, amping up the media frenzy that had been swirling around her for months. Crocker posted a plaintive video on YouTube and MySpace begging viewers to "leave Britney alone," a phrase that eventually gave the video its name. A tearful identification with his fellow Southerner, and a hysterical indictment of Britney's critics, the video immediately went viral, with two million views in the first twenty-four hours. Although Crocker's persona and MySpace page already had a dedicated following, the Britney video set him on the path of the modern version of celebrity: national press, a consulting gig with MTV, a development deal for a reality show (fittingly called *Chris Crocker's 15 Minutes More*), and a recording deal.

Crocker leveraged his newfound fame into a move to LA and a very public amplification of his feminine appearance and gay lifestyle. While he has abandoned his MySpace channel and his reality show development deal, citing "censorship," in September 2008 he announced on his newest blog that he had acquired another badge of modern celebrity: an unauthorized Internet sex tape.

When I first saw the "Britney" video, my immediate reaction was that Crocker's behavior indicated a simple but extreme narcissism. He does not use his real name, presenting instead a deeply entrenched false persona, a pseudo-self. After becoming more familiar with his story, I began to see a young man who is obviously suffering. His demeanor and blog lead me to suspect a background

of sexual trauma and abuse. Like any severe narcissist, he is so helpless and shattered that he appears to seek control by projecting his pain out into the world. He may even derive some satisfaction from being an object of ridicule, but this type of emotional arousal comes at serious expense. And while his level of self-absorption and preoccupation is profound, I suspect that he suffers quiet moments of self-loathing.

The interesting thing about those who achieve fame through the Internet is that society elevates them to celebrity status not because they exude glamour or have any proven talent as artists or performers, but because they present a model of hypersexualized, damaged behavior, and because they project a certain vulnerability. Whether the audience attacks or supports them doesn't seem to matter. When narcissistic individuals are singled out, from millions of others on the same Internet platforms, it feeds their narcissism and propels them to increasingly exhibitionistic revelations. This kind of random reinforcement is the same mechanism that drives gamblers to continue to bet even when they're deep in the hole: Convinced that lightning can strike twice, they keep on broadcasting the persona that first got them attention. A vicious cycle can develop: Some of these individuals become famous when a sudden flurry of Internet attention piques the interest of the commercial media. That kind of implicit endorsement by the mainstream only amplifies their behavior before reflecting it back to us under the affirming banner of celebrity. Before you know it, other narcissistic individuals start seeing similar behavior as normal, even desirable, and mirroring the behavior back themselves, copycat style.

When eighteen-year-old Disney star Vanessa Hudgens poses nude for "private photos" for her boyfriend that are then leaked over the Internet, or when fifteen-year-old Miley Cyrus's provoca-

tive cell phone pictures are uploaded for all the world to see, the message being sent to thousands of tween and teen girls is: "This kind of behavior is okay. It's how really popular girls have fun." Furthermore, despite a flare of negative publicity surrounding each episode, neither girl appears to have suffered any long-term consequences from such public overexposure. For a teenage girl with a digital camera or cell phone, imitating a celebrity couldn't be easier.

Without appropriate monitoring, these social networking platforms are subject to abuse by those who are most vulnerable to the endless feedback loop they create. This is known as an *urge/ compulsion/reinforcement cycle*, and it's very similar to what happens to those who crave drugs or other addictive substances. The Mirror Effect has the potential to turn a vulnerable young person with some narcissistic traits into a Narcissus on OxyContin.

Don't misunderstand me: The mass media aren't responsible for introducing narcissism into society, but narcissistic celebrity behavior can have a powerful magnifying effect on the latent narcissism in all of us. When some new celebrity incident strikes a narcissistic chord in a wide audience, the result is like an effective opioid. It gives relief, a sense of euphoria, focuses aggression, and gives users a chance to get outside the body and escape. It may not be physically addictive, but can have a deep and lasting effect on a person's psychological cravings.

■ ■ ■

The Internet's broadcasting power offers anyone a chance to manufacture a new self-image (that is, a pseudo-self), to project it into the world, and to bask in the global audience's reaction. It gives people with dominant narcissistic traits a chance to indulge their most dangerous impulses before literally millions of viewers. If

they're lucky, their fantasies might even become reality, making them bona fide celebrities with the opportunity to interact with an audience of fans, and accept a real-time stream of admiration and validation in return.

One of the most successful Internet celebrities I've met is Tila Tequila, who parlayed a drive for fame and an attention-getting MySpace page into a self-described career as a singer, actor, stripper, model, and businesswoman. When Tila appeared on *Loveline*, Mark and I watched as she spent the two hours in the studio simultaneously answering questions and comments from listeners, replying to online and text messages, and updating her MySpace page. Tila says she set out to become popular just to prove everyone wrong who ever said she couldn't be famous. But in an interview with Time.com she may have come closer to the core reasons for her fame: "There's a million hot naked chicks on the Internet," she says, but "there's a difference between those girls and me. Those chicks don't talk back to you."

Despite her constant communication with them, Tila Tequila doubtless has a more arm's-length relationship with her millions of MySpace friends than she does with her flesh-and-blood acquaintances. Yet the irony is that her MySpace audience may be more meaningful to her career, at least in the short term. Years ago, in his essay "The Strength of Weak Ties," sociologist Mark Granovetter argued that weaker relationships, such as those formed with colleagues at work or minor acquaintances, are more useful in spreading certain kinds of information than our networks of close friends and family. In a recent issue of *The New Atlantis*, author Christine Rosen applies this argument to today's social networks. "The activities social networking sites promote are precisely the ones weak ties foster, like rumor-mongering, gossip, finding people, and tracking the ever-shifting movements of popular culture

and fad. If this is our small world, it is one that gives its greatest attention to small things."

One of the best examples of the "weak ties" theory, and a powerful online manifestation of the Mirror Effect, is the popularity of the gossip blog. Over the past few years, celebrity gossip sites have become destination reading for those with a constant thirst for celebrity news updates. There are hundreds of gossip blogs, but some of the most heavily trafficked are those owned by media conglomerates, including TMZ.com (Time Warner), People.com (Time Warner), E!Online.com (Comcast), and Scandalist.com (VH1/Viacom). Gawker Media, a company devoted to blogs covering everything from celebrity (Gawker.com, Defamer.com) and sports (Deadspin.com) to pornography (Fleshbot.com) and the automotive industry (Jalopnik.com), has at least a dozen active sites.

Though most users may never give it a second thought, the corporations maintain these gossip sites because they help to promote their other entertainment interests—the latest movies, TV shows, or CDs by the stars whose personal lives are hung out like laundry on the sites. However, there are other, independent gossip sites, and in some cases, these have catapulted individual bloggers to celebrity beyond the Internet. The best known among these is the blogger Mario Lavandeira, who calls himself Perez Hilton. Since launching his blog, perezhilton.com, in 2005, Perez has gone on to establish a radio and TV presence, sign a book deal, make innumerable personal appearances, and create a clothing line.

Perez is known for the often-cruel commentary that's a regular feature of his blog, and for the scatological "doodles" he inks over certain celebrities' pictures. Perez himself protests that it's all in good fun. He once told me that, growing up in a strongly matriarchal family, he internalized his mother's and grandmother's attrac-

tion for gossip as a means of exchanging important information. But of course one person's gossipy fun can lead to another's hurtful consequences, and it's hard to defend his knee-jerk habit of referring to women as "sluts" (he has repeatedly referred to fifteen-year-old Miley Cyrus as a "Disney slut"), especially when you're playing to an audience of millions.

■ ■ ■

All these innovations in technology and media programming have fueled today's narcissistic notion that everyone is entitled to be famous. They've paved a slick road between the celebrity media machine and the consumer, speeding the vicious cycle of supply and demand that drives the Mirror Effect. Tabloid reporting and reality TV were the first venues that allowed us to indulge our obsession with turning ordinary people into celebrities (and celebrities into ordinary people), but the Internet has served as a powerful accelerant.

And this new relationship to the media has created a hybrid breed of celebrity that exists only as long as we keep watching: celebrities like Tila Tequila, Perez Hilton, Kim Kardashian, even Paris and Nicole. In the past few years, professional and amateur online commenters have created a whole new celeb lexicon for these figures: They've been dubbed *celebutantes* (debutante-age girls famous only because of their wealth, lifestyle, and perceived glamour); *celebuspawn* (offspring of a celebrity or celebrity couple); and, most cruelly, *celebutards* (stars known for ignorant behavior or opinions).

These quasicelebrities fuel the Mirror Effect, insinuating themselves into the public consciousness by inspiring equal measures of attraction, judgment, and envy. They are famous only as long as they can keep themselves in front of the media and in the eye of

the public. It takes work to maintain this kind of celebrity, striving to always stay in the limelight. But it's not the kind of work ethic that results in a lasting career. These people aren't spending their time studying for their next audition, or writing songs for their new CD. They're too busy being *famous*.

The individuals who manage to attain this most ephemeral level of celebrity are also the ones who are most intent on preventing it from fading. Having clawed their way to fame by surviving the trials of reality television, or by parading themselves in frankly sexual fashion on the Internet and the red carpet, they're petrified of what will happen if they lose their fame. And they're supported by the entertainment media that thrives on their antics, as well as a corporate culture that's invested in their continued celebrity. Actress Julia Stiles is one young star who believes that extensive press coverage only encourages Hollywood's party-loving elite to misbehave. "We reward bad behavior. They get a lot of attention for misbehaving, and it reinforces the idea [that] this is who they're supposed to be. . . . And they're surrounded by people who won't stop them, because they're making so much money for everybody."

Here's how to recognize these new celebrities, those whose behavior is most clearly underpinned by narcissistic traits, and whose example most clearly sparks the phenomenon we call the Mirror Effect.

They identify themselves as celebrities first and foremost. Their résumés may present them as actors or actresses, singers, or models or, often, as all of the above. However, their simple celebrity is more important than any of their fleeting career achievements.

They are immature and unregulated. Jamie Lynn Spears, Britney's little sister, got pregnant at the age of sixteen. Seventeen-year-old Nick Hogan was arrested on felony reckless-driving charges

after a car accident that critically injured his passenger. At fifteen, *Gossip Girl* star Taylor Momsen already has a reputation as a party girl on the New York scene. The first whiff of scandal came when pictures allegedly leaked from her MySpace showed her kissing a scantily clad girl. Now gossip sites track her every move and rumors on everything from her health to her behavior surface regularly.

They spend much of their time courting media attention—good, bad, or inappropriate. As Vanessa Hudgens told *GQ*: "If you have paparazzi, you know you've gotten somewhere."

And finally, they have an almost all-encompassing sense of entitlement. The roar of the modern celebrity is "Don't you know who I am?" Consider just a few examples:

Don't you know who I am? I almost won **American Idol!**

—Singer Chris Daughtry, trying to claim stage space next to Scott
Weiland and Billy Corgin at an Alice in Chains concert.

Don't you know who I am?

—Actor Jeremy Piven to a hostess at a Hollywood restaurant after he was
unable to get a table there. In the tirade that followed, he screamed at the
hostess, belittling her for working in a restaurant.

Do you know who I am?

—Singer John Mayer, throwing a "diva fit" on being asked for ID
in a Circuit City store in Santa Monica, California.

Do you know who I am?

—Actress Tatum O'Neal, a former child star, as police arrested her
for buying crack from a street dealer in New York City.
O'Neal claimed she was doing research for a role.

*Do you know who I am? I'm a big star, and I can look
you up, find where you live and blow you up.*

—Talk show host Montel Williams, intimidating a teenage newspaper
intern who asked him a question at a press event.

*Do you know who I am? I'm Tara f***ing Reid!*

—Actress Tara Reid, on the rope line at a Hollywood nightclub.

■ ■ ■

From the severe dysfunctions of the patients I treat, to celebrity
meltdowns glamorized by the media, to the reaction and participa-
tion of the increasingly self-dramatizing audience, I see evidence
every day that narcissism is the common thread weaving through
much of our pop-culture universe. The influence of drugs and al-
cohol may fuel some celebrities' extreme behavior, but substance
abuse can't explain the escalating media coverage of this dysfunc-
tional exhibitionism, or our responses. And I feel strongly that it's
time for us to stop accepting these narcissistic behaviors as natural
by-products of fame, and start recognizing them for what they are:
a sign of danger for our culture.

For decades now, I've treated thousands of patients who acted
out in these same extreme ways, with flagrant displays of exhibi-
tionism, entitlement, self-abuse, and more. And it's clear to me
that the underlying psychological condition driving both that be-
havior and our reaction to it is an unhealthy level of narcissism.
The fact is, some celebrities *have* gotten sicker over the past ten
years, and their indiscretions are more public than ever before,
thanks largely to today's media delivery system, which relays such
stories almost instantaneously. While it's troubling that certain
dysfunctional behaviors have become the celebrity media's daily
bread, what's even more distressing is the way we, the audience,

respond to this phenomenon. Why is it that we're so eager to read more and more about our favorite stars' troubles, instead of responding with concern and sympathy? In part, it's because the media glamorizes such behavior. It's also because of deep-rooted psychological constructs that predispose us to accept salacious gossip and disturbing behavior as entertainment.

This exchange of narcissistic behaviors between celebrities and the vulnerable audience who dotes on them is at the heart of the Mirror Effect. The increasingly amplified and dysfunctional behavior of celebrities, the size and speed of the distribution system, and the response of the consumers add up to a perfect storm of conditions, with troubling implications for our value systems and society at large. And our children, who are more fully immersed in media culture than any previous generation, are at risk of internalizing such behaviors at a developmental stage when it could permanently affect their emotional well-being.

Before we can truly understand the dangers of the Mirror Effect, however, it's important to look more closely at what narcissism actually is, to appreciate which personality traits are amplified by unhealthy levels of narcissism, to consider why we as human beings are biologically predisposed to mimic the narcissistic strategies of others we consider successful, and to examine how prolonged exposure to narcissistic celebrity behavior can affect anyone who follows celebrity gossip, especially children. Finally, it's crucial to explore steps we can take in our daily lives to connect consciously and empathetically with people we actually know, as well as the celebrities we think we know, if we're going to bring a healthy perspective to the celebrity and entertainment news we consume every day.

The Genesis of Narcissism

In The Metamorphoses, *the Roman poet Ovid tells the story of a handsome youth named Narcissus, a tale he learned from Greek mythology. Narcissus is so intent on his own desires that he is unable to fall in love, rejecting the advances of all who are attracted to him. Never having seen his own image, he understands the power of his beauty only through the reactions others have to him. When he rebuffs the love of Echo, a nymph, her unrequited passion causes her to waste away and die. When one of Echo's handmaidens prays to Nemesis, the goddess of revenge, Nemesis responds by declaring that Narcissus shall get a taste of his own medicine: If he should ever fall in love, he will be denied the very thing he so desires.*

One day, while stopping to drink from a forest pool, Narcissus catches a glimpse of his reflection in the smooth water. Smitten by the sight, he falls madly in love with his own beautiful image. He lies next to the pond, staring at his own reflection in the water. But whenever he reaches into the water and tries to embrace the image, it dissolves. Unable to kiss, or hold, or in any way capture his true heart's desire, he too dies of unrequited love.

■ ■ ■

Most people assume that the Narcissus myth is a cautionary tale about the dangers of falling in love with oneself. In common parlance, *narcissism* is often used as a synonym for egomania or excessive self-regard. In psychological terms, however, egotism and

narcissism can be very different things. Egotists are preoccupied with themselves to an extreme degree. Their self-importance is unshakeable, so much so that it generally allows them to disregard reality.

Narcissism, on the other hand, springs from an opposite relationship with the self: not self-involvement, but a *disconnection* with oneself. The key to understanding the Narcissus myth is not that he fell in love with himself, but that he failed to recognize himself in his own reflection. In other words, true narcissists are not self-aware. A real narcissist is dissociated from his or her true self; he feels haunted by chronic feelings of loneliness, emptiness, and self-loathing and seeks to replace that disconnection with a sense of worth and importance fueled by others. Narcissism is also marked by a profound lack of empathy, a fundamental inability to understand and connect with the feelings of others. Taken together, these are the traits psychologists measure in diagnosing what's known as *narcissistic personality disorder* (NPD).

These traits—the profound lack of self-knowledge and the inability to experience an empathetic connection with others—force narcissistic individuals to fixate on the reactions of others in order to shore up their own sense of self. For the narcissist, the whole world is a mirror; life is spent in constant pursuit of a gratifying reflection, a beautiful self-image to help stave off feelings of internal emptiness. The modern narcissist seeks those reflections in the pages of glossy magazines, and on the screens of their TVs and computers. The celebrity-media looking glass responds with images of a privileged life where the participants are beautiful, charismatic, powerful, and free to act as they choose. The mirror of celebrity reinforces every narcissist's belief that a world of constant admiring attention is possible: All you need to do is act sexy, play the diva, demand privileges, and party with abandon.

■ ■ ■

For some people these roles come more easily than for others. Every individual's personality combines many traits. Some people are shy, others gregarious; some are stingy, others generous; some even-tempered, others volatile. Our personality traits are formed in early childhood, persist throughout life, and affect every aspect of our day-to-day behavior. Yet most people are able to adjust the influence of these traits based on specific situations. Very shy people learn to overcome their self-consciousness, for example, in order to function in social situations. Stingy people may be moved to donate money to a cause they deem worthy. People with hot tempers moderate them in the workplace.

Narcissism is a particular constellation of personality traits. The seven traits classically associated with narcissism are: authority, entitlement, exhibitionism, exploitativeness, self-sufficiency, superiority, and vanity. A diagnosis of narcissism is not a black-and-white matter; rather, it's a matter of degree. People at the psychologically healthy end of the narcissism continuum exhibit these traits in normal, moderated levels. People at the other end manifest their narcissistic traits in such extreme ways that they demonstrate the pathologies of narcissistic personality disorder. In between lies a spectrum of infinite gradation.

All healthy individuals exhibit narcissistic traits throughout their lives, and the traits of narcissism can affect our personality in positive ways. For example, people who have high levels of authority and self-sufficiency may be highly motivated and exhibit strong self-confidence. They may be charismatic, compelling, and persuasive in convincing people to listen to their ideas. Other narcissistic traits are simply part of life: It's realistic to feel entitled once in a while, for instance, or to expect accolades on a job well done, or to

enjoy a degree of exhibitionism, or even to feel superior to others in certain ways. However, people with healthy levels of narcissism are also able to step outside their own perspective long enough to assess how their behavior may be affecting others around them. This ability to avoid becoming stuck in narcissistic mode, and to consider the impact of your actions on the feelings of others, is one of the key distinctions between healthy and extreme levels of narcissism.

In my work as a doctor, for instance, I must be authoritative and, to a degree, self-sufficient. It requires authority and conviction to make diagnoses and recommend treatment. Particularly when working with addicts, I have had to learn to trust my gut when assessing their total condition. However, I also need to be able to listen to my patients, to know when to ask for another opinion, to admit if something particular concerns me. There's no question that patients would suffer if their doctors were unable to moderate the narcissistic side of their personalities. In fact, what my patients need most from me is to balance that self-sufficiency with a deep empathic appreciation of their troubling experiences.

In contrast, people who have an overtly narcissistic personality style—that is, those who exhibit heightened levels of narcissistic traits—can be obnoxious or overbearing in their interactions with others. Unhealthy narcissism can generally be traced to a childhood disruption in emotional and moral development. A common indicator of unhealthy, or problematic, narcissism is when a person is unable to accept or genuinely feel good about praise from others. For a true narcissist, simple praise does not even begin to fill the bottomless pit of emptiness and the longing he or she constantly experiences.

■ ■ ■

We are all born narcissists. As infants, we are fixated completely on survival, turning our focus inward on our own needs, while relying on the abilities of others to meet them. A baby is purely, wholly connected to his truest self. He is completely preoccupied with addressing fundamental drives, such as satisfying his hunger, learning how to control the movement of his limbs, or dealing with the discomfort of a wet diaper.

At first, infants are unable to identify their own primary emotions, such as disgust, rage, or satisfaction. Until these emotions, both pleasant and unpleasant, are recognized, they cannot be understood or regulated. According to Dr. Peter Fonagy, a specialist in early attachment theory, this process begins at roughly six months, when an infant's attention shifts slightly to focus on things beyond his body boundaries. When an infant begins to recognize his own nascent emotions through interaction with his caretakers, he begins to develop primitive mechanisms for emotional regulation. Dr. Fonagy calls this mechanism *mentalization*, the process of creating a mentalized representation of one's emotions.

Research has helped us understand how infants develop attachments to their mothers, fathers, and even other caregivers, but it also tells us that each of these attachments is independent and differs in quality. Children need to form what are known as *secure attachments* in order to thrive emotionally. A secure attachment is a relationship in which a child desires contact with a caregiver, viewing himself as basically good and loveable and the caregiver as trustworthy and responsive. A child who is securely attached feels protected, and thus feels comfortable and willing to venture out and explore his world. Secure attachment is also an important component of emotional regulation. As children grow older, relationships with friends, and later, romantic partners, assume the

importance of their early relationships to mothers, fathers, and caregivers. The quality of these early attachments is thus believed to provide the emotional template for future adult relationships.

Dr. Fonagy's research confirms that a young child's relationships, particularly with his mother, play a key role in teaching the child how to study the outside world, and other people, in order to learn to place his emotions in context. And the adult's behavior in this relationship is critical. As child psychiatrist Donald Winnicott notes, in a healthy relationship "the mother 'looks like' what she sees" in her child; that is, she mirrors his behavior back in her own. Picture a mother studying her crying child and responding with an exaggerated frown of her own, even reinforcing what she sees by saying "You're very unhappy." The mother may not be feeling unhappy herself—indeed, it's important for her not to confuse the child's emotions with her own—but by imitating her child's expressions she literally signals that she appreciates his emotional state. The mother then underscores this message by offering appropriate interaction: holding or stroking a crying child, feeding one who is hungry, interacting playfully with one who is smiling.

As the child learns to interpret the expressions on his mother's face in the context of his emotional state, he begins to take the important developmental step of identifying his own feelings. Two important emotional processes are at work here: the ability to *regulate* one's own emotions by identifying and understanding them, and the ability to *connect* with others in a way that soothes or pleasurably enhances these emotions. Gradually, with ongoing appropriate responses from a parent, a healthy child gains the ability to identify, manage, and exchange emotions.

One developmental theory, known as mirror self-recognition, posits that a child's ability to recognize his image in a mirror implies an awareness of self, an ability to monitor one's own thoughts

and feelings, and a capacity to use that knowledge to understand the thoughts and feelings of others. This is the key to the evolution of empathy—the ability to appreciate the thoughts and feelings of others, as filtered through our own personal experiences. As empathy evolves, a child's grandiose feeling that he is the center of the universe begins to diminish, and his conscious recognition and appreciation of others begins.

■ ■ ■

When this early, primary form of emotional interaction malfunctions, however, the result is problematic, even traumatic. Children in such circumstances tend to misinterpret or disregard feelings, suffer from an inability to connect with others, and find it difficult to regulate their emotions. Such children often come to depend on *dissociation*—a state of complete disconnection from feeling, almost like an out-of-body experience—as a primary means of emotional regulation. Rather than feel too intensely, they feel nothing at all.

When humans face danger or trauma, our central nervous systems respond in a characteristic way. When our instinctive fight-or-flight response is thwarted, the body switches from a state of hyperexcitation to a state of hyperinhibition. The brain is bathed in chemicals that cause it to shut down in preparation for imminent assault: Blood centralizes, heart rate slows, and the individual may literally feel he or she is watching the experience from afar, as a third person.

If this primitive adaptive strategy is triggered early in childhood by traumatic experiences it can be emotionally shattering. If experienced repeatedly, it can actually block the brain's growth. The interconnections between the emotional centers of the brain and their capacity to communicate with each other become markedly reduced.

It is this kind of emotional retardation that lays the foundation for the development of narcissistic personality disorder.

Unfortunately, it's easier than you may think to short-circuit this delicate developmental process. This can happen when a mother is unavailable for this critical two-way interaction with her child for some reason, because she is depressed, for example, or overly absorbed with work, or abusing drugs or alcohol. Her own traumatic experiences may cause her to misidentify her child's primary emotions and neglect to mirror them appropriately. As a result, her child will be unable to connect to his or her own feelings, experiencing them only to a weak degree, or not at all. If a child cannot comprehend his own emotions, he will be unable to attain the next emotional milestone of empathetically understanding the feelings of others.

Neglect isn't the only factor that can prevent a child from developing a sense of his own emotional landscape. If a parent is overly involved in *participating* in the child's feelings, rather than reflecting them, rushing in to rescue a child from an unpleasant feeling before he has been able to identify it, for instance, or catching the child's emotions and becoming equally overwhelmed by them, the child can fail to develop regulatory control of his emotions. In the first case, the child gets the message that he cannot manage his feelings without being rescued by his mother. In the second, he learns that every time he has a feeling, it creates a scary or negative reaction in others. In both cases, he learns that his feelings don't really exist within his own body boundaries. They exist *out there*, in the responses of others.

■ ■ ■

This use of physical expression as a means of tuning in to the feelings of others is called *intersubjectivity*. This interpersonal exchange

depends on both people involved being able to appreciate each other's feelings through emotional connection, and on each individual's capacity to trust the other. It is this form of communication, also referred to as a *cocreated experience*, that allows humans to understand one another intimately at many levels and to trust the creation of a relationship.

As a child grows older and begins to explore the world, he begins to appreciate that there is a difference between himself and his mother, while still maintaining a narcissistic expectation of an idealized union with her. Even as the child tests his autonomy and independence, he will return to the mother for emotional refueling. As his emotional development continues (until around the age of twelve), the mother continues to play a critical role in shaping his behavior and his capacity for healthy social functioning. During these years, the child shifts from an idealized sense of omnipotence—*I control those around me and they will meet my needs without question*—to a more realistic appraisal of self, and an ability to appreciate the existence of others and the importance of their emotional landscape.

When trauma occurs to a child under the age of twelve, it triggers a characteristic—and normal—thought process. The child will first believe that he has somehow invited the traumatic actions; that they are all his fault. This grandiose thought becomes fixed in his mind, resulting in a deep sense of shame. One of the most confusing aspects of the typical response to trauma is that it results in an unconscious urge to seek out reenactment of the traumatizing event. This is why young girls who have been abused by men will seek out relationships with abusive men throughout their lives. Teenage girls who call in to *Loveline* to complain that they never have relationships with "nice guys" will usually admit with little prompting that they were abused as children. This type of uncon-

sciously damaging behavior is called *repetition compulsion*, and it helps to explain why narcissists so often become caught up in perpetual cycles of certain kinds of acting out.

In healthy development, the child learns to tolerate feelings of shame when his behavior conflicts with his idealized mother's expectations. By allowing their children to experience such feelings, then offering opportunities for repair and reunion, parents teach their children to trust in the all-important interpersonal exchange. If the child experiences feelings of shame, but is not allowed a chance for rapprochement, he will come to expect further shame, exploitation, or abuse. When this occurs, the child withdraws from closeness, shutting himself off from the very experiences he needs for emotional nourishment and development, and falling back on the primitive emotional strategies discussed above. Over time, the child becomes convinced that his or her own feelings don't matter. Just as critically, he also comes to believe that other people's feelings especially don't matter.

The belief that one's feelings don't exist, except as interpreted and expressed by others; the inability to trust others or engage in intersubjective experiences; and the perception that feelings don't matter—all these effectively prevent a child's genuine self from properly developing, much less flourishing. That dysfunction, the lack of a sense of self, is the hallmark of narcissistic personality disorder.

■ ■ ■

When the narcissistic character traits described here become very rigid and self-defeating, they can interfere with an individual's personal and social functioning throughout adulthood, and can even lead to psychiatric symptoms. The American Psychological Association (APA) defines personality disorder as "an enduring pattern

of inner experience and behavior that deviates markedly from the expectations of the culture of the individual who exhibits it."

Narcissism falls in with the types of personality disorders classed together in three main groups, or clusters. Cluster A disorders include odd or eccentric behavior, and include paranoid personality, schizoid personality, and schizotypal personality. Cluster B includes narcissistic personality disorder (NPD) as well as histrionic, antisocial, and borderline disorders. Cluster C consists of anxious or inhibited behaviors and includes dependent or obsessive compulsive disorders.

People with Cluster B disorders manifest narcissistic traits and feel very disconnected from their genuine feelings. They crave attention, and often fall back on highly dramatic or erratic behaviors to attract it. Unable to accept real-world demands and limitations, they show a disregard for social norms and laws, along with a lack of remorse for any transgressions. They often suffer from dysfunctional interpersonal relationships, addictions, and other emotional, physical, or psychological impairments. Other traits include an unstable self-image, extreme anger or aggression, suicidal feelings, and chronic feelings of emptiness. They have highly evolved strategies for manipulating their environment to satisfy their individual needs. Perhaps the most distinguishing feature, however, is their chronic empathic failure.

Pathological narcissism, that is, narcissism that can be definitively diagnosed and treated as a personality disorder, is relatively rare. The *Diagnostic and Statistical Manual of Mental Disorders* (DSM-IV-TR), used by mental health professionals to diagnose disorders, maintains that 2 to 16 percent of the population currently in treatment, and less than 1 percent of the general population, suffer from narcissistic personality disorder. Many professionals believe that this is a drastic underestimate. High levels of narcissistic traits

and behaviors associated with Cluster B disorders are clearly common in our culture. In fact, some research suggests that as much as 5.3 percent of the population, or over 16 million people, show signs of NPD.

Narcissistic personality disorder must be diagnosed by a properly trained mental health professional (such as a psychiatrist, psychologist, or licensed social worker) through a process of personal interviews, observations, psychological tests, and interviews with significant others. The diagnosis can be made when an individual meets at least five of the following nine characteristics.

1. A grandiose sense of self-importance. A person with NPD exaggerates his achievements and talents, and expects to be recognized as superior without the qualities to support that conclusion.

2. A preoccupation with fantasies of unlimited success, power, brilliance, beauty, or ideal love.

3. A sense of specialness, a belief that he is so unique that he can only be understood by, or should only associate with, other special or high-status individuals or institutions.

4. A need for excessive admiration.

5. A heightened sense of entitlement, leading to unreasonable expectations that others should treat him especially favorably, or comply automatically with his expectations.

6. A tendency to be interpersonally exploitative. A person with NPD does not hesitate in taking advantage of others to meet his or her own ends.

7. A lack of empathy, an inability or unwillingness to recognize or identify with the feelings or needs of others.

8. An envy of other people, or, conversely, a belief that other people envy him.

9. A tendency toward arrogant behavior or attitude.

One reason it's difficult to diagnose NPD is that the various Cluster B personality disorders all share certain characteristics, among them grandiosity, lack of empathy, exploitative interpersonal relations, and a need to be seen as special or unique. Instead, specialists typically distinguish NPD from borderline, antisocial, and histrionic disorders by the *absence* of certain behaviors. Narcissists are rarely inclined to hurt themselves, for instance, whereas individuals with borderline personality disorder are prone to self-injury and attempted suicide. Narcissists avoid intimacy, while people with histrionic or borderline disorders exhibit intense desires for relationships. Narcissists rarely commit violent crimes, but individuals with antisocial personality disorder or psychopathy have no remorse over using physical violence.

Despite the low numbers of individuals who are diagnosed with narcissistic personality disorder, there has been an obvious increase in narcissistic and other Cluster B styles of behavior. I have witnessed the growth personally in my own medical career, but you don't have to be a doctor to see evidence of the trend everywhere in our culture. As we've seen, one night watching reality TV, flipping through the tabloids, or surfing the Internet would be bound to turn up many instances of behavior that fits most of the criteria above. And NPD isn't confined to the ranks of celebrity: Any of the talk shows that feature average people in crisis—*Dr. Phil,*

The Tyra Banks Show, Maury, Jerry Springer, even *Judge Judy* or *Divorce Court*—would doubtless leave you with a similar impression of the general population. I can't help but conclude that there are many more individuals suffering from unhealthy levels of narcissism than there are patients diagnosed with narcissism as a psychological disorder.

Another reason NPD can be difficult to diagnose is that narcissism, even at NPD levels, doesn't stop people from attaining positions of power, wealth, or prestige. Narcissists often develop attractive or persuasive social skills to help them maintain the persona they have constructed to get what they want from the world. High-functioning narcissists are often well liked by casual friends and colleagues who never get close enough to detect the emptiness beneath the veneer of success. Furthermore, narcissists rarely have qualms about lying in order to maintain their carefully constructed image, making it harder for a therapist to recognize where the patient's version of events leaves off and the real story begins. Finally, diagnosis can be challenging simply because it's extraordinarily difficult to convince a narcissist that he needs psychological help. Any challenge to a narcissist's unrealistic self-image is likely to provoke rage, disdain, denial, or other protective behaviors, as the individual struggles to protect the pseudo-self at all costs.

■ ■ ■

Because narcissists feel empty and alone, they require constant reinforcement from the world around them to inform and inflate their sense of self. Because their sense of true self is so flimsy, narcissists are masters at creating ways of getting what they *do* need to exist: positive feedback and stroking from others. This is just one of the reasons that celebrity and narcissism go hand in hand: Nar-

cissists crave the constant validation of an audience, and the job of the contemporary celebrity is to court his audience, 24/7.

One of the most obvious examples of this dynamic is the relationship between director and actor on any film or television set. We all know the stereotype of the actor who must be handled with kid gloves, and that image exists for a reason: A narcissistic actor may not even be consciously aware that he's behaving in certain ways in order to evoke a steady stream of encouraging feedback, but their needs are usually obvious to those around them. Actress Julia Ormond, who has worked on stage and screen for more than two decades, has noticed this behavior: "Actors who move me, or whom I respect from a craft point of view—their level of self-esteem and their level of confidence really needs to be nurtured by those around them, because it can be crushed in a second. It's like a small flame that burns inside them and any director can walk up to them [blows] and *poof*. It's really very hard to bring it back." When an actor storms off the set, or refuses to deal with a certain director, or quits a project outright, he's acting out his narcissistic defenses, protecting himself against criticism that might trigger his insecurities and threaten his fragile sense of real self.

To protect his flimsy self-esteem, and avoid the pain of the inadequacies he constantly feels, the narcissist creates a pseudo-self, an idealized version of himself, and consciously or unconsciously projects it out to others to prime that continual stream of admiration and desire. As long as the pseudo-self remains firmly in place, the narcissist can continue to believe he's in control and capable of getting what he wants from others without exposing any real needs or vulnerabilities.

Narcissists rarely feel ashamed of their behavior. In fact, they have a remarkable ability to avoid shame. Narcissists don't perceive themselves as vain, or entitled, or exploitative, so they're un-

likely to worry that someone else will see them that way. What *is* stressful to a narcissist is when the pseudo-self slips to expose his or her real self, the one they feel is inadequate, that they're desperate to keep under wraps. This scenario is intolerable to a narcissist, and since they have no healthy internal mechanisms to help them process these overwhelming and painful feelings, they direct the shame outward. When a narcissistic person feels threatened, he tends to fall back on the primitive coping strategies of childhood: dissociation, aggression, and reversion to other immature behaviors such as lying, distorting, projecting, or extreme rationalizing.

We'll look at the Britney Spears saga in more detail later, but for now consider just one thread of the story: Soon after the birth of her first son, Sean, Britney began attracting criticism for her parenting. First, she was photographed driving with her infant son on her lap instead of in a car seat. Then, child welfare officials visited her home after Sean was injured in an incident involving his high chair. Many parents take such careless risks with their children, of course, and many kids are injured in freak accidents. When such things happen, most parents face their errors in judgment, realize the dangers involved, adjust their behavior, and make amends if needed.

When the press implied that Britney was a bad mother, her defensive reaction was that of a textbook narcissist. In an interview with Matt Lauer that aired on both the *Today* show and the evening news magazine *Dateline*, she called motherhood "amazing," and denied being anything less than an ideal mother: "I know I'm a good mom." She blamed the media for putting her in a situation that allowed her mothering skills to be called into question: "I can't go anywhere without someone judging me." She rationalized putting her child in a dangerous situation: "I did [the same thing] with my dad. I'd sit on his lap and I'd drive. We're country."

The same can be said for Joe Francis, the controversial founder of the *Girls Gone Wild* media empire, who constantly reverts to classic narcissistic defenses to maintain his pseudo-self as a successful multimillionaire businessman. When he's accused of exploiting inebriated young women by filming them naked in compromising situations, he insists that they enjoy it, that they're choosing to participate in a cultural phenomenon, a twenty-first century rite of passage. Felony tax evasion charges? Not his fault; the accountant never showed him the documents. Sued for collection of massive gambling debts? He's not to blame; the casino deceived him. Press coverage criticizing his treatment of women? Nonsense. He's a rich successful man; what woman wouldn't want him?

Defend, deny, blame, rationalize—using every mechanism they can, narcissists will consistently reject reality. From their distorted point of view, the real world is the problem, not them. There is no need to behave in any way that might acknowledge any imperfection. Britney considers anything short of portraying herself as a perfect mother unacceptable. Joe Francis can't understand why everyone is always picking on him. In their worlds, it's inconceivable that they might be part of the problem. In their minds, if we'd all just adjust our ideas of parenting, or realize that it's a wonderful and normal thing for beautiful (and often inebriated) college students to strip and simulate sex for video crews, we'd see that we, not they, were wrong all along.

■ ■ ■

One of the defining characteristics of the narcissist is a lack of *empathy*, the ability or willingness to recognize, perceive, and relate to the emotions of another person, to experience the world from another's point of view. People who are empathetic reach out; they

offer sympathy, ask about feelings, and validate what others feel. For the narcissist, the sole purpose of being around other people is to support his exaggerated pseudo-self with a constant stream of admiration. A narcissist will value a friend so long as that person provides validation. When narcissists feel they're not getting sufficiently supportive feedback, they're prone to lash out at, or simply drop, their offending friends with no regard for their feelings or how important the relationship may have been.

An empathetic nature does not suddenly evolve. Rather, empathy develops over time, reinforced constantly by positive experiences of emotional attunement with others. When a child's emotional interactions are traumatic, however, his emotional development is arrested and his capacity for empathetic response is impeded. Because narcissists are unable to access their own feelings, it is difficult for them to relate to the emotions of others. If you choose to share intimate feelings with a narcissist, and for whatever self-involved reason he or she decides to listen, your emotional outpouring is likely to elicit one of two responses: denial (*What's the matter with you? Nothing's wrong!*) or dismissal (*Toughen up and get over it!*).

The behavior of one of television's biggest self-help experts suggests a striking inability to feel empathy. Dr. Phil McGraw has attracted fame and a huge following for his "tough-love" brand of pop psychology. The people who appear on his show often have serious problems, but his frequently impatient demeanor toward his guests and his signature response, telling them to "get real!", suggests that he has difficulty appreciating their emotions. On the *E! True Hollywood Story*, Dr. Phil McGraw described dealing with the problems of the patients he counseled during the year he spent practicing clinical psychology: "They'd want to sit there and talk to

you for six months. There were a lot of times I figured this out in the first hour, and I'd be sitting there saying, 'Okay, here's the problem. You're a jerk.' " Such posturing may make good TV, but it also makes one wonder about Dr. Phil's capacity for truly empathetic response.

■ ■ ■

Even when a narcissist is successful at hiding what he perceives as his shamefully inadequate real self by arranging his world so that it reflects the image of his idealized pseudo-self back to him, along with a constant flow of praise, he still feels a deep sense of longing. Instead of pursuing real intimacy, however, narcissists tend to seek out high-arousal situations that allow them to bask in the love and attention of the people around them. Unable to create the real intimacy they crave, they are driven by a need to be needed by others, and that need is often expressed in an impulse to perform. The pseudo-intimacy of performing in front of an audience is an ideal setting for a narcissist who wants to believe he is relating to others. Bette Midler has noticed this tendency among current pop stars: "They don't talk to their audience," she points out. "They may say 'Hello, New York' or 'Hello, Las Vegas,' in the beginning and 'Thank you' in between songs, but they don't talk. They don't tell stories or take the time to make a connection, build a rapport. There's no emotion."

Lacking the emotional sensitivity to develop a full and complex sense of self, the narcissist fixes on the highest set of expectations—she must be the most beautiful; he must be the strongest, or funniest, or most daring—and behaves in extreme ways that cause others to validate these qualities. Being the object of dramatic attention becomes the narcissist's primary goal. That's why tabloid

celebrities don't care whether they're famous for being crazy, or sick, or almost dead. All that matters is that the audience keeps watching.

The same internal tendencies that lead to the creation of a pseudo-self also drive many celebrities (and other narcissists) to addiction and abuse. Narcissists seek fame because they want recognition from others to shore up their sense of self. Even after achieving celebrity, however, the narcissist remains disconnected, unempathetic, self-preoccupied, and lacking in genuine self-worth. Celebrity can't alleviate their feelings of emptiness and pain. And so, narcissists often turn to addictive behaviors as a way to numb the self-loathing they experience when they're not in the spotlight or performing for an admiring audience. This is the primary reason narcissism is so commonly linked with addiction.

Countless performers have attested to this dynamic. On the intimate interview program *Inside the Actors Studio*, a fresh-from-rehab Melanie Griffith explained to host James Lipton her vulnerability to addiction. "I feel things very strongly. And I think in my youth I used alcohol and cocaine in order to cover up the pain that I felt." She went on to describe her pain as an "emptiness inside that you don't know how to fill, really. I can fill a *character* great, but I don't know how to fill myself, you know? And therein lies the rub." Johnny Depp has admitted to drinking heavily early in his career to deal with his anxiety about public appearances: "I guess I was trying not to feel anything." In a March 2001 interview, he characterized drug use as having "less to do with recreation and more to do with the fact that we need to escape from our brains. We need to escape from everyday life."

I have heard many celebrities say the same things as Melanie Griffith and Johnny Depp about using drugs, alcohol, or even sex to cover feelings of emptiness or provide outlets for escape. As I

continue to talk with these people, they usually reveal childhood experiences that were clearly traumatic—the kinds of damaging episodes that are at the root of narcissistic disorders. My professional training and experience help me to understand the behavior of stars who act out in public, and to place it in context. For other observers, however, the meaning—and consequences—of such dysfunctional behavior are lost in the media spin. Where I may see an addict about to hit bottom, or an individual suffering a painful psychological crisis, the entertainment media sees the next episode of drama in the ongoing soap opera of celebrity scandal.

Even as I became increasingly attuned to the narcissistic drift in the celebrities I treated, I also began to see ordinary patients whose behavior followed similar patterns. Significantly, these non-celebrities often attempted to excuse or minimize their behaviors by explaining that they were acting no differently than the entertainers they admired. It became clear to me that this intersection of celebrity and narcissism was the nexus of a potentially dangerous phenomenon.

The celebrity media industry projects the image of a life where all participants are privileged, powerful, beautiful, and charismatic. However, when we look beyond the gloss of the media machine, a clear and troubling pattern emerges. Each one of the seven traits of narcissism identified in this chapter is an amplified expression of these characteristics. And, as we've seen, when these behaviors are consistently expressed at extreme levels, they point to a serious pathology.

Each one of us falls somewhere on the spectrum of narcissism. We are all born as complete narcissists and then, based upon our emotional development in early childhood, we arrive at our adult expression of these traits. A secure attachment to a parent nurtures empathy, high self-esteem, and self-awareness. But when traumatic

experiences short-circuit the delicate process of empathic development, individuals become locked in patterns of grandiosity and emotional disconnection.

The nature of our society today makes narcissistic personality disorder (NPD) notably harder to diagnose than other more obvious physical or mental dysfunctions, such as schizophrenia or obsessive compulsive disorders. The fact that narcissistic traits can be positive motivators for achievement and self-confidence makes it difficult to perceive their potential downsides—and the truth is that narcissists, even those with more extreme traits, often thrive in our society. They tend to master the persuasive social skills that help them pull others into their orbit in order to maintain the personae they have constructed.

I've said before that becoming a celebrity is the "de facto cure for narcissism." In other words, many individuals yearn for fame, at least in part, as an attempt to manage (one might even say to *treat*) the emotional emptiness that's characteristic of narcissism. For someone with "healthy" levels of narcissism, celebrity may very well be a satisfactory way to access admiration and validation for certain talents or physical characteristics. For individuals with unhealthy levels of narcissistic traits, however, becoming famous often causes more problems than it cures.

Mark and I agreed that high levels of narcissism likely predisposed stars to grandiose behavior. If this was true, were the worst behaviors we see in the celebrity media blatant manifestations of specific narcissistic traits? To learn more about it, we launched a study to determine just *how* narcissistic today's celebrities are—and why.

Celebrities Really *Are* More Narcissistic Than the Rest of Us

Particularly after the success of [my early career], I noticed my narcissism got dialed up. Suddenly, for a minute, I felt like everyone needed to take a knee and listen to what I had to say, because I fuckin' made it, and my way works, and all this stuff. Then [I'd] go home and I go, "Oh, my God, what's happening to me? I gotta get grounded here."

——*Robert Downey, Jr.*

I went from being a young senator to being considered for vice president, running for president . . . becoming a national public figure. All of which fed a self-focus, an egotism, a narcissism that leads you to believe you can do whatever you want, you're invincible and there will be no consequences."

——*John Edwards, after his extramarital affair was revealed*

Think about it. Just the thought of wanting to get into comedy—you have to think you are funny. You have to be narcissistic.

——*Artie Lange,* on The Howard Stern Show

I'd say it's the one quality that unites everybody in the film industry, whether you're an actor, a producer, a director, or a studio executive. You want people to look at you and love you and go, "Oh, you're wonderful." It's a nightmare. Narcissism is the part of my personality that I am the least proud of, and I certainly don't like to see it highlighted in everybody else I meet. It's like all things in life: You have these qualities in you that are awful, and the best you can do is to try to be aware of them and actively try to diminish them.

——*Ben Affleck,* Interview, December 1997

As we saw in the previous chapter, everyone has narcissistic tendencies; narcissism can be a positive as well as a negative motivating force. When channeled productively, it can drive one's success and promote a healthy impulse to make one's mark in the world. There's no doubt in my mind that celebrities, as a rule, have high levels of narcissism. There's also no doubt in my mind that, whether through self-awareness, or intermittent or ongoing analysis and treatment, many celebrities are able to keep their narcissism under control, connect with their real selves, and engage in fully connected lives.

For instance, a star like Oprah Winfrey, who has admitted to childhood abuse and has struggled with sexual promiscuity and food issues, has seemingly learned to acknowledge, appreciate, and modulate any narcissistic tendencies she may have had. She is conscious of the effect her actions have on others, and has clearly benefited by channeling her strong motivational drive toward positive behaviors and incredible success, both for herself and for the countless others she now reaches out to help.

Many performers have talked openly about the narcissism they have seen in themselves or among others in their profession. Actor William Hurt, for example, has decried what he sees as the "pathological sickness" of our celebrity culture, describing celebrities and their fans as "narcissists on screen being consumed by narcissists off screen." Hurt recognizes the role of narcissism in any actor's psyche: "When you walk into a room, eyes are on you. . . . After enough years, you [develop] the confidence to stare back. But the mendacity of it is, you start to believe it—that somehow you are the center of the room, of the universe, somehow you are [better than] the people around you. . . . And then how do you work?"

Succeeding as an entertainer is extremely difficult. Those who try face constant rejection, even humiliation. Any entertainer can be

a success one day and a complete failure the next. And few of those who become famous, or aspire to, are self-aware enough to acknowledge the psychological motivators that drove them. Strong narcissistic traits can propel certain people forward. While many may turn to substances along the way, it's their narcissism that ultimately drives them to get up and try again. Consider the former stars who continue to sign up for celebrity-based reality shows like *The Surreal Life, Celebrity Fit Club, I'm a Celebrity . . . Get Me Out of Here!*, or *Dancing with the Stars*: Nothing demonstrates a celebrity's basic drive for attention more powerfully than a willingness to check one's dignity at the door, week after week, in front of millions of viewers.

The more celebrities I met, the more apparent it was that these individuals possessed strongly pronounced narcissistic traits. The more I knew about the celebrities I met, the more obvious it was that these narcissistic traits were established long before the person became famous. I began to wonder if seeking to become famous was, in fact, a strategy for narcissists to manage—or even self-treat— their chronic feelings of emptiness. My experience and training told me that my theory was a highly plausible explanation for many of the celebrity behaviors I had observed.

But Mark, as a social scientist, was intent on scientifically studying this claim. There is a phenomenon called *self-selection* in which individuals with the same characteristics become a group that is defined by the characteristics that brought them together. If the world of celebrity was a self-selected group of narcissistic individuals, as I believed, Mark and I reasoned that it should be possible to demonstrate scientifically.

With that in mind, we launched what would be the first in-depth scientific study of celebrity personality.

■ ■ ■

To collect data for the study, we turned to a well-known psychological survey known as the Narcissistic Personality Inventory (NPI). Developed in the late 1970s, by psychological researchers Robert Raskin and Calvin S. Hall, the NPI has since been used in hundreds of narcissism studies. For our study, we used a refinement of the original survey published in 1988 by Raskin and Howard Terry.

The NPI alone cannot determine whether an individual suffers from narcissistic personality disorder. That kind of diagnosis must be performed in a clinical setting over an extended period of time. Rather, we used the NPI to identify and evaluate the levels of the seven component traits of narcissism we introduced earlier: authority, entitlement, exhibitionism, exploitativeness, self-sufficiency, superiority, and vanity. A true narcissistic personality manifests each of these characteristic traits to a varying degree.

To review those seven traits more closely:

Authority is related to superiority, and can be an asset under certain circumstances. A person needs authority to carry out responsibilities, sometimes without concern for others. An individual with a healthy sense of authority usually has the achievement and expertise to justify that authority, and is able to recognize the outcome of his actions on others. Unhealthy narcissists, on the other hand, are often highly authoritarian, even when such behavior undercuts their intentions. Moreover, highly narcissistic individuals often display unregulated aggression, and aggression can amplify authority in ways that can be quite unpleasant for others. Authoritarian narcissists generally feel justified in their actions and have little appreciation of the effect they have on others.

For narcissists with a high authority level, power and control are paramount. They are driven to regulate every aspect of their

environment, including the actions of those around them, which is an unconscious compensation for feelings of childhood helplessness. Because narcissists have such a severely impaired ability to trust, they must present their opinions as unassailable. Paradoxically, the strident attitude of highly authoritarian narcissists often undercuts their chances of getting what they want from others. For instance, excessively authoritarian parents can make their children feel unheard, or, worse, convince them that their feelings don't matter. Rather than valuing their children as unique individuals with legitimate opinions of their own, they expect their children to step in line with their expectations, no questions asked.

It's no surprise that some celebrities seem to have an excessively high sense of their own authority; each new season, the competition-based reality shows turn up a handful of stars who eagerly seize the alpha-dog role (and usually succumb to their own hubris within a few episodes). This kind of behavior also marks those who use their fame to promote themselves as experts in areas unrelated to their profession, from politics to foreign policy to the efficacy of prescription drugs or psychiatry. Because their celebrity allows them to speak to millions, such figures can confuse the weight of their authority with that of international relations scholars, tenured economists, or experienced medical professionals.

Entitlement seems to be on the rise among narcissists today, and may be supported by a general tendency toward entitlement in our culture. The doctrine of "American exceptionalism" has long been a part of our national identity, and in a nation where "We're number one!" is the rallying cry, it's no surprise that many people feel they're entitled to have anything they want. What's more, if reality doesn't cooperate with their desires, they simply blame whoever

gets in their way. Personal responsibility is the opposite of entitlement: To the highly entitled narcissist, to require any sacrifice is to trigger envy, resentment, and rage.

Entitlement is one of the narcissistic celebrity's most common coping mechanisms. Mark interviewed the owner of a business that runs the valet parking service at several Los Angeles celebrity hot spots. The owner reported that celebrities very often refuse, or "forget," to pay for the service of parking their cars. When confronted, they blame the staff for not telling them there was a charge, claim that they "never carry money," or simply try to leave without paying.

Some stars take things much further, demanding that businesses close their doors to regular customers so they can shop, sometimes without offering to pay for the merchandise they select. Concierge.com recently voted Mariah Carey one of the world's worst hotel guests for her diva behavior: According to hotel owners, she has demanded that her suites be equipped with gold faucets, new toilet seats, and mineral water for her to bathe in, and her dogs to drink. The Web site thesmokinggun.com has published scores of contract riders in which entertainers list their green room requirements, from the gratuitously inconvenient (hard-to-find foods, beverages served at specific temperatures, or a private flush toilet with a *new, unused* seat) to the outright ridiculous (freshly painting and decorating the dressing room to exacting instructions). And celebrities expect vendors at the gift suites at Hollywood events to provide them with extra goodie bags full of thousands of dollars' worth of free merchandise, from watches to jewelry to jeans.

Exhibitionism may be expressed as a desire to perform or speak before an audience, or it may decay to a primitive desire to be seen

without clothing or even to act out in more dangerous ways. The stars of *Jackass*, Johnny Knoxville and Steve-O, who attained celebrity by performing outrageous, arguably degrading stunts on themselves and others, serve as perfect examples of the latter breed of exhibitionism.

Some have speculated that such acting out may be deeply rooted in our genes, as a way to display genetic prowess and adaptability. In this theory, males (in particular) who survive dangerous stunts are displaying their biological capacity to survive in adversity. Such behavior obviously requires a narcissistic sense of invincibility. By the same token, it's been argued that both men and women who parade their sexuality openly are simply advertising their reproductive potential.

Exhibitionism can easily go off course when it becomes a compulsion or preoccupation. For evidence of Hollywood's penchant for exhibitionism, look no further than the parade of panty-free celebrities in recent years. But the Four Horsewomen aren't the only ones who have displayed their wares in a bid for public attention. At the age of twenty, Drew Barrymore leapt onto David Letterman's desk and flashed her breasts at him; she posed nude for *Playboy* the same year. Janet Jackson gave us the phrase "wardrobe malfunction" with her infamous Super Bowl appearance in 2004. Paparazzi routinely scan beaches the world over with telephoto lenses, looking to catch Jennifer Aniston or the girls from *The Hills* sunbathing topless on the beach. Men aren't immune to the same behavior; just ask Matthew McConaughey or Mario Lopez, neither of whom can seem to find a shirt. Miley Cyrus may not have flashed much more than her midriff and bare back, but I can't help worrying that she's put herself on a slippery slope.

Yet nothing speaks to exhibitionism more than the explosion of celebrity sex tapes. In 1998, a home video of Pam Anderson and

then-husband Tommy Lee having sex on a yacht was allegedly stolen from their home and distributed without their permission by the Internet Entertainment Group, although many now believe that Pam and Tommy played a behind-the-scenes role in the tape's release. In its initial distribution, the video generated $1.5 million in revenues and continues to sell well today. The Anderson-Lee video wasn't the first time we had seen famous people naked, of course; nude pictures of celebrities had circulated for years, and a surprising number of actresses and models had even agreed to pose in carefully retouched *Playboy* pictorials or to appear briefly nude in the occasional film. The closest thing to the Pam-and-Tommy tape was in 1988, when a blurry hotel-room tape nearly killed Rob Lowe's career.

But this was the first time one of the world's most desired women was seen onscreen having intimate relations, and much had changed in those ten years. By the mid-1990s, explicit sex of every kind was widely available online. But Pam Anderson was not a porn star, she was a mainstream actress. The moment that tape was released, it blurred the line between the private person and the performer. It gave anyone interested, whether casually or lasciviously, direct access to her sexuality, beyond even what the trained performers in porn films afford.

Twenty, even ten years earlier, Pam Anderson and Tommy Lee might have slinked off into exile, waiting for memories to fade. Instead, the incident only increased their Q rating. The old phenomenon of public shame was overridden by the temptations of narcissism. The tape spawned hundreds of copycats, and to this day new tapes surface constantly, particularly from minor celebrities hoping to reinvigorate their careers. The Internet gave rise to dozens of fakes, purporting to feature celebrities like Lindsay Lohan, Britney Spears, Jimi Hendrix, even Marilyn Monroe. But

there were also plenty of authentic instances of celebrities playing amateur porn star:

- **Paris Hilton** and then-boyfriend Rick Salomon (2003). Their tape was ultimately approved by Paris and released under the title *1 Night in Paris* (2003).

- **Colin Farrell** and *Playboy* Playmate **Nicole Narain** (2004). Farrell successfully blocked distribution of the tape, only to see it surface on the Internet in 2006.

- **Gena Lee Nolan** of *Baywatch* and former husband Greg Fahlman (2004).

- **Pamela Anderson** and **Bret Michaels**, lead singer of Poison (2005).

- **Fred Durst** of Limp Bizkit and an unknown woman (2005).

- **Keeley Hazlett**, a model for British tabloid *The Sun*, and her ex-boyfriend (2007).

- **Amy Fisher**, the so-called Long Island Lolita who became famous for shooting her boyfriend's wife in 1992, and husband Lou Bellera (2008).

- **Verne Troyer** (Mini-Me from the Austin Powers movies) and his girlfriend, Ranae Shrider (2008).

When Dustin Diamond, who played the awkward adolescent Screech in the early '90s series *Saved by the Bell*, was widely mocked for his 2006 tape, it may have seemed like a death rattle for the sex-tape phenomenon. Then along came Kim Kardashian, a Hollywood club girl whose biggest claim to fame was being friends

with Paris Hilton. When she appeared in a tape with rapper Ray J in 2007, it propelled her to instant fame, marking the first time a star was born purely because of a sex tape.

Exploitativeness is probably the most pernicious trait in the inventory. There is little positive usefulness to being exploitative, which requires a disregard for other people's priorities and feelings. Like any trait, it can appear in milder or stronger doses: It's only mildly exploitative, for example, to befriend someone who has an interesting career, wide intelligence, or even desirable possessions, in hopes of benefiting from the friendship. The true measure of the exploitation is in whether you get to know this new friend well, or simply use him for your own self-interest.

Individuals who are highly exploitative have trouble accurately appreciating other people's feelings. They are uncomfortable allowing themselves to be vulnerable or open in an interpersonal context, and prefer to keep their relationships utilitarian. They take advantage of situations to serve their own interests, whatever the cost to others. When former presidential candidate John Edwards admitted to having an affair with Rielle Hunter, a videographer he had hired to create Internet ads for his presidential campaign, he defended himself by exploiting a family tragedy, lamenting in a TV interview that he'd felt "slapped down to the ground when my son Wade died in April of 1996."

Arguably every stage mother is exploitative to some degree, but Dina Lohan, the mother of Lindsay Lohan, seems particularly willing to use her family's notoriety (thanks to Lindsay's exploits and to Dina's own particularly nasty divorce from her husband, Michael) to push her youngest daughter, Ali, into the spotlight. I can't imagine how Dina can believe that launching Ali onto the same show-business trajectory as Lindsay would result in a healthy

lifestyle for her younger daughter. Yet, with Lindsay now out of her control, Dina, as mom and manager, has decided to build the reality show *Living Lohan* around Ali. Can eleven-year-old Cody be far behind?

In a similar vein, Britney and Jamie Lynne's mother, Lynne Spears, recently published a book about raising her daughters, a topic on which her authority is questionable at best. In *Through the Storm: A Real Story of Fame and Family in a Tabloid World*, she writes about "a dark period" in her Britney's life and discusses the challenges she faced in raising Britney and Jamie Lynn. Perhaps it would have been more revealing if Lynne Spears had waited a bit longer to write this book, as I believe that Britney literally owes her life to her mother and father's decision to step in and parent their adult daughter in the face of extremely challenging circumstances.

Self-sufficiency is one personality trait that doesn't sound like a liability. In clinical terms, self-sufficiency refers to a high degree of confidence in one's own ability or point of view. What could be wrong with that? The problem is that overly self-sufficient people can find it difficult to collaborate, or to register other people's points of view. Furthermore, when this trait strongly predominates, it can interfere with a person's ability to ask for help. For example, children who have survived trauma consistently hover close to their teacher until they hit their head or have some other tender need, at which point they hide in the corner and become unreachable. At just the moment when the child should be reaching out for help in dealing with an overwhelming feeling, he turns away from the person who can help, because prior experience has taught the child that his need will be either painfully ignored or purposely intensified.

In adulthood, this lesson can harden into a brittle self-sufficiency, locking the narcissist into his perceptions and experiences and closing off the potential for more flexible emotional regulation. Extreme self-sufficiency may even foster mild paranoia when the narcissist's worldview is challenged.

The celebrity world is full of people who put great stock in their own self-sufficiency. Donald Trump displays high levels of the trait, as does Gene Simmons, who prides himself on managing his career on his own, without agent or publicists. The rapper Snoop Dogg paraded his self-sufficiency in a conversation with MTV's Shaheem Reid last year: "Me and Pharrell [Williams] went into the studio last night, and we're gonna start on this album called *Ego Trippin'*. I'ma do the whole record. Me. By myself. I don't want no guest rappers, no singer, nothing. Just Snoop Dogg. I want you to feel me." But this brand of blustery narcissism isn't the only signifier of self-sufficiency: There are plenty of other examples, from working actors who claim they manage all their childcare themselves to the frequent tendency for celebrities to declare themselves experts in medical or health issues and, instead of asking for help from genuine professionals, turning to pseudo-professionals they declare to be "special" or "the best."

Superiority is closely related to authority and entitlement. It's a belief that one is better than others, and thus entitled to deference or special treatment. In moderation, this trait can help individuals to influence or lead others. However, when an individual with unhealthy feelings of superiority tries to assert his dominance over others, superiority can also devolve into threatening behavior. Studies show that rapists believe they are superior to women, and domestic violence commonly results from a compulsion to exert superiority over a partner one perceives as disobedient.

A person's feelings of superiority can be fed when he interacts regularly with a person or group he considers inferior. Hollywood lore is rife with stories of how celebrities torture their personal assistants, an image that's been a comic staple from *The Devil Wears Prada* to *Entourage*. The refrain "Don't you know who I am?" is the cry of the narcissist with high levels of superiority, who demands immediate recognition. The special treatment demanded by most celebrities sends a not-so-subtle signal that they consider themselves better than those around them.

Vanity, of course, has much to do with superiority and exhibitionism, but there are aspects of clinical vanity that go beyond a preoccupation with oneself and one's appearance. Vanity, which also involves an inflated sense of one's abilities, tends to fuel a narcissist's denial. We've all seen individuals who have some ability but clearly overestimate their talents or achievements. When forced to face reality, particularly after they have blatantly misrepresented their qualifications, narcissists are often able to carry on, clinging to their vain sense of self, often fueled by a sense of superiority and/or authority. (The defiant, deluded behavior of dismissed *American Idol* contestants comes to mind.)

It seems almost redundant to single out examples of vanity among genuine celebrities. Suffice to say, most of the entertainers I've met exhibit a strong sense of vanity, whatever their levels of attractiveness or talent. Think of the celebrities who appear in so-called candid photos every week, caught heading to the grocery store with their hair and makeup done and sporting four-inch heels. Or consider the celebrity who's caught in an unflattering photo, only to invite showers of praise a few months later for their remarkable weight loss or suddenly fresh-faced appearance. And, remember, vanity isn't always about appearance. When a book

called *TrumpNation: The Art of Being the Donald* reported that Donald Trump's net worth was between $150 and $250 million, instead of the billions he claimed, Trump sued the author and publisher for $5 billion in damages, alleging that the claim hurt his "brand and reputation."

While not everyone with high levels of vanity will turn to the legal system to validate their narcissistic self-perceptions, the truth is that it's rare to find a narcissist who is not deeply preoccupied with how he appears to others. Lacking any deep sense of self, narcissists rely on their outward appearance for a sense of personal worth. When celebrities demand to be portrayed solely through idealized images, their vain projections become grist for a distorted measurement of beauty, success, and self-worth for the rest of us.

■ ■ ■

The Narcissistic Personality Inventory is what's called a *forced-choice* survey: Presented with two statements, the subject must choose the one he most agrees with, even if he doesn't completely agree with either. Individuals taking the NPI are given a booklet containing forty pairs of statements. In each case, one of the choices is the narcissistic choice; the other is the nonnarcissistic choice. The score is determined by adding up the number of narcissistic choices the subject makes out of a possible forty. (The full NPI and scoring key are provided in the appendix, along with information on how to determine your overall score, your component trait score, and what these scores may indicate regarding where you fall on the scale of narcissism.)

The forty pairs of questions are designed to measure the seven traits of narcissism just discussed. Some of the traits are more complex to assess than others, so more questions pertain to some traits than others. For instance, eight questions relate to authority, only

three to vanity. Because each trait is a component of narcissism, an individual's answers will reveal which of the seven aspects of narcissism are most strongly reflected in his or her personality. This can be illuminating when observing and understanding particular behaviors.

Over a two-year period, we gave the survey to two groups of subjects: celebrities and MBA students. Mark and I gave the test to celebrities in person during their visits to the *Loveline* studio, a laid-back, nonthreatening environment away from fans and the paparazzi. The MBA students took the NPI online.

The celebrity group was comprised of two hundred people: 142 males and 58 females. For purposes of our study, we defined a celebrity as someone prominent enough to be invited to appear on *Loveline*. The show has been broadcast for more than 25 years, co-hosted most recently with "Stryker" (KROQ DJ, Ted Stryker), and engineered by Anderson Cowan. The show's producer, Ann Ingold, is careful to select only those celebrities she knows will draw an audience, but this includes a wide variety of people, from porn stars to Oscar winners, rappers to opera stars, A-list movie stars to D-list reality show contestants. Our sample group represented a broad cross section of the entertainment industry, including comedians, actors, reality TV personalities, and musicians, all of whom appear regularly on television, in the movies, in magazines, and in concerts. Our subjects had from one year to thirty-eight years of experience in the entertainment industry, with an average of twelve years.

When we first came up with the idea for the study, Mark was concerned that we might not find enough willing participants. However, once we began approaching the *Loveline* guests his fears were immediately allayed: Every single person we asked to complete the survey agreed to do so. Most of them were not only will-

ing, but very curious and anxious to know the results. Though we told the participants the study was designed to assess aspects of their personalities, we did not reveal the precise nature of the test, lest we influence their answers. (A few guests were unable to complete the survey due to time constraints; their surveys were eliminated from the study.)

We were careful to follow well-established research procedures when administering the survey. We made it clear to each subject that their participation was voluntary and not a requirement of being on *Loveline* and that he or she could stop filling out the survey at any time. We also guaranteed everyone anonymity—although, as you'll see in the appendix, certain celebrities were willing to publicly share their scores.

In undertaking the study we hoped to demonstrate scientifically the popular assumption (and our own observation) that celebrities were not only narcissists, but more narcissistic than average people. Given the entertainment industry's focus on female attractiveness, we wondered whether narcissism in male and female celebrities would follow trends in the general population, where men have been shown to be more narcissistic than women. Our intuition told us that women who pursued celebrity were, in fact, more narcissistic than their male counterparts. If this was the case, we would be able to show another difference between the celebrity and general populations when it came to measuring levels of narcissistic traits. We were also very curious about whether certain types of celebrities would score higher than others on the test. Many people believe that actors are very narcissistic, for instance, but no one had ever looked at whether levels of certain narcissistic traits corresponded to particular types of work in the entertainment industry. Finally, it was clear that even experts were split on why celebrities were so narcissistic. Some thought the industry cre-

ated narcissism, while we believed that narcissists were attracted to the industry. Answering this chicken-and-egg question would offer important insights into the nature of celebrity.

With these four questions in mind, we analyzed the results of our data:

1. ARE CELEBRITIES MORE NARCISSISTIC THAN THE GENERAL POPULATION?

The celebrities we surveyed had an average score of 17.84 out of 40 on the Narcissistic Personality Inventory. But how does that measure up against the average American?

To answer this question, we compared our celebrity data to that gathered by psychologists Joshua Foster, Keith Campbell, and Jean Twenge, who administered the NPI to a very large cross section of people in the United States (2,546 participants). Their data, published in 2003, showed the average NPI score for all participants was 15.3, with the average American males scoring higher than females. Thus, on average, celebrities are 17 percent more narcissistic than the general public.

Next, we compared the celebrity results with those of the two hundred MBA students (144 males and 56 females) to whom Mark gave the test online. The students' average age was twenty-nine; they had an average of five years' work experience, and all were in the final year of their MBA program. Anyone who has watched *The Apprentice* has probably wondered about the levels of narcissism among America's aspiring business leaders, and we felt these MBA students would make a useful comparison to the celebrities. If the celebrities were more narcissistic than the general population that was one thing, but showing that they were more narcissistic than aspiring business leaders would be even more compelling.

And that's exactly what happened. The MBA students' average NPI score was 16.18, about 6 percent higher than the general population's, and about 10 percent lower than the celebrity average. Male MBAs were significantly more narcissistic than female MBAs, and scored higher than the female MBAs in entitlement and self-sufficiency.

2. WHO ARE MORE NARCISSISTIC: MALE OR FEMALE CELEBRITIES?

According to the *Diagnostic and Statistical Manual of Mental Disorders* (the DSM-IV-TR), the American Psychiatric Association's digest of all recognized mental health disorders, men are more narcissistic in general than females. As our study showed, male MBA students were more narcissistic than female MBAs. When it came to male versus female celebrities, however, the findings from our study were surprising.

Among celebrities, females were significantly more narcissistic than males. The average female score among our celebrities was 19.26; among males it was 17.27. That means that female celebrities are, on average, 26 percent more narcissistic than the general population.

To understand this result, we drilled deeper into the results, looking at how male and female celebrities scored on the various traits that comprise the NPI. In four of those categories—entitlement, authority, self-sufficiency, and exploitativeness—there were no significant differences between men and women celebrities. In three others, however—exhibitionism, superiority, and vanity—female celebrities scored significantly higher than their male counterparts. These results suggest that female celebrities have a greater preoccupation with their physical appearance, and a greater sense of superiority, compared to their male counterparts.

This trend may be more circumstantial than genetic. For a woman to believe she can get noticed in Hollywood—in a business that focuses on beauty, youth, and glamour—would be practically impossible without high levels of exhibitionism, superiority, and vanity. And those female celebrities who do manage to attain fame are all too aware that the shelf life of women in show business can be woefully short. Narcissism is what drives any celebrity to rationalize increasingly obvious rounds of plastic surgery, suggestive outfits, or nude photo shoots. To her, each is a necessary step to keeping her persona looking good and in the public eye.

3. WHICH GROUP OF CELEBRITIES IS MOST NARCISSISTIC: ACTORS, MUSICIANS, REALITY TV PERSONALITIES, OR COMEDIANS?

Among those four groups, one clearly came out on top: According to our study, reality TV personalities are more narcissistic than any other group, with a very high average score of 19.45. Reality stars scored highest for authority, self-sufficiency, and vanity. Comedians came in second, at 18.89, actors third at 18.54, and musicians last at 16.67.

There are very concrete reasons that reality TV personalities are generally more narcissistic than even traditional celebrities. As discussed in chapter 3, reality-show producers have told us they consciously seek out contestants who are vain and controlling, because they make for more dramatic, watchable television. And research shows that narcissists tend to make a very good first impression, so it's no surprise that casting agents and producers would be drawn to hire them.

More obviously, the people who try out for reality shows have a strong desire to be seen. Many of them believe they deserve stardom simply because of who they are. Talent and achievement are

not necessary prerequisites. In fact, despite the hundreds of reality shows that have come and gone in the last few years, only a handful of individuals have been able to garner any type of sustainable career from these opportunities, often by continuing to appear on reality shows.

Elisabeth Hasselbeck, a former shoe designer, parlayed a 2001 stint on *Survivor* (on which she finished fourth) into a gig as a judge at the Miss Teen USA Pageant and a host on Style Network's *The Look for Less*. In 2003, she auditioned for a permanent spot joining three other hosts on *The View*. Known for her conservative point of view and tearful conflicts with her cohosts, Hasselbeck had the dubious distinction of being voted the "worst interviewer on TV" in a 2008 AOL poll.

Adrianne Curry, the winner of the first season of *America's Next Top Model*, didn't exactly choose a traditional modeling career after her appearance on the show catapulted her into the public eye. She did some runway and print, but it was her 2004 stint on a second reality TV series, *The Surreal Life*, that really launched her career as a celebrity. On that show she met Christopher Knight (a.k.a. Peter Brady), and they parlayed their rocky romance into a third reality show: *My Fair Brady*. With other film and radio work and an ongoing modeling career, including a cover and two *Playboy* pictorials, Curry is one of the few reality TV personalities who have successfully extended their fifteen minutes of fame.

The questions that make up the NPI also allow us to study each group's tendency to favor specific narcissistic traits, and these scores offer some interesting insights as well. Although musicians appear to be the least narcissistic celebrity group, they did register the second highest scores on entitlement and self-sufficiency. One explanation for this result may be that a career in music requires one to display an authentic talent, on stage in real time, night after

night. Either you can sing or play well or you can't. You can't fake it, and you can't get by on looks alone. Yet that doesn't stop musically proficient narcissists from making outlandish requests for their entourage, or believing they don't need anyone else to help them succeed—classic expressions of entitlement and self-sufficiency.

Comedians had the second highest overall NPI scores, and they scored highest on four of the traits, including exhibitionism, superiority, entitlement, and exploitativeness. One reason for this may be that many comedians suffered traumatic or chaotic childhoods. Comedians don't generally trade on good looks, which jibes with their low scores on vanity, but they're usually intelligent and creative, and often aggressive; feelings of superiority and entitlement, and a willingness to exploit situations to their benefit, would serve any comedian well in a stand-up routine. For such personalities, comedy can offer a solution to their narcissistic impulses. As a kid, comedian Bob Saget remembers, he was "so insecure that I [was viewed as] either really popular, as I was so funny, or a total geek." He vividly remembers acting out, doing the kinds of "delinquent things [that] the guys in *Jackass* do, what Jamie Kennedy does, or Tom Green," in what he calls "a nine-year-old's cry for attention."

Finally, the group of working actors we surveyed was notable for scoring third on almost every trait measured by the survey. Many actors seem aware of the role their individual psychologies play in their profession. They often speak out to acknowledge their discomfort with attention from fans, and their understanding of the privileges that come with fame, sometimes even admitting that narcissism is both a professional given and a potential hazard.

Frankie Muniz, who played the title role in *Malcolm in the Middle*, has been acting on stage, film, and TV since the age of eight.

He scored an extremely low 10 on the NPI, making him not only 44 percent less narcissistic than the average celebrity, but also 35 percent less narcissistic than the average individual. Not surprisingly, Muniz now considers himself retired from show business and is pursuing a career in professional auto racing. "I fell into acting by accident and stayed and I made a lot of money," he says. "I had no trouble leaving the celebrity lifestyle behind when I discovered my true passion for race-car driving."

Another working actor, Diora Baird (a former Guess Jeans model who has accumulated twenty-nine film and TV credits in the last three years), scored an 11 on the survey. Diora is an extremely attractive woman who initially built her reputation on her voluptuous physical assets, which are often featured in her film roles. Yet her scores in the traits of vanity and exhibitionism were extremely low. Her higher scores were in the area of exploitativeness and authority. Diora explained that she "never really wanted to show my body, as I am actually a very shy person. However, I knew it was a means to an end. So, I suppose I did exploit the situation initially." It's no surprise that as Diora's career continues to accelerate, she's been able to exercise her authority to take more control over the roles she takes, and is moving away from her sexually charged persona toward more serious roles as an actress.

There are doubtless plenty of working entertainers who fit this profile. You may not be able to name many immediately, but that's the point; these are working practitioners who stay out of the limelight and don't court publicity except to promote their projects.

We suspect that there are also many actors who, while likely to score high on a narcissistic scale, have cultivated degrees of self-awareness and empathy that assist them in recognizing and checking unhealthy displays of narcissism. For these actors, and any individual who is high on the narcissism scale, the key to their

continued success is being able to express their narcissistic traits in positive ways and to avoid the narcissist's tendency to exploit others to achieve what they want.

4. DOES THE ENTERTAINMENT INDUSTRY CREATE NARCISSISTIC TENDENCIES AMONG CELEBRITIES, OR ARE THE CELEBRITIES NARCISSISTIC BEFORE ENTERING THE INDUSTRY?

To us, this was the key question. Most people probably assume that fame leads to narcissism, that a constant diet of attention and adulation will give anyone a swelled head. As we've seen, though, narcissism isn't about ego, it's more about self-loathing and emptiness. And its causes are easily misunderstood.

Even psychological professionals have differed over the origins of narcissism. In the last decade or so, Robert B. Millman, professor of psychiatry at Cornell Medical School and the medical adviser to Major League Baseball, has coined the term *acquired situational narcissism* to describe how the fawning behavior of the entertainment industry and the audience may lead to heightened narcissism in celebrities. Millman theorizes that the support system of sycophants surrounding athletes, actors, politicians, musicians, and others may lead these celebrities to develop unhealthy levels of narcissism.

There's no doubt that the coddling environment enjoyed by most celebrities can fuel an amplified expression of narcissistic traits. But Millman's theory doesn't jibe with the scientific consensus that the driving force behind narcissism is early childhood trauma. When we initiated our study, we believed that narcissism itself was the primary motivator for individuals seeking fame, rather than a byproduct of the fame itself. We also wanted to test that theory, so we asked all participants a very straightforward

question: "How many years of experience do you have working in the entertainment industry since your first paycheck?" Among the two hundred celebrities we surveyed, the average number of years of experience was twelve. The newest celebrity had one year in the business, the most experienced had thirty-eight years.

The point of this experience question was to determine whether prolonged immersion in the celebrity lifestyle had a measurable effect on a person's level of narcissism. If the popular assumption (and Millman's theory) were true—that celebrity creates toxic levels of narcissism—we would expect the NPI scores of more experienced celebrities to be higher than those of younger or less seasoned stars. The data said otherwise. Our survey revealed no correlation between the length of a performer's career and his NPI score.

This is likely to ring true with anyone who works with celebrities in a clinical or professional setting. When I work with patients, it's apparent to me that the issues they're grappling with don't originate in the present day. What I uncover at the root of all unhealthy narcissistic personalities, without exception, is profound childhood trauma.

Of course, our study looked only at average scores, and it's possible that the NPI scores of some individuals may be influenced by their history in the industry; but testing individuals repeatedly throughout their careers to monitor their levels of narcissism would be highly impractical and, in truth, beside the point. All the most rigorous research on narcissism has demonstrated that, regardless of any situational triggers in adulthood, narcissism is a deep-seated and complex dysfunction. And every celebrity patient I have worked with has confirmed to me, through the stories they have shared, willingly or reluctantly, that their issues have their roots not in an excess of praise in adulthood, but through some much deeper, and more damaging, childhood experience.

The results of our study on celebrities and narcissism were published in the *Journal of Research in Personality* in October 2006. Our research had shown not only that celebrities were generally more narcissistic than average, but that there were significant differences between male and female entertainers, and that certain types of performers consistently ranked higher than others, exhibiting high levels of specific narcissistic traits. At the time of our study, the average score for a person taking the NPI was 15.3 out of 40. Among the two hundred celebrities taking part in our study, the average was 17.84. There was an inverse relationship between the levels of discernible skills and the levels of narcissistic traits: talented performers, like musicians, scored lower (16.67) than celebrities with no readily discernible skills, such as reality stars (19.45). Comedians had an average score of 18.89; working actors averaged 18.54.

The study struck a chord in the cultural zeitgeist and the media was quick to pick up on the fact that it centered on celebrities. *The New York Times Magazine* named it one of "The Top 70 Ideas of 2006," and it made international headlines: the *Los Angeles Times* ("Celeb Note to Self: You are Fabulous—A Scientific Study Shows that Stars Really are Narcissists First"); Norway's *Business Daily* ("Mirror, Mirror on the Wall—Stars Are Their Own Biggest Fans"); *China Daily* ("Celebrities Really are More Narcissistic"); the *New York Daily News* ("I Love Me—Mirror, Mirror on the Wall: We Pick NYC's Biggest Egos of Them All").

The media may have picked up the story, but they missed the message. Almost without exception, the interviews and articles echoed our friend (and my then-cohost of *Loveline*) Adam Carolla's initial reaction to the survey: "Is this groundbreaking—that celebrities are narcissistic? I mean, this is like you found out Liberace was gay." There were plenty of jokes about "celebrity narcissism"—

but very little real, informative discussion about the study and what it might really be telling us about celebrities. In nearly every interview I tried to turn the conversation around—to help people understand what narcissism really was and the pain inherent in a narcissistic personality disorder. In interview after interview, Mark and I stressed how important it was to understand that narcissists weren't "in love with themselves," and that our societal preoccupation with celebrity was fraught with negative implications. From our perspective, the real headline here was that the celebrity behaviors so many people strive to emulate grow out of a genuine personality disorder—a discovery with troubling implications for all of society.

As you'll recall from the previous chapter, celebrities—like all narcissists—aren't "in love with themselves." They rely on the world as a mirror, constantly gazing outward in search of gratification or affirmation, in order to stave off their unbearable feelings of internal emptiness. When the image in the looking glass disappoints them, or fails in some way, they turn to other solutions.

These other solutions—addiction, extreme vanity, sexual drama and dysfunctional relationships, exploitativeness, and outrageous entitlement—have come to dominate celebrity culture. And it is the celebrities and their outrageous behavior on one side, and our preoccupation with celebrity on the other, that gives rise to the notion of the Mirror Effect: the way that malignant forms of narcissism, as showcased by the media, can cause vulnerable everyday people to descend into dangerously narcissistic behaviors. And there is a third factor that significantly amplifies the Mirror Effect's potential influence on all of us: the twenty-first century media universe has become a potent delivery system with the power to spread those behaviors from celebrity circles to society at large.

CHAPTER SIX

The Mirror Effect and How It Affects Us All

The celebrity is a person well known for his well-knownness. We risk being the first people in history to have been able to make their illusions so vivid, so persuasive, so realistic that we can live in them.

———*Daniel Boorstin, The Image (1961)*

The media give substance to and thus intensify narcissistic dreams of fame and glory, encourage the common man to identify himself with the stars and to hate the "herd," and make it more and more difficult for him to accept the banality of everyday existence.

———*Christopher Lasch, The Culture of Narcissism (1979)*

Do you long to strut into the world's most elite hotspots without a care in the world except how fabulous you are? Ever wish the velvet ropes didn't exclude you from the social circles of the A-List? How about the fantasy of jet setting around the world with the ultimate BFF, whose fierce style, charisma and star power is only matched by your own?

Now that's hot! MTV is giving the opportunity of a lifetime to one girl or "fabulous" guy who has what it takes to become Paris Hilton's new BFF. Finally, you have the chance to show the world that you have what it takes to achieve social stardom; allowing you unprecedented access to young Hollywood as never before. Loves It!

[The casting company] is seeking "Hot Bitches" and "Fabulously Fierce Guys" who are at least the age of 21 and appear under 30.

Are you sick and tired of envying the social icons? Will you be the next pop-arazzi obsession and quintessential star of the red carpet? Prove it bitches!

———*MTV casting call (2008)*

Each in his own way, Daniel Boorstin and Christopher Lasch fore-saw the changing role of celebrity in American culture, and the emergence of entitlement as a driving force in American life. Lasch in particular was prescient in identifying society's increasing preoc-cupation with celebrity as the result of an increasingly narcissistic culture, theorizing that the grandeur of celebrity attracts narcissists who are driven by the belief that they, too, are entitled to acco-lades and special treatment; however, neither could have imagined how the news media would create such a fertile environment for today's rampant glamorization of narcissistic behavior. Nor did they consider how the power of envy would transform the rela-tionship between celebrity and audience.

Celebrities, especially those who behave outrageously, are often individuals with a history of deep trauma. But the entertain-ment news industry invites us to view them as caricatures, and to pass swift judgment on their conduct, based on our deeply primi-tive reactions, with no knowledge of what drives their behavior. We might react positively, yearning to be as glamorous (or sexually bold) as the stars of *The Hills*, or admiring the entitled moms of *Real Housewives* for getting what they want, or calling everyone a "hot mess" like a winner of *Project Runway*. Or we might react neg-atively, mocking contestants on *American Idol* or logging onto gos-sip sites to post snarky comments about some young starlet. Either way, when we respond to such narcissistic behavior by changing our own behavior, the Mirror Effect is at work.

It's important to understand that the Mirror Effect can't actu-ally *create* unhealthy narcissism where none already exists. Nor can it cause mildly narcissistic people suddenly to develop Cluster B pathologies. Rather, the Mirror Effect occurs when everyday peo-ple who already harbor mild narcissistic traits, as most do, begin to mimic more malignant forms of narcissism, leading them to be-

have in more severely problematic ways. It magnifies whatever pre-existing narcissistic traits we may have into increasingly detrimental types of behavior, which can in turn evolve into fixed personality traits.

The Mirror Effect involves a certain progression of steps: (1) The viewer consumes a consistent diet of images of celebrities behaving in attention-getting, narcissistic ways, images that make the behavior appear both entertaining and attractive. (2) The viewer develops a preoccupation with these images, to the point that the behavior begins to seem normal, even desirable. (3) Consciously or unconsciously, the viewer begins to adopt the behavior, with detrimental or even dangerous consequences. Though it's not a necessary step, the cycle is completed if (4) the viewer then takes advantage of open-access media to indulge his own narcissistic urges, reflecting the behavior back to the public at large.

Adolescents, who absorb cultural messages constantly, are particularly vulnerable to the Mirror Effect; more on their special concerns in chapter 8. However, the Mirror Effect has the potential to influence anyone who consumes a regular diet of narcissistic imagery. Most of us are awash in troubling examples of celebrity behavior. Whether we follow the story lines avidly, or absorb them as passive bystanders, we are all at risk of having distorted and unhealthy levels of narcissism reinforced within us by these cultural messages.

But why do images of narcissistic behavior evoke such primitive and powerful responses? And how are those responses appearing in society today? Let's look more closely at the answers.

■ ■ ■

To understand the potent allure of celebrity in our culture, it helps to appreciate the evolutionary power of mimicry in the primate

species. The behavior behind the expression "monkey see, monkey do" has evolved in human beings to a far more complex expression of social and cultural desires. In the most fundamental terms, humans tend to mimic behavior we see around us because doing so enhances our sense of belonging.

According to psychologist Abraham Maslow, human behavior follows what he called the *hierarchy of needs*. After satisfying physiological needs, such as food and water and security, human beings seek to satisfy social needs, including a feeling of belonging to a group. Research in other disciplines has demonstrated that feelings of exclusion from one's society have devastating psychological, emotional, and behavioral consequences. A study called "Exclusion and Mimicry," published in *Psychological Science* in August 2008, concluded that behavioral mimicry is an automatic, low-risk method of affiliation. The study also showed that individuals who are excluded from a group will mimic people who can restore their status within the in-group.

The interesting thing about this study is how the mimicking behavior is unconsciously and automatically directed at the individuals perceived to have the highest status within a given society. Traditionally, young people and others in need of social guidance tended to look to family, community, and political or governmental leaders for direction. Yet, in recent years, research has shown a steady erosion in public confidence in these social institutions. According to polls at the time we wrote this book, roughly two-thirds of all Americans felt more politically alienated from their government than ever before; only 24 percent of Americans said they trusted their government. This disillusionment had been exacerbated by a series of scandals that arguably started with Watergate, peaked again with the Clinton-Lewinsky scandal, and included the sex scandals of Senator Larry Craig of Idaho, Representative

Mark Foley of Florida, Senator David Vitter of Louisiana, Governor Eliot Spitzer of New York, and two-time presidential candidate and former senator John Edwards of North Carolina.

At the same time our civic leaders were disappointing us, studies have showed a decline in religious affiliation and beliefs, especially among America's youth, who have become increasingly disenchanted with church doctrine and the perceived hypocrisy of high-ranking church officials shown to be complicit in various sex scandals themselves. And, perhaps the most fundamental institution of all, the family, continues to be torn apart. According to the U.S. Census Bureau, single-parent households are now the most common type of household in America, displacing two-parent families as the dominant household form. One of our biggest social problems is the rise in the number of men who abandon their families. One-third of all U.S. households with single mothers live below the poverty line. Most single-parent households are the result of divorce or illegitimate births. The divorce rate has also escalated to the point where over 50 percent of all marriages today end in divorce, and child abuse and neglect are steadily increasing.

As confidence in all these institutions diminishes, it is only natural that people will look to other things to take their place. According to research by John Maltby and his colleagues, as the level of religious devotion decreases, the degree of celebrity worship increases. The rich and famous have become the most prominent, and exclusive, in-group we have. And the more we watch, and feel excluded from, such a desirable group, the more we're unconsciously motivated to mimic their behavior.

This is not a new theory. René Girard, a French historian whose career has embraced anthropology, religion, literary criticism, sociology, psychology, philosophy, and theology, touched on it when he developed the idea of *mimetic desires*. Girard's theory is that our

desires never come purely from within ourselves; rather, they are inspired by the desires of another. When someone has something we desire, we conclude that we can attain the same thing if we imitate the behavior of the person who already has it. Although Girard's theory of mimetic desire was inspired by his study of literature, it has been influential in the field of psychology, and offers support for the idea of the Mirror Effect. When the observer comes to desire the power, fame, status, or wealth they associate with celebrity, they model their behavior on that of the celebrities they most identify with.

Certainly modern media has only increased the potential for celebrity behavior to inspire mimetic desires in everyday people. The behaviors idealized by the celebrity media are primitive and compelling to imitate. The celebrity industry is a powerful force in promoting certain desires revolving around sex, appearance, possessions, power, and entitlement, and these certainly require no special talents or skills to mimic. As students of the advertising industry have known for years, American audiences are presented with a steady barrage of messages that imply that wearing certain clothes, having certain status objects, having a certain body type or hairstyle, or behaving in certain attention-attracting ways will make you part of the in-crowd. These images, unto themselves, don't *cause* the Mirror Effect. We're all free to disregard the messages they send us about celebrity. But they are difficult to resist, especially when they trigger narcissistic impulses that already exist within us.

■ ■ ■

In these terms, the Mirror Effect might sound like pure mimicry, as "monkey see, monkey do" is transformed into "narcissist see, narcissist do." To grasp how and why such media images can cause

us to change our behavior, it's important to understand another piece of the puzzle, what psychologists call *social learning*.

Human beings, and to a lesser extent, other primates, are the only creatures that can learn by observing behavior and consequences in one another. By paying attention to the examples of others, we learn both positive lessons (*Do what she did and good things will come your way*) and negative lessons (*Don't do what he did or you'll get in trouble*). Unfortunately, the accuracy of social learning can be jeopardized when the consequences of the actions are distorted. And that's exactly what happens in most media coverage of celebrity behavior.

The attractions of the celebrity lifestyle are obvious: Stars are portrayed as having the most desirable virtues (beauty, glamour, talent, charm) and being showered with the most desirable rewards (fame, wealth, leisure, adulation). So it's hardly surprising that we, as observers, would wish to be like them. We project ourselves into that fantasy world. And from there it can be just a short step to deciding that we should behave in the same ways they do. *They're doing it*, we tell ourselves. *Obviously it's working for them. Why shouldn't I do the same?* Step by step, we change our behavior to match that of the celebrities we admire and envy.

The bubble of celebrity is alluring for another reason: It seems to insulate people from the consequences of their actions, allowing them to slip through shameful, embarrassing, and even illegal situations with little or no damage. The prospect of negative behavior without consequences is highly attractive to a narcissist. When problematic celebrity behavior is regularly ignored, excused, or forgiven without holding the stars responsible for their actions, the bad behavior is reinforced for both the celebrity and the observer. And when the media diminishes or hides the emotional chaos these celebrities live with, or the carnage their behavior cre-

ates, they create a false promise of invincibility. If the unattractive outcomes of bad celebrity behavior—including the human suffering that is incurred—were reported on, it would offer an opportunity for valuable social learning, with potentially positive impact. But such reports are relatively uncommon. Instead, step by dangerous step, the dysfunctional and dangerously narcissistic behavior we see in celebrities is becoming normalized throughout society.

One of my goals in creating *Celebrity Rehab* was to counter that trend, to show people the havoc wreaked by drugs and alcohol, even in the lives of those who could be perceived as sheltered by their celebrity. Rather than simply evoking a knee-jerk response of judgmental envy, I thought, celebrities should be seen as they really are: human beings with their own profound issues, who deserve our genuine concern and empathy largely because, far from being immune to the consequences of their actions, they are imprisoned by them.

■ ■ ■

Mimicry and social learning, then, are the biological and sociological underpinnings of the Mirror Effect. But the single condition that has left a progressively larger population vulnerable to the effect, and that amplifies the resultant narcissism in society, is the increase in childhood trauma. Consider these statistics from the Centers for Disease Control (CDC), published in its Spring 2008 fact sheet on child maltreatment:

■ In 2006, U.S. state and local child protective services (CPS) investigated 3.6 million reports of children being abused or neglected.

■ 64 percent of these children were classified as victims of child neglect, 7 percent as victims of emotional abuse,

9 percent as victims of sexual abuse, and 16 percent as victims of physical abuse.

■ Overall, girls (52 percent) were at slightly higher risk than boys (48 percent) for all forms of child maltreatment.

It is childhood trauma that makes individuals most vulnerable to unhealthy levels of narcissistic traits, and that allows narcissistic behavior to take hold and flourish. The incidence of childhood trauma has increased by more than 40 percent over the past twenty years, and as a result, we are all feeling the effects of a generation with deep narcissistic wounds.

Victims of such trauma spend their lives desperately struggling to avoid the shame and emptiness that are the legacy of their childhoods. In this struggle, they grasp at certain primitive strategies that promise to ease their pain. They become driven to perform; to be needed by other people; to achieve some type of validation from a valued source. Toward that end, the Mirror Effect will compel those on the lower end of the narcissistic continuum to behave in troubling ways: to act out sexually in hopes of being popular at school, for instance, or to play the diva at work in hopes of getting special treatment. Those at the higher end of the continuum may reach for celebrity, or at least notoriety, for themselves by posting a homemade prank video on YouTube, or creating a sexy MySpace page, or even committing a crime.

The Mirror Effect allows the most basic and deeply rooted evolutionary mechanisms—mimicry and social learning—to drive our behavior. With today's near-constant tabloid diet of celebrity narcissistic behavior, few of us are completely immune to its effects, and those who have endured childhood trauma are at far greater risk of falling victim to the phenomenon. However, there is another at-risk group that is just as vulnerable to the media's relent-

less celebration of celebrity dysfunction: teens and young adults. The Mirror Effect can have far-reaching consequences for any young people who fixate on celebrity—influencing how they want to look, how they define success, how they behave in relationships, and how they conduct themselves in potentially dangerous social situations.

■ ■ ■

At the same time we were administering the NPI to celebrities, we interviewed a number of female college students (average age nineteen), soliciting their opinions on Paris Hilton, Nicole Richie, and Lindsay Lohan. This was at the height of their popularity, in 2005, and we weren't surprised when the young women we spoke with said they were interested in the exploits of these celebrities. But their reasons were interesting.

The first reason had to do with the commodification of celebrities, especially female celebrities. Most of the students said they followed celebrities like Paris Hilton in order to keep in touch with fashion trends. They all wanted to wear what young women in Hollywood were wearing. In the past decade, celebrities seem to have replaced supermodels as fashion icons; they fill the front rows at runway shows, courted by designers to lend an air of excitement to the showing of the collections. As cultural historian Neal Gabler points out, "In the eyes of the public, models are unidimensional. They are purely visual, whereas celebrities have these lives we can attach to and they seem more fully dimensional to us."

Most female celebrities today seem to take their roles as trendsetters very seriously. With stylists of all kinds at their disposal, these celebrities can exert an almost dictatorial control over how teens and young adults think they should look. Some of their chosen designers and stylists have even become celebrities in their

own right. Rachel Zoe, who has been a stylist to many of the hottest celebrities, popularized a chicly bohemian look that's instantly recognizable on the red carpet. She also formed close relationships with her celebrity clients, frequently being photographed with them in social situations. At the height of her influence, Nicole Richie, Lindsay Lohan, Kate Beckinsale, and Mischa Barton were called *Zoebots* for their slavish devotion to Zoe's rules of style.

Zoe has been criticized repeatedly for allegedly encouraging her clients to maintain skin-and-bones physiques. The *Los Angeles Times* suggested that she was singlehandedly responsible for "bringing back anorexia." She's denied rumors that she provided illegal diet drugs for "her girls," as she calls her clients. Zoe's Hollywood status took a hit when first Nicole, then Lindsay, publicly severed their relationship with her. Even that doesn't seem to have curbed her style: she's just published a book and, like everyone else, launched a reality show.

For the college students we talked to, though, it wasn't just about looking like a celebrity. What they told us they *really* wanted was to step into the stars' shoes. They wanted to be invited to celebrity parties, cross the rope line at the hottest clubs, and date Hollywood's young male stars. Many of them knew about stories of the lucky few who have managed to cross over, like Sarah Larsen, a former cocktail waitress who was whisked from the casino to the red carpet for a brief but glamorous stint as George Clooney's girlfriend. From afar, it looked to them as if dating a star might be just as satisfying as becoming one.

We also discovered something that may seem surprising: Most of the students told us that watching the drama surrounding female celebrities actually made them feel better about their own lives. Though these celebrities appeared to have it all, they also seemed to be struggling with many of the same issues the students

were. The students said they tended to look to the celebrities for solutions.

The impulse to look to others for constructive solutions to one's social or emotional problems may sound benign. But research has shown that the desire to emulate a strongly envied in-group can contribute to the weakening of healthy social boundaries and the normalization of unhealthy behaviors. The problem is only intensified when the in-group in question are highly narcissistic celebrities, whose entitled, grandiose, and self-destructive conduct raises the public's tolerance for dangerous behavior while playing down the apparent consequences. The inevitable result is that more and more everyday people, especially young people like the students we interviewed, dream of joining the ranks of the famous-for-being-famous.

■ ■ ■

Reality TV and the Internet have made fame potentially accessible to everyone. Rock stars are discovered on YouTube, *American Idol* winners (and runners-up) are sent on arena-filling concert tours, and dancers are plucked out of obscurity on *So You Think You Can Dance*. Fans have the power to decide who becomes a celebrity, and who is returned to anonymity, by voting directly for their favorite contestants. The idea of fame as a reward for merit has been replaced by a belief that just getting noticed is enough.

Perhaps the most overtly narcissistic expression of the notion that anyone can be a video star is the proliferation of the amateur sex video. Though YouTube takes some steps to monitor inappropriate content, sites like Youporn.com, Pornotube.com, and Mega erotic.com have emerged as forums where anyone can upload their own homemade sex movies. This may go without saying, but anyone who publicly releases a video of him- or herself having sex

exhibits an extremely high level of narcissism and, specifically, of vanity and exhibitionism. People with healthy self-esteem have no desire to attract attention by publicizing images of themselves having sex. The concept that sexual intimacy is a private matter is yet another social standard that has come under siege.

Such trends aren't isolated: There are probably hundreds of thousands of amateur and semiprofessional sex tapes afloat on the Internet today, the large majority of them featuring vulnerable young women, but somehow there has been little public hue and cry over the spread of such imagery. Technology seems to have altered our sense of privacy, of how to manage our own body boundaries and how adolescents and young adults are managing theirs. It's obvious that the growth of amateur sex tapes has been inspired or encouraged by the mainstreaming of professional pornography. Anyone who encounters such imagery, or contemplates creating it him- or herself, should be aware that the people who create pornography tend to have been exploited as children and often sexually abused, badly damaging their sense of personal or body boundaries. When society accepts a phenomenon like amateur pornography as normal, it opens the door for young people everywhere, whether or not they have genuinely high narcissistic traits, to mirror the behavior. That is a dangerous trend: Frequent exposure to pornographic or salacious material from a young age can alter one's sense of physical intimacy and may compel previously healthy people to indulge in behavior usually exhibited by people with serious emotional disorders.

■ ■ ■

As fame has become increasingly democratized, it's also become an end in itself. There are so many ways to pursue celebrity today that the simple desire to become famous seems to have replaced

the drives for power and wealth. Tom La Grua, an actor and executive of the Screen Actors Guild (SAG), told us that the main purpose of SAG is to negotiate fair wages and working conditions for performers in order to protect them from employers who would take advantage of them if the protections of the guild were not in place. The other side of that coin is that those minimums and working conditions protect members from themselves. According to La Grua, too many actors are tempted to work for less than the guild's minimums or for free if not for his organization's efforts to require that they are fairly compensated for their work.

Of course, there's nothing new about everyday people wishing they could live out their rock-star fantasies. The economic boom of the 1980s and '90s poured an extraordinary amount of wealth into the economy, and suddenly the life, or at least some of the trappings, of celebrity seemed almost within reach to the upper-middle class. More people became outright rich. And more of the rich displayed staggering levels of entitlement. This is the culture that gave us *My Super Sweet 16* and *Gastineau Girls* and the *Real Housewives* franchise, which now tracks the narcissistic exploits of underemployed wives in Orange County, California; New York City, and Atlanta.

For younger Americans today, however, research suggests that just being rich isn't enough. In a survey conducted by the Pew Research Center, 51 percent of 18-to-25-year-olds said that becoming famous was their generation's most important, or second most important, life goal. In our modern culture of increasing narcissism, celebrity seems poised to surpass wealth as the new standard of success. One reality TV producer we've spoken with, who has been working with teens since the early 1990s, has seen them grow increasingly savvy about their pursuit of fame. "These kids, they

know," she says. "They are so on it. If I had to give someone particular direction on how to react [on camera] ten years ago, they would have done something that felt uncomfortable and staged. But today, I think the kids all study reality [TV] to learn. They know who the best-known reality stars are and what they do. There's definitely mimicking. They know how to become a particular type of character in a scene. Ironically, as a reality show producer, my job has gotten so much easier, because now, the kids know how to act."

The data from our celebrity NPI scores, and our additional surveys, confirmed our theory that a need for attention was a driving factor in seeking fame. Was it the dominating factor? We wanted to know if celebrities would acknowledge which mattered more to them: fame or money. So, in surveying the celebrities who completed the NPI for us, we also asked them to evaluate two simple statements. On a scale of 1 to 5 (with 1 indicating strongly disagree, 2 indicating disagree, 3 meaning neutral, 4 meaning agree, and 5 indicating strongly agree), we asked celebrities to respond to the statement "I am in entertainment to become wealthy." Their average score was 1.92. We then asked them a similar question regarding fame. Their average score was 3.32. The result was clear: Celebrities may be motivated by wealth, but their hunger for fame apparently dominates their desire for money.

In a survey for his book on Americans and fame, *Fame Junkies*, Jake Halpern asked sixth to tenth graders in the New York area what famous person they would most like to meet. The results were predictable: 17.4 percent would choose to have dinner with Jennifer Lopez, and 15.8 percent with Paris Hilton or 50 Cent (a tie), as opposed to 3.7 percent for Albert Einstein or 2.7 percent for George W. Bush. 16.8 percent of those surveyed did choose the

opportunity to meet Jesus Christ, slightly less desirable than a date with JLo, but slightly more so than a night out with Paris or 50 Cent.

It's this generation of young adults, 75 million strong, that is already redefining celebrity in our time. These young men and women do have some tremendous advantages over previous generations; among other things, they are the first truly technologically savvy generation, with access to extraordinary online resources and the know-how to take advantage of them. But those virtues come with a cost. The attention spans of these millennial kids have been curbed by text-messaging, video games, and the instant gratification of the Internet. They are growing up with the highest rates of divorce, of drug and alcohol abuse, and sexually transmitted diseases in our history. And the permissive, overpraising atmosphere in which their boomer parents raised them has led them to exhibit an extreme degree of entitlement and a high incidence of narcissistic traits.

The business of fame has risen to the task. The massive entertainment economy exists to reward and exploit the celebrities—an economy that includes media conglomerates, clothing manufacturers, concert promoters, and all manner of licensees. These interlinked industries join forces to brand celebrities, often starting at a very young age; think Hannah Montana, the Jonas Brothers, even Britney Spears. Their goal is to hook impressionable young consumers on these brands earlier than ever before, creating an intense personal connection between celebrity and fan, locking in a loyal audience for years to come. Entertainment companies like Disney and Nickelodeon work constantly to ensure that the 26 million children between the ages of nine and fourteen, with an estimated spending power of between $39 and $59 billion, are devoted not just to their shows, but to their show's stars.

One key reason for the explosion of celebrity reporting today is the steady consolidation of the mass media. Vertically integrated conglomerates such as Time Warner, Viacom, Inc., and News Corporation control motion picture studios, television networks, cable stations, newspaper companies, magazine and book publishers, and social networking Web sites. News Corporation, for example, owns 20th Century Fox, Fox Television, Direct TV, *TV Guide*, the *New York Post*, HarperCollins Publishers (the publisher of this book), and MySpace.com. Time Warner owns Warner Bros. Studios, the CW Network (jointly with CBS Corp.), CNN, HBO, *Entertainment Weekly*, *People*, AOL, TMZ.com, and, until recently, Time Warner Cable.

Each of these conglomerates not only produces content, but also owns the channels of distribution. Having multiple platforms and distribution channels allows for faster information sharing and dissemination. Such large corporations also demand that each unit posts ever-greater profitability and returns for their shareholders. Hence the popularity of celebrity news: Not only is it incredibly cheap to produce, it's a reliable ratings winner, pulls in advertising dollars, and thus increases profitability, even as it helps to promote other businesses under the same corporate umbrella. In the past twenty years, the broadcast and cable networks who supply coverage of politics and international news have slashed that coverage and replaced it with less expensive, more profitable entertainment news. This is perfect for consumers of celebrity news, who are less interested in having their horizons challenged by the messy entanglements of real news about important world events than they are in the spectacle of the idealized world in which all their hopes and dreams reside.

Whenever you choose the entertainment media's offer of escapism cloaked as "news," you do so at the expense of a real con-

nection with humankind. You're anaesthetizing yourself, while reinforcing and amplifying your latent narcissistic traits. You're abdicating your interest in the world and surrendering to the false image of the world as you wish it to be. Even when the high-drama 2008 presidential campaign caught the entertainment media's attention, magazines and shows like *Entertainment Tonight* and *The Insider* ran with stories about the candidates' wardrobes, families, and secrets for looking good on the campaign trail. As far as the entertainment media was concerned, the candidates had transcended politics and become bona fide celebrities. Janice Min, the editor of *US Weekly*, confirmed as much to the *New York Times*: "When you look at the great celebrity dramas of the past few years you have Team Aniston, Team Jolie, Team Heidi and Team Lauren. And now we have Team Hillary and Team Barack."

Her message is inescapable: Politics may be boring, but celebrity sells.

■ ■ ■

The explosion of celebrity news reporting has obscured another important distinction—the line between being famous and being infamous. It's not that society in general can't tell the difference between good and bad people. It's that the outcome—everyone knowing your name—is the same. Notoriety has taken its place alongside legitimate achievement as a measure of fame, and visibility has become synonymous with celebrity.

Robert Hawkins, a nineteen-year-old student who perpetrated the worst massacre in Nebraska history, killing nine people and then himself in a department store in an Omaha mall, knew this explicitly. In a suicide note he left for family and friends, he wrote: "I've been a piece of [expletive] my entire life it seems this is my only option. I know everyone will remember me as some sort of

monster. . . . I want my friends to remember all the good times we had together. Just think tho I'm gonna be [expletive] famous."

Hawkins wasn't the first disturbed young man to choose violent crime as a path to fame. In the days before they launched the bloody Columbine attack, teenagers Dylan Klebold and Eric Harris filmed themselves making final preparations. "Directors will be fighting over this story," Klebold told Harris. They even debated whether Steven Spielberg or Quentin Tarantino would be the right choice.

Nearly twenty years earlier, John Hinckley's obsession with Jodie Foster drove him to attempt to assassinate Ronald Reagan, in hope that the act would somehow bring Hinckley and Foster together. Hinckley, too, viewed his actions in terms of their media potential: When he was apprehended, Hinckley asked the arresting officers if his story would preempt that night's Academy Awards broadcast.

Hinckley's remarks in a *Newsweek* interview in 1981 serve as a prophetic warning about the seductive effect of celebrity culture on a vulnerable audience: "The line dividing life and art can be invisible. After seeing enough hypnotizing movies and reading enough magical books, a fantasy life develops which can either be harmless or quite dangerous."

■ ■ ■

As we've seen, these days the media often counters that pure-fantasy element of their celebrity coverage with the flattering come-on that celebrities are "just like us." The college students we interviewed related to stories of the celebrities' everyday worries, which reminded them of their own: *Can my relationship work? Am I sexy enough? Thin enough?* The more mundane the stories are, the easier it is for real people to suspend disbelief and buy into this

questionable image of the celebrity as real person. Better yet, in the tabloid versions, celebrities always seem to find solutions to their problems, or at least manage to slip by without paying for their mistakes.

The Mirror Effect plays havoc with that comparison, because celebrity solutions can lead to nothing but trouble in the real world. Look at how celebrities generally solve their problems: *Marriage on the rocks?* Have a tropical affair with another woman. *Heartbroken over a lost love?* Throw yourself into anonymous sex. *Not getting what you want?* Throw a tantrum. *Not thin enough?* Get plastic surgery, or go on starvation diets, or use drugs—prescription or illegal—to lose weight. In theory, of course, society still disapproves of such measures, but that rings hollow when celebrities regularly disregard social boundaries in ways that would have been unthinkable twenty years ago.

This is the most pernicious aspect of the Mirror Effect: the normalizing of unhealthy behaviors, as the vulnerable audience is seduced into believing that these narcissism-induced "solutions" glorified by celebrity behavior—sex, alcohol, drugs, uncontrolled rage—can help them with their own emotional issues. I've been especially troubled by how many young women I've seen adopting these celebrity-inspired strategies to keep their boyfriends happy: do drugs, have a threesome, make a sex tape. These are options our celebrity culture has put on the menu, and too many young people are coming to see them as viable.

Celebrity abuse of drugs and alcohol has glamorized the sickness of addiction. It's hard to think of a more abject example than Amy Winehouse, the talented but desperately sick British singer, whose struggles with addiction have played out in the public sphere for the past several years. Most mainstream stars at least attempt to combat public coverage of their substance abuse, and the media

has traditionally been willing to play along, but Winehouse blew right past such discretion with her breakout hit, "Rehab." With its unforgettable refrain, "They tried to make me go to rehab—I said no, no, no," "Rehab" was a narcissist's cry of defiance, and a troubling one, especially when it became clear how many teen and even preteen girls were singing along without quite knowing what they were saying. And yet: when a recent UK poll asked people under twenty-five to name their hero and heroine, Winehouse came in at number one. Singer Pete Doherty, more famous now for being an avowed junkie than for his music, ranked number two among the so-called heroes of British youth.

The millennial generation gets much of its celebrity coverage on the Internet, and reporting, rumors, and commentary on celebrity drug use is far more explicit there than it ever was in the broadcast media. Sites like Gawker openly referred to drug use among the Paris-Nicole-Lindsay crowd long before their arrests made such talk fair game in the glossy magazines or on TV. Web sites like wasted celebrity.com now offer regular updates on celebrity DUI and drug-related arrests and links to photos and videos of celebrities apparently taking drugs. And in rock 'n' roll and hip-hop culture, where drug use has always been more open, there are few secrets left: Snoop Dogg is just one of the many rap artists who are open about their marijuana use, and stars like Lil Wayne talk casually about cocaine and more. ("I don't do too many [drugs]," Wayne recently told *Blender*. "I just smoke weed and drink. But I'll never fuck with no more coke. It's not about the bad high; it's just about the acne: Cocaine makes your face break out. I'm a pretty boy.")

Results from the Department of Health and Human Services National Survey on Drug Use for 2007 show that an estimated 19.9 million Americans aged twelve or older were using illicit drugs like marijuana, cocaine, crack, heroin, hallucinogens, and inhalants, as

well as nonmedical use of prescription-type pain relievers (such as OxyContin or Vicodin), tranquilizers, stimulants (such as methamphetamines), and sedatives. Nearly 2.1 million teenagers (from ages twelve to seventeen) account for 9.5 percent of that total.

The frightening statistics continue. Twelve- and thirteen-year-olds reported the highest nonmedical use of prescription-type drugs, followed by inhalants and then marijuana. Among fourteen- and fifteen-year-olds, marijuana was the most commonly used drug, followed by prescription-type drugs, and then inhalants. Marijuana was also the most commonly used drug among sixteen- and seventeen-year-olds, followed by prescription-type drugs, and then hallucinogens, inhalants, and cocaine. The average age of the first-time heroin user is twenty-one, while most ecstasy users had tried the drug before they were eighteen.

Slightly more than half of all Americans aged twelve or older reported drinking alcohol, which translates to an estimated 126.8 million people. Twelve- to thirteen-year-olds account for 3.5 percent of all alcohol users; fourteen- to fifteen-year-olds account for 14.7 percent; sixteen- to seventeen-year-olds make up 29.0 percent of the total, and nearly 51 percent of all eighteen- to twenty-year-olds use alcohol. Each day, 12,500 people over the age of twelve try alcohol for the first time. More than 85 percent of these first-time users are younger than the legal drinking age of twenty-one, and the average age for first-time alcohol users is sixteen years old.

■ ■ ■

When such obviously distressing behavior is presented to us as entertainment, we have a choice as to how to react. Some turn away in distress or disbelief. Many others are seduced by the compelling or dramatic nature of the stories, and keep tuning in. Whether we find the behavior attractive or not, though, most of us

have no compunction about dissecting the troubles of the decompensating celebrity du jour with our friends.

Recent research shows that men today spend about as much time gossiping as women, but that women tend to gossip about other women rather than share information about their own lives. Research also shows that women, like all female primates, tend to be exceedingly competitive with one another. They spend a good deal of time observing, sizing up, and jockeying for position with other females. The primary consumers of tabloids documenting the exploits of these beautiful young women are, in fact, women. As the *New York Times* has reported, the readership of *US Weekly* is 70 percent female; for *People* it's more than 90 percent. And what women want to read about is other women, so much so that these female-oriented magazines rarely if ever put men on their covers. As *US Weekly* editor-in-chief Janice Min says, "Women don't want to read about men unless it's through another woman: a marriage, a baby, a breakup."

When we asked people why they follow the celebrity soap opera, they consistently offer the same reasons. "It's just for fun," they say. "It's entertainment." Some are defensive about their taste for celebrity gossip: "I don't actually *buy* the stuff! I just look at it when I'm on line in the supermarket, or at the dentist's office," or "I just check People.com or Gawker when I'm taking a break at work." When we press them further many finally admit that they don't know *why* they can't resist: "I just keep doing it"; "It's just so compulsive—I feel a little guilty." What's interesting is that much the same excuses are given by people who are locked in a cycle of destructive behavior driven by repetition compulsion. People afflicted with repetition compulsion unconsciously seek out and reenact traumatic events in the hope of healing a childhood wound. However, instead of repairing the wrong, they are repeatedly reinjured as they continuously

experience the same behavior they were trying to rectify. The damaging cycles of acting out exhibited by true narcissists are usually the expression of this repetition compulsion.

When today's audience embraces the idea of getting to know celebrities through following their melodramatic problems—they drink too much, they're aggressive, even violent, they have bad relationships—they're generally using this false sense of relationship either to validate their own similar issues or as an excuse to indulge their own sense of superiority. Unfortunately, neither of these responses fully assuages the intense envy that can be triggered by the spectacle of celebrity. The audience *wants* to believe that the rich and famous can be just as miserable as they are. Yet, at the same time, they want to believe in the possibility that any one of them could become as famous as those they watch. Whenever a star gets in trouble, the public eagerly waits to see if he or she will self-destruct and become a cautionary tale, like Anna Nicole Smith, or find a way to turn it around and deliver a satisfying redemption story. Then, as if they've reached the end of a vaguely diverting movie, they casually move on to the next arousing story, with little or no sense that a human being's life may hang in the balance.

When it comes to celebrity gossip, it seems as though more and more consumers are in the grip of a mild repetition compulsion. This affliction often affects viewers who lead challenging yet entitled lives, who identify with celebrity narcissistic behavior because it resonates with their own narcissistic traits. Such people follow the celebrities' seemingly perfect lives in hopes of someday living similar lives themselves. When reality intrudes on their fantasy, and the perfect people beyond the looking glass disappoint them by suffering the same petty problems we all do, they react aggressively, often taking a perverse pleasure in the downfall of the very people they once idealized. And, to complicate matters fur-

ther, because these viewers never will have a satisfying emotional connection with these celebrities, they'll never be able to break the psychological cycle without some kind of intervention or recognition on their own part.

This process plays out quite vividly on the comment boards on Internet gossip sites, which allow readers to share the same stage as those they're trying to become. These boards are a potent incubator for narcissistic envy, and the tenor of the comments posted there show clearly how aggressive and, often, hate-filled these reactions can be. Many of the comments are exceedingly cruel or obscene, taking a gratuitous glee in deriding young women as "bitches" or "sluts," excoriating them for their affairs or addictions. When a new round of rumors about Amy Winehouse's drug use surfaced on one site recently, one commenter sniped "As long as the creep OVER-DOSES a.s.a.p." When *Forbes* published a list of popular celebrities (as measured by their magazine cover sales), one "fan" responded: "Eww . . . Why is Heidi Montag on the list? She is such a nobody. I can't stand that little biotch—is her 15 minutes of fame up yet???" Another took a broader view: "I always buy a tabloid if the following ppl are on the cover[:] Britney Spears, Paris Hilton, Tara Reid, Jessica Simpson, Nicole Richie, MK Olsen. I like reading about those women, cause they are so f***ed up and entertaining."

Such rhetoric is troubling, but it doesn't surprise me. What it represents is one of the most primitive, and enduring, mechanisms in human nature: When people join together to gossip about an individual or group, they are collaborating in an effort to make themselves feel better about their own lives. However, they are also expressing a deep-seated aggression—a response that's triggered by narcissistic envy.

■ ■ ■

In psychological terms, there is an important difference between envy and jealousy. Jealousy can be a mobilizing force: *I want what you have, and I'm going to figure out how to get it.* Envy, on the other hand, involves direct aggression: *I want what you have, and it makes me feel bad. So I'm going to take it from you, or at least knock you down to my size.* Envy, thus, is far more toxic than simple jealousy. Psychologist Elsa Ronningstam, who has spent more than two decades studying and treating narcissists, drives this point home eloquently in her book *Understanding and Identifying the Narcissistic Personality:*

> *Envy-prone people who experience goodness in another person feel the goodness to be painfully insufficient and resent both their own dependency upon the other and the other's control over the goodness. Envy is defined as hatred directed toward good objects. Compared to "regular" hatred, in which the good object is protected [and] the bad object is attacked, in hatred with primitive envy another's goodness is experienced as a threat to the person's own grandiosity or idealized self-experience, and the goodness is destroyed. In other words, by attacking the good object, the person is trying to ward off feelings of pain, vulnerability, dependency, and defectiveness that are evoked by recognizing the threatening goodness in another person. Envy can destroy the possibility for hope and diminish capacity for enjoyment.*

This is the most destructive force unleashed by the Mirror Effect: the envious, often hate-filled aggression that's triggered when our idealized images disappoint us, forcing us to confront our own narcissistic tendencies. Rather than deal with the shame we feel concerning our own narcissistic traits, we strike out at the reflections in the mirror, intent on tearing them down to avoid confronting our own weaknesses.

Narcissism and Envy, Sacrifice and Redemption

TEEN SINGING SENSATION BRITNEY SPEARS TO CHAT
WITH FANS ON ABC.COM
——*Business Wire, August 31, 1999*

SEVEN DAYS IN MAY: BRITNEY SPEARS DOES IT AGAIN!
——*Salon.com, May 25, 2000*

BRITNEY SPEARS DEATH RUMOR TRAVELS AROUND
THE WORLD
——*CNN.com, June 13, 2001*

BRITNEY SPEARS, JUSTIN TIMBERLAKE CALL IT QUITS
——*Buzzle.net, March 28, 2002*

BRITNEY WOULD NOT KISS ANOTHER WOMAN
BESIDES MADONNA
——*CNN.com, September 3, 2003*

BRITNEY SPEARS MARRIAGE ANNULLED
——*CNN.com, January 5, 2004*

BRITNEY GIVES BIRTH TO BABY BOY
——*CNN.com, September 15, 2005*

BRITNEY DIVORCES KEVIN FEDERLINE
——*MSNBC.com, November 6, 2006*

BRITNEY'S CROTCH SHOT TAKES WEB BY STORM
——*Associated Press, November 11, 2006*

BRITNEY'S BALD HEAD: CRY FOR HELP?
——*MSNBC.com, February 20, 2007*

BRITNEY SPEARS ATTACKS AN SUV WITH AN UMBRELLA OUTSIDE
KEVIN FEDERLINE'S HOME
——*Hollywoodgrind.com, February 22, 2007*

WAS BRITNEY'S HAIR FULL OF DRUGS?
——*Slate.com, February 23, 2007*

BRITNEY SPEARS COMEBACK A BUST AT VMAS
——*People.com, September 9, 2007*

BRITNEY LOSES CUSTODY OF KIDS
——*MSNBC.com, October 1, 2007*

BRITNEY'S TWISTED CHILDHOOD
——*US Weekly, December 3, 2007*

BRITNEY SPEARS DATING PAPARAZZO AFTER
CRAZY ONE-NIGHT STAND
——*Starpulse.com, December 24, 2007*

TIMELINE: BRITNEY'S POST-DEPOSITION MELTDOWN
PHOTOS: BRITNEY SPEARS: INSIDE THE AMBULANCE
——*People.com, January 4, 2008*

WEB SITE ASKS PEOPLE TO PREDICT BRITNEY'S DEATH
——*Hollywood.com, January 14, 2008*

THE AP HAS WRITTEN BRITNEY SPEARS' OBITUARY
——*USMagazine.com, January 17, 2008*

AT THE MTV VIDEO MUSIC AWARDS, A BIG DRAW, A PUNCH LINE
AND, NOW, A WINNER
——*New York Times, September 8, 2008*

The impulse to tear down those we envy, and to share the responsibility with a group, is an ancient response to a primitive emotion. No other feeling is as potentially damaging, to both ourselves and others, as envy, and the Mirror Effect has an extraordinary power to provoke the kind of primal, subconscious envy that easily transforms into aggression. Whenever we elevate a person, or group, to an idealized position in society, they're at risk of becoming a lightning rod for envy and a target for the aggression that inevitably

follows. This tendency to trigger malignant envy and aggression may be the most damaging effect of our preoccupation with celebrity.

History is full of moments when rampant envy and aggression have affected the course of human events; at times it has even brought down entire social orders. For years, I have been comparing our celebrity-obsessed society to the aristocracy and court of Louis XV in prerevolutionary France (an analogy Sofia Coppola brings to life beautifully in her Oscar-winning 2006 film *Marie Antoinette*). I've taken some ribbing from friends over the comparison, but the similarities are too striking to ignore.

The levels of narcissism, to my eye, are parallel to the levels we see today. Childhood trauma was rampant in eighteenth-century France. A glimpse at Jean-Jacques Rousseau's *Confessions* provides an interesting window into the dynamics of his day. While Rousseau is championed as the philosophical genius who conceived the idea of the social contract, and the idea that man lived a life of pure goodness in nature before being corrupted by the chains of society, the writer himself sent five of his children to orphanages without a second thought. And without apparent empathy for their mother, who was expected merely to comply. His life is testament to how severe narcissism follows on the heels of childhood trauma creating a cycle wherein the pain of one generation is the legacy of the next.

Marie Antoinette was the very model of a self-indulgent socialite. In her court, the pain of childhood traumas, empty emotional lives, and sexual dysfunction was subverted to fashion, parties, and gossip. The court set an aspirational example for the citizens of France and much of Europe, but a constant roil of envy among the people kept the aristocrats constantly on guard. At any hint of perceived public criticism, the aristocrats would order arrest and

punishment. And the mob would constantly shift their favor, turning envy to aggression, and aggression to sacrifice, to punish those who disappointed them.

Human society has survived in part because of our innate drive to perpetuate our species, which is one of the most powerful instincts we have. This instinct is deeply connected to the part of the brain that helps regulate human emotion, and underpins our capacity for empathy and altruism. Our psyche also contains the potential for a force that's directly opposed to empathy and altruism, and that is sacrifice. Though most modern human beings recoil from the idea, many primitive human civilizations used some form of sacrifice to respond to, and protect themselves from, a fearsome environment. The notion of sacrificing something of great value in order to win favor with the gods was widely accepted. Once a sacrifice was made, morale improved, and the group that had just engaged in an act of destruction could now renew itself.

While we have evolved to the point at which altruistic instinct wins out over sacrifice, the sacrificial urge still lingers in the human psyche, a residual, perhaps, of our primate heritage, where behaviors such as infanticide still lurk, defying our evolutionary instinct to preserve our species. René Girard has suggested that the sacrificial impulse can have deep psychological significance for a cohesive social group, offering them a means of expressing their aggressive impulses while bonding with other members of the group in opposition to the victim. This mechanism, he argues, allows societies to focus and contain their aggressive impulses so that they may otherwise live together in harmony. The emotional release the group experiences through the sacrifice helps them to keep any further violence against other group members under control.

Today, we stop short of stoning our sacrificial victims to death,

but not by much. Our contemporary media machine affords us other, subtler, but perhaps equally satisfying ways of playing out our envy and aggression against our idols. First, we lift them out of obscurity, showering them with worship, installing them as demigods. Then, the minute they reach the celebrity firmament, we reverse the process: We watch their every move, looking for flaws in their beauty, talent, character, or behavior, and when, inevitably, we find them, we start tearing them down again, reducing them to human, flawed, addicted, washed-up, or tragic figures worthy of either pity or contempt.

When it comes to tearing down celebrities, our culture appears especially eager to choose female targets. When actors like Keifer Sutherland or David Hasselhoff suffer public bouts with alcohol abuse, their stories may make the news for a day or two, but their careers continue with little interruption. When Lindsay Lohan is photographed passed out in the back seat of a car, we chase the story like a pack of coyotes. Historically, such moments of perceived public betrayal tend to trigger aggressive responses among women who have no other outlet for diffusing or redirecting the impulse, and that aggression can result in unpleasantness. The Aztecs reserved a particularly gruesome ritual of sacrifice for their highly cherished females: In a bid to please the fertility gods, thus ensuring the fruitfulness of the land and the people, they sacrificed a beautiful woman by flaying her and allowing chosen citizens throughout the kingdom to wear her skin. Today's women may prefer to wear her Manolos, but the concept is the same: When the female celebrity disappoints us, or strays too far from the rules of the clique, society rears up and exacts its punishment upon her.

There are many forces at work here. Female sexuality has been a central preoccupation throughout history, and the current scapegoating of female celebrities may be an attempt to contain female

sexuality by acting out our societal aggression against a few representative women, making them cautionary tales for women as a whole. It is interesting to note that the celebrities at greatest risk of being torn down are beautiful young women who present themselves as sexual objects—treacherous territory for women in our society.

There is no clearer example of this envy/aggression, sacrifice/redemption dimension of the Mirror Effect than Britney Spears's transformation from adorable Mouseketeer to sexed-up teen pop idol to reviled drug addict and unfit mother. From the moment her debut album, . . . *Baby One More Time*, topped the charts in 1999, Britney's story has been chronicled in a decade's worth of headlines like those listed earlier. And the most trenchant commentary on her apotheosis came from an unlikely source: the animated series *South Park*.

In a 2008 episode titled "Britney's New Look," *South Park* creators Trey Parker and Matt Stone offered an unflinching portrait of the cruelty of our popular culture and a dark vision of our collective role in attempting to destroy another human being who had disappointed us. The episode is a brilliant tracing of the narcissistic frenzy of a crowd's response to celebrity, from adoration, to envy, to heightened aggression, and ultimately, to a modern-day equivalent of ritual sacrifice.

As the episode opens, a beleaguered Britney is trying to escape from the paparazzi by camping out in the woods of Colorado. When the *South Park* gang hears that a man was paid $100,000 for a photo of Britney urinating on an insect, they set out to make some money by getting their own photo. Posing as Britney's kids, they talk their way into her hotel room with cameras poised, only to find a depressed Britney at the end of her rope. When she finds out that she's not actually going to see her kids, she feels so be-

trayed that she places a shotgun into her mouth and pulls the trigger, blowing off the top of her head.

Flash forward to the MTV Video Music Awards, where a still-headless Britney is performing a new comeback song. She is lifeless, unable to form words, and no one seems to notice that she only has half a head. Instead the reviews are merciless: Britney looks "tired" and "fat," her performance is "phoned in," and what's with her whole "crazy-no-top-of-the-head look"? Kyle empathetically concludes that people are just "not going to let up" on Britney and decides to abscond with her by train to the North Pole.

The paparazzi are hot on their trail, so as Stan gets Britney on the train, Kyle dons a blond wig and leads them astray. The paparazzi think they've cornered Brit, but Kyle reveals himself, telling the paparazzi it's time to "Let this one go." One photographer steps forward and urgently explains that "Britney must die. . . . What do you think all of this is for? The purpose is too great. Britney was chosen a long time ago, to be built up and adored and then sacrificed—for Harvest." The paparazzi begin to chant in unison.

Meanwhile, ahead of the train, the townsfolk and paparazzi gather anxiously at the station, repeating that Britney needs to die, just as in earlier times when a young girl was sacrificed for the good of the harvest. Of course, the paparazzi patiently explain, we are now too civilized to stone our victims to death. Instead the sacrificial method we choose is to kill people "through magazines and photos."

When Britney and the boys get off the train, they're engulfed by hundreds of people brandishing cameras. Stan and Kyle are handed cameras as the crowd moves in, snapping endless photos of Britney, until she falls to the ground and dies in a fusillade of flashes.

In the final scene, the residents of South Park remark how good the corn harvest has been for the year. On a nearby television screen a photo of Miley Cyrus as Hannah Montana appears, accompanying a story hailing her as the next young superstar. The crowd at the market begins to chant anew . . . and the boys, not really comprehending what is happening, join in.

"Britney's New Look" is a vulgarian gloss on Shirley Jackson's well-known 1948 short story "The Lottery," which depicts a society that sacrifices a person each year. It's a theme that's shown real staying power in our culture, recurring in fiction and film (variations include Thomas Tryon's novel *Harvest Home*, Stephen King's short story "Children of the Corn," and the horror film *The Wicker Man*). But the modern spectacle of celebrity sacrifice has given it a painful new resonance.

■ ■ ■

This constant, communal preoccupation with our celebrity idols creates a disorienting cocktail of emotions among viewers with heightened narcissistic traits. When their behavior triggers our aggression, we feel an urge to unseat or co-opt them. But that usually proves impossible, thus heightening our feelings of inferiority. When these viewers feel disappointed with the celebrities they follow, when they conclude that the stars have somehow failed to meet their idealized needs, they are exposed to the shame and emptiness that lurk beneath their grandiose defenses. When their defenses against these feelings fail, their envy morphs into aggression, which is the basis for the urge to sacrifice. And that is the urge that transforms a group of angry individuals into a mob. This scenario is reenacted time and again as celebrities are created and destroyed at the whim of a narcissistic public. The behavior may

seem like a matter of innocent gossip, but its effects, on not just the celebrity victim, but the attacking group itself, are corrosive.

How conscious are we, as a society, of these effects? After "Britney's New Look" aired, fans and bloggers squared off about the meaning of Parker and Stone's allegory. The opinions ran the gamut, but most of the comments posted online were negative. Some found the episode disappointing, or not funny enough. And many thought it failed to cast the blame for Britney's demise where they felt it belonged: on Britney herself.

> *I thought it [the episode] took too sympathetic a view of Britney . . . the show seemed to take any blame away from Britney herself. Britney keeps making headlines for doing increasingly stupid things. South Park instead made her seem normal. Sure, you can say that they were making the point that she was normal before the media made her lose most of her brain, but I'm not convinced that's correct, and if that's their point they could have had brainless Britney doing stupid things. . . .*

> *I thought this was a pretty bad and un-funny episode up until the last seven minutes, which were hilarious. Still, not a very good episode in my opinion. And I highly disagree with any message Stan and Kyle were trying to spread, Britney's getting what she deserves.*

Some in the media felt the same way about Britney's fall from grace. In a November 2007 *Rolling Stone* interview, Perez Hilton exposed his own feelings of anger and betrayal: "I used to be the biggest Britney fan. Unlike the Nicole Richies or whoever, she really is talented. In her prime, she could sell it like no other. Then

to see everything that's happened, I feel lied to and cheated, like that girl I used to know and love wasn't the real deal. It was all an act. And this is the real Britney. And the real Britney is stupid. Like stupid stupid. A dumb, druggie, awful bitch."

Perez's remarks capture perfectly the trajectory of the narcissistic response to celebrity: fall in love; develop the sense that you actually have a relationship with the star; then, when the star disappoints you, react with anger and aggression and a profound sense of rejection. *She has brought all this trouble on herself,* we think. *She's rich and (more important) famous; she can do anything she wants. So why has she made so many bad choices? How could she let herself go this way? We'd give anything to be in her position and yet she's throwing it all away. We would never do that if we were as famous as she was. What happened to the goddess we used to adore? She's let us down. We're done with her. She's no longer satisfying our (narcissistic) needs; she's not keeping up her end of our bargain. We won't get fooled again. We're moving on. Who's next?*

And yet there were some sympathetic voices in the online chatter about "Britney's New Look":

> We all saw this one coming, an episode dealing with Brittany [sic] Spears. However, what most of us didn't expect was how Matt and Trey would portray Brittany. Instead of taking the obvious route and making Brittany out to be stupid, selfish, and the cause of all her problems, Matt and Trey made Brittany the victim. It showed the media and us, as the problem. The message of the episode was clear, we concentrate on the wrong things. While Brittany is being wheeled into the hospital, all the media can focus on is a scar under her breast from plastic surgery. . . . Society needs to realize that celebrities are people just like you and I. They have feelings and should be treated as such. For the first time ever, I actually

felt sorry for Brittany, she doesn't deserve the things that happen to her and most likely was pushed into this lifestyle by her parents. . . . This episode taught us a lesson, but in the South Park tradition.

Wow, it seems a lot of people totally missed the point of the episode. It was about how sick Americans and the paparazzi are for getting off on destroying celebrities. It seems that everyone who said this episode was the worst ever are the people being satirized. I loved this episode, and thought it was very on point and had a very important message.

But seriously, this episode basically mirrored the perverseness of reality. Normally, celebs on the show are made fun of mercilessly, but here the whole episode was about how cruel the world is TO Britney. It's a really upsetting episode, because the media depiction is so accurate. The obsession with Britney is beyond inhuman, it's barbaric. The show really hit the nail on the head.

As these comments demonstrate, there are still voices of empathy out there—an encouraging sign and, with luck, signs of a trend toward a more enlightened view. The truth is that Britney Spears, the human being, not the *South Park* character, suffered from life-threatening mental illness. When her condition eventually reached crisis levels in January 2008, she was placed on a 5150 forty-eight-hour hold against her will, a status reserved for only the most unstable patients in a psychiatric hospital. She may or may not suffer clinically from addiction, as well as apparent bipolar disorder, both dangerous conditions shared by millions of Americans. The *South Park* episode, which aired just a few months after her breakdown, should have been a catalyst for discussion of such conditions. Yet

there was no public outcry, no national conversation about the issues. Society as a whole simply gaped, shrugged, and moved on.

So who *is* responsible for the downward spiral of a star in free-fall? Certainly the behavior of the celebrities themselves plays an immediate role, but this behavior is often the result of addictions or other narcissistic dysfunctions an outside observer cannot hope to understand. What *is* true is that almost everyone who reads magazines, or watches TV, or surfs the Internet also plays a role in a saga like Britney's, with the media as equal co-conspirators. Having stoked the fires of her career, they feel justified in stomping them out when their creation threatens to burn out of control.

■ ■ ■

Traditionally, famous people come by their fame because of some exceptional quality—acting or musical talent, athletic prowess, wit, charm, or simple beauty. What about the average people who are cropping up more and more as fame objects these days? Are they as vulnerable to attacks from the outside world?

The answer is that these figures—the kinds of reality TV and Internet stars who topped our narcissistic-celebrity survey—are more powerfully driven to attain and preserve their fame than entertainers. We call these people *supernarcissists*, and they delight in putting themselves in our crosshairs, because for them being famous trumps every other motivator.

By all evidence, Heidi Montag and Spencer Pratt of MTV's *The Hills* are two such supernarcissists. They appear fully aware that there is no such thing as bad publicity, as long as the only thing you care about is getting noticed, and they're extremely calculating about what they say and do to provoke maximum attention. As Jason Gay reported in *Rolling Stone*:

The pair engender eye-scorching animosity on the Internet, but in their minds, at least we're paying attention. "Good girls are so vanilla," Heidi says. Spencer is routinely referred to as "the most hated man on television"—but he wears the title like a badge ("Who is that person they always compare me to, on Dallas?*" he asks).*

"It's jealousy, man," Spencer says. "It's human. I'm jealous of Jay-Z, Bill Gates, Rupert Murdoch. I feel for these people who wish they could be on reality television and not in their cubicles. You got to thank your haters."

"You have to understand, we have so many fans," Heidi says. "The haters are the ones who ask us for photos. The haters are the ones who are downloading songs." She looks out at the restaurant, which is packed. Don Antonio's has always been a popular joint, but since she and Spencer started eating here on The Hills, *it's getting crazy, she says. "The world works on haters now."*

The *haters* Montag refers to are a mixture of the jealous and the envious. The jealous folks are the one asking for photos and downloading their music; the envious are the ones who have now fully turned against the pair, and their aggression is rising daily. They are ready to serve up Heidi and Spencer as the next sacrifice.

The question is whether Heidi and Spencer have got their number. They certainly act like they do. When thousands of people are vying for what that couple has, managing an envious audience's animosity is a monumental task but, so far, the duo seem willing to play the role of the celebrities we love to hate. *US Weekly*'s Janice Min has reportedly signed a million-dollar deal for exclusive interviews with Montag and Pratt. Harvey Levin of TMZ recently told Kate Aurthur of the *Los Angeles Times* that the couple's disingenuousness only enhances their appeal. "They are so

lame, and so staged and canned, that it makes it almost entertaining and fun to poke fun at. The secret for them is that they get the joke. . . . We have done story after story poking fun at them, and in some cases just trashing them for their ridiculously staged conduct." And yet when Levin saw Heidi and Spencer at an event, to his astonishment, they came up and hugged him.

Despite the couple's narcissistic smugness, it's hard not to wonder whether the pair, who are still in their early twenties, really comprehend what a true fall from grace would be like. Their public comments suggest a profound naïveté beneath their sheen of savvy. "No celebrity does anything, really, unless you're a famous athlete who actually physically does something," Spencer Pratt says in Aurthur's article. "Like, how much work is reading lines from a script? We're improv TV personalities. That's *way* harder."

These young celebrities, reared in the mirrored glow of instant celebrity, seem eager to accept the pursuit of fame as their be-all and end-all. What remains to be seen is whether they understand its potential costs.

■ ■ ■

In his 1976 book, *The Selfish Gene*, ethnologist Richard Dawkins coined the term *meme* to denote a unit of cultural information that, by spreading from person to person, could influence cultural evolution. Dawkins's theory ignited lively discussion in the scientific community, and was picked up by scholars in other disciplines, from art and religion to war and political ideology.

The concept of the meme has taken on new power and currency, though, in the Internet era. So-called Internet memes are catchphrases, concepts, or personalities that spread rapidly online, like the "Dancing Baby" video on YouTube, or Chris Crocker's "Leave Britney Alone." Even though no person-to-person exchange

takes place in such cultural transmission, it's still a form of communication: A link is forwarded, an image registered, a comment left, a consensus formed. Large numbers of people are given the opportunity to form the same idea, without physically gathering or conversing directly. Just as primitive societies would create an almost involuntary cohesion around a specific message by using drums in a relay system, today the Internet shapes opinion, fosters support or discord, and offers users the chance to become part of a global in-group, especially when it comes to celebrity culture.

The Internet, together with reality TV and even the tabloid magazines, have an unprecedented power to promote negative groupthink by spreading insulting or degrading memes to a wide and hungry audience. These media aren't the source of the narcissism that is increasingly prevalent in society today, but they can amp up narcissistic aggression until it spirals out of control, leading to the modern equivalent of sacrifice.

Inherent in every human sacrifice is a striving for renewal. The Aztecs believed that sacrifice led to the sun's daily journey across the sky; primitive agricultural societies in Europe shed blood to bring about the next season of crops. Either way, sacrifice was understood as a generative mechanism for renewal for the good and safety of the whole. Today, it's difficult to accept that human beings could countenance such cruelty in the service of an abstract idea. But severe childhood trauma would have been nearly universal in such primitive societies, hampering the growth of the brain's anterior cingulate region and hindering the development of genuine empathy. When the altruistic centers of the brain are so severely compromised, there is little ability to monitor or control their aggression. As a result, there is a lowered threshold for acting out through human sacrifice and relatively little appreciation of

harm to others. A group who shared such conditions would experience little or no guilt over their behavior or even any real awareness that another person—with thoughts and feelings of their own—was harmed.

Today, thankfully, human beings are better equipped to understand the consequences of their actions. When individuals realize that, by becoming caught up in the emotions of a group, they may actually have affected the life of someone they had admired, they experience a sense of guilt and unease. One antidote to such discomfort is the possibility of redemption. Stories of resurrection abound in history: One might argue that this impulse was circulating in the late Roman Empire when one individual came forth to serve as a lightning rod for such urges.

Redemption stories can even occur in our fickle media culture. Robert Downey, Jr.'s triumphant return as *Iron Man* is a prime example. After years of highly erratic behavior, drug abuse, time in prison, and a long period of probation, the talented actor was fully redeemed by his critical and popular success in the movie, which grossed over $100 million in its opening weekend. Knowing firsthand how he had struggled with his early sobriety, it was gratifying to witness his success as I watched the movie. In a clear nod to Downey's own trials, the script was full of references to the weakness of the man who becomes Iron Man. After seeing the movie, I shared the backstory with one of the teenage kids who saw the movie along with us. "Wow, that's some comeback," he said.

At this writing, even Britney Spears seems on the road to renewal. In fall 2008, back under her parents' supervision, Britney captured three MTV Video Music Awards, an honor that had eluded her for years. But does redemption really sell? I'm an optimist, so I want to believe it does. Yet reality may not be so accommodating: When Owen Wilson attempted suicide in 2007, *People*'s

cover story was one of its best-selling issues. A follow-up story on his recovery, however, was one of the magazine's worst sellers.

When celebrities fail to oblige us with a magnificent resurrection—"dying too young," often in the grip of their own narcissistic demons—we often recast them as martyrs to the cult of celebrity and revise their life stories to fit the comforting, misleading conventions of mythology. We tell ourselves that Marilyn Monroe was a woman/child who died because of a Washington/Hollywood conspiracy, when in fact she was a mentally ill individual with an opiate addiction. We mourn Chris Farley as a funny fat guy who died of heart disease, when he was an addict who died from the effects of his opiate addiction. Heath Ledger died from an overdose of prescription drugs that he was taking without proper supervision. In all my experience with addicts, it is only in the setting of an addictive process that I have witnessed accidental overdoses of multiple prescriptions. I did not know Heath Ledger, or know if he was an addict, but the method of his death could have provided an opportunity to discuss a phenomenon that has suddenly become spectacularly common in a very short period of time. The tragedy of his death, if openly discussed, might have been an opportunity for increased awareness of the dangers of prescription drugs.

Modern society has come up with other, more ghoulish means of perpetuating our delusions of resurrecting departed heroes, and of connecting with those not yet dead. Madame Tussaud's wax museum has nine locations around the globe, allowing us the opportunity to bask in the illusion of celebrity. The Web site for Madame Tussaud's in Las Vegas promises "an emotionally-charged journey through the realms of the powerful and famous. . . . There are no body guards or velvet ropes here, you can get as close as you want to our stars! Rub shoulders with Hollywood's finest and challenge your favorite sports stars at their own game. Then meet the

kingpins of international politics and perform alongside your favorite pop stars." Though the star herself was unable to attend, the parents of Amy Winehouse recently unveiled her statue at the museum's London headquarters, calling it "the reward for her musical achievements and her talent."

■ ■ ■

Mob mentality is especially dangerous because of how swiftly it can overwhelm the better instincts of any group of people. Mobs are irrational; they function purely on momentum and the power of negative emotions. And they thrive when no other voices step forward to combat them or to offer alternatives.

Yet there are hopeful signs that individuals can be directed away from a mob mentality and toward kinder sentiments toward fellow humans. In Michael Addis and Jamie Kennedy's movie *Heckler*, Kennedy seeks out the anonymous bloggers and critics who generate cruel or offensive commentary about his movie performances and stand-up routines in order to ask them a simple question: Why?

In one scene, Kennedy sits down with a blogger named Kevin Carr, who had written a gratuitously cruel review of Kennedy's performance in the film *Son of the Mask*. As Carr squirms uncomfortably, Kennedy reads back the review: "Jim Carrey made the first film. Heck, he is the heart and soul of the film. But Kennedy is just irritating beyond words. He manages to wander through scenes like a wino on a bad night, and replaces dialogue with screams at the camera."

Looking Carr straight in the eye, he asks, "So why so harsh?"

Carr replies, "I have to tell you, I had a 104 fever that night . . ."

Clearly, there was no good reason for Carr to go after Kennedy

that way. But anonymous bloggers often rationalize envious cruelty as wit, especially when it's directed against the idealized celebrities who are enjoying an audience's attention, the same type of attention a writer or critic might crave.

We are all subject to deeply primitive impulses, and these can become exponentially more damaging when expressed through a group mentality. As our society becomes increasingly narcissistic and less connected, we're at an escalating risk of uniting under the banner of envy. Ultimately, it's incumbent upon each of us to learn to direct these impulses in a healthier way, as an expression of our shared cultural empathy, rather than allowing ourselves to become carried away in an act of mob sacrifice.

For healthy adults, turning away from the mob's rush to judgment shouldn't be difficult. For children and teenagers, however, the temptations can be far harder to resist.

Remember, when the mob turns on Miley Cyrus at the end of "Britney's New Look," the boys join in, even though they're not quite sure why they're doing it. When it comes to the Mirror Effect, young people are the most susceptible members of our society. It is to them that we now turn.

The Most Vulnerable Audience:
Teens and Young Adults

Whitney has graduated college and is dealing with the stress of her first real job and the drama of being newly single. Audrina is trying to handle her first real boyfriend ever but hitting the town every night with her single roommate Lauren won't make it easy. Heidi's trying to play house with Spencer and deal with the separation from her best friend Lauren, but when Spencer wants to take their relationship to the next level, who can Heidi turn to for advice? Lauren's had enough of being single and is looking for Mr. Right, but with new responsibilities at Teen Vogue, *a new roommate, and a boyfriend from her past back in her life, how will she ever find him? Lauren and Heidi haven't spoken at all since Heidi moved in with Spencer . . .*

Miley Cyrus stars as Hannah Montana, a teenager who lives a secret life as a pop star. Cyrus's real life dad, country crooner Billy Ray Cyrus, plays her dad and manager. Miley just moved from Tennessee as a country singer and now has to adapt to life in Malibu. The show includes original music recorded by its star, Miley.

■ ■ ■

Teens, tweens, and young adults are biologically, environmentally, and culturally predisposed to desire what celebrity promises:

wealth, special privileges, and unlimited attention. From the scripted reality of *The Hills* to the metareality of *Hannah Montana*, in which a pop singer plays a teenager who leads a secret life as a pop singer, these hit shows are as remarkable for their subtext of narcissism as they are for their pop-culture success. Between the two, they influence an impressionable audience of millions. In 2008, the spring season premiere of *The Hills* drew 3.9 million viewers. When *Hannah Montana* premiered in 2005, it drew an audience of 5 million viewers; it swiftly became the number-one cable show for kids ages six to fourteen, reaching 2.2 million viewers daily.

Both shows broadcast the same narcissistic message to their rabid fans: Anyone can be famous. *Hannah Montana* nurtures the pop-star fantasy of millions of little girls who dance in front of their bedroom mirrors or sing into pretend microphones. Adam Bonnet, senior vice president of original programming for the Disney Channel, explains Hannah Montana/Miley's allure: "She's a normal kid, but you have this incredibly aspirational hook for the show that the kids seem to love." Whether the "normal kid" he's referring to is the character of Hannah Montana, with her split personality and her enormous rotating closet hidden behind a secret door in her Malibu home, or the real-life Miley Cyrus, a fifteen-year-old who is on her way to becoming a billionaire, is unclear. In either case, encouraging the young viewer to aspire to what is decidedly *not* a normal kid's life amounts to a blatant invitation for her to surrender herself to her most highly narcissistic traits.

The Hills, on the other hand, is so addictive because the daily minidramas of the are-they-or-aren't-they-scripted lives of Heidi, Lauren, Audrina, and company mirror the kinds of arousal and chaos that many young adults crave in their own lives. Brian

Graden, president of entertainment for MTV, called *The Hills* "the most influential show we've ever had."

That both of these shows have such an iron grip on the attention of their target audiences is a testament to the seductive power of narcissism. These shows rely on fans forming a strong psychological attachment to the actors, and not simply in the context of the characters they play. The media fuels this illusion of intimacy with its nonstop, unblinking coverage of the stars, leading fans to feel the celebrities are as much their friends as their objects of desire or admiration.

This intense personal connection a fan feels for a celebrity is called a *parasocial relationship:* a voyeuristic one-way relationship in which one person knows a lot about another, but the other does not have the same knowledge. These relationships, actually, nonrelationships, are based on the illusions of interaction and intimacy, such as those created by reality programs, talk shows, and Internet chat rooms where fans can "talk" with their favorite celebrities. In the chat room for *The Hills,* for instance, fans have conversations like the following:

> Q: *Hey Lauren I love watching you on the Hills. I love your style its so cool and i love the shoes that you have. Paris must have been amazing! ttyl! p.s. my name is lauren too*
> A: *Thanks! It was so cool. You are going to love the new episodes.*

It's perfectly normal for adolescents to imagine connections with bigger-than-life figures, and it's also a perfectly normal part of development to want to emulate an admired figure in the media. But in recent years the quality of teens' and preteens' focus on celebrities has seen a distinctive shift. The around-the-clock access fans now have through the media allows them to develop a more

intense, more tangible, fantasy of a genuine relationship. Forty years ago, a teenager's fantasy of meeting the Beatles might have involved plotting how to get to a concert, or sneaking into a hotel where the band was staying. Today, a teenager enamored of a particular artist could simply visit the band's MySpace page and leave her idol a personal message.

And, for most teens, the fantasy doesn't stop with the idea of simply being noticed by their favorite stars. The fantasies fueled by these parasocial relationships have become more intense and grandiose as the nonstop delivery system amplifies the smallest details of the celebrities' lives. The average teenager's sense of the boundaries between everyday life and stardom often deteriorates until it's replaced with something like a delusion. The young person who admires a celebrity begins to believe she can *be* that person: "I *am* her." As one ten-year-old Hannah Montana fan told a reporter for the *Washington Post*: "I really like her show because the way she acts is kind of like how I act sometimes . . . When I sing her songs, I feel like her. . . . I really think I've actually become a singer."

Remember, none of this is to suggest that being a Hannah Montana fan, or watching a guilty-pleasure soap opera like *The Hills*, actually *causes* unhealthy levels of narcissism; as we've seen, it's childhood trauma, not media exposure, that causes unhealthy narcissism. However, the media's role in normalizing narcissistic behaviors has certainly had a detrimental effect on the developing personalities of today's teens, particularly the growing number who have had traumatic experiences. Research has demonstrated links between media imagery and real-life behavior in a number of areas: Media violence has been proven to provoke aggression in children and adolescents, and the viewing of sexual content has been shown to hasten the onset of sexual activity in teens. When shows (even an informational show like *Loveline*) or characters (in-

cluding our callers) resonate with an audience member's own experience, it can lead to a strong sense of identification. This can be a good thing when the program confronts the destructive behavior and offers sound advice, connecting with an audience that can otherwise be hard to reach. On the other hand, when the show amplifies or glamorizes aspects of life its audience relates to, it can provoke a confusing mix of desire and disdain in the viewers.

For example, a young adult watching *The Hills* may feel intense envy toward Lauren as she struggles to decide between taking a business trip to Paris or spending the summer in a gorgeous Malibu beach house with her boyfriend. The viewer might channel that envy into contempt for the decision she makes, or perhaps for the character in general. If she sees that her anger is shared by others, whether her friends or fellow fans in a chat room, the cycle of envy and disdain becomes almost reassuring, creating a sense of shared mission: *Let's all destroy that stupid idiot and take over her privileged life.* Expressing or acting on these twin feelings of envy and disdain can reinforce the viewer's narcissistic traits and the undesirable behaviors associated with them.

Tweens, teens, and young adults are drawn to the self-indulgent fantasy and high drama of the celebrity lifestyle, and they are highly inclined to emulate the behavior exhibited by their favorite stars. Developmentally, it's normal for teens to work through this fascination with provocative behavior by engaging in secretive activities or having mixed feelings about sexualizing themselves. Most teens don't act out on their worst impulses. However, for certain teens who are already disposed toward attention-seeking behavior, the celebrity-industrial complex makes it drastically easier and more alluring for them to act out their grandiose fantasies in public. These are the teens who devour images of narcissistic behavior as documented in the tabloids (drug use, alcohol use,

extreme dieting, sexually reckless behavior), on TV and video (*The Hills, Gossip Girl,* MTV's *Spring Break, Girls Gone Wild*), and on Internet gossip sites (perezhilton.com, TMZ.com, omg.yahoo.com, Gawker, and so on), and mirror those types of behavior back into the culture via YouTube, MySpace, and elsewhere. Each time such behaviors are reflected back and forth, they become less shocking, more socially accepted, and more frequently rewarded with attention and encouragement.

The children and teens who are most vulnerable to the Mirror Effect are those whose early childhoods involved traumatic damage to their self-worth, whether because of devastating causes such as sexual abuse or alcoholic or drug-addicted parents, or due to less dramatic but still traumatizing feelings of abandonment during those years. Such individuals are often diagnosed with one of the Cluster B personality disorders. On a more fundamental level, though, we now know that *all* preteens, teens, and young adults are highly susceptible to the negative lessons broadcast by celebrity culture. The neurobiological development of the adolescent brain, and the documented increase in instances of milder forms of childhood trauma, leave our children extremely susceptible to the Mirror Effect.

■ ■ ■

Over the past decade, science has proved what parents have long suspected: It's impossible to reason with a teenager. The *prefrontal cortex*—the part of the brain involved in empathy, emotional control, impulse restraint, and rational thinking—is shut down for remodeling between the ages of twelve and twenty. Instead of evaluating the social context and projecting the future consequences of their emotional impulses and actions, young adults respond to the signals of a much lower, more primitive area of the

brain, the *amygdala*, which drives responses such as fear and aggression.

This dynamic is complicated by the fact that individuals in this age range experience a drop in their ability to interpret the human emotions conveyed in facial expressions. With the amygdala in overdrive, teens, especially males, tend to read most facial expressions as either fear or anger, making it difficult to accurately experience the intersubjectivity so critical to empathetic understanding.

In other words, you can put on your most compassionate, yet serious expression, and urgently explain that the tabloid headline-grabbing behavior of your child's favorite celebrity points to dangerous emotional instability, not the free spirit of an entertainer, but your child won't get it. He won't particularly want to get it, either. What an adolescent craves is the type of highly arousing, exciting experiences the amygdala finds satisfying: the mindless danger of a stunt on *Jackass*, for instance, or the drama of a catfight on *America's Next Top Model*.

As we've mentioned, all infants exist in a narcissistic state; that's why trauma during early childhood is what lays the groundwork for primary narcissism in adulthood. However, our narcissistic traits surge again in adolescence, making all preteens and teenagers vulnerable as they develop the neurological wiring of rational, empathetic adults. Once the development of the prefrontal cortex is completed and it comes online, the irrational, moody teenager becomes a young adult with a developed regulatory system, who expresses emotions appropriately, shows an ability to control primitive impulses, and has a capacity for empathy. For teens, as for toddlers, it's critical that the self-gratifying impulses of the amygdala are frustrated, so that they may develop appropriate self-control and independent function. If traumatic experiences (with sex, substances, family, or peers) undermine this develop-

ment, the teen can emerge from this developmental period with the wiring of his prefrontal cortex awry, locked in a form of secondary (that is, late-developing) narcissism. In the worst cases, these unhealthy traits and behavior patterns can persist throughout adulthood; I have seen them progress to addiction, criminal or violent behavior, hypersexuality, and other self-harming behavior.

Navigating this developmental corridor is challenging under any circumstances. Today it's made even more difficult by the array of self-gratifying options our culture offers teens: drugs, alcohol, antisocial behavior, sex, and dangerous acting out. These types of behavior, projected out by celebrities with whom teens have formed intense parasocial relationships, are often accepted by adults who see them as "just what teens *do*." And so, the celebrity lifestyle, in all its dramatic and dysfunctional glory, continues to hold out the alluring promise that pursuing fame is a legitimate way for teenagers to manage their desire for arousal, chaos, and drama.

■ ■ ■

As actor William H. Macy has put it, "Nobody became an actor because he had a happy childhood." Hollywood is full of stories of dysfunctional families, and the evidence of generational legacies of pain, neglect, substance abuse, and other traumas is clearly displayed in the behavior of the young celebrities that make tabloid headlines today.

It's not just the privileged children of Hollywood families who are at risk. The past twenty years have seen a 40 percent increase in documented childhood trauma in the general population. There are four common types of child maltreatment, as described by the Child Welfare Information Gateway:

■ **Neglect**. Neglectful abuse includes failure to provide necessary food or shelter; lack of appropriate supervision; failure to provide necessary medical or mental health treatment; failure to educate a child or attend to special education needs; and most significantly, inattention to a child's emotional needs; failure to provide psychological care; or permitting the child to use alcohol or other drugs.

■ **Physical abuse**. Physical injury, ranging from minor bruises to severe fractures or death, as a result of punching, beating, kicking, biting, shaking, throwing, stabbing, choking, hitting (with a hand, stick, strap, or other object), burning, or otherwise harming a child. Such injury is considered abuse—particularly *any* striking with an object—regardless of whether the caretaker intended to hurt the child.

■ **Sexual abuse**. Sexual abuse includes activities by a parent or caretaker such as fondling a child's genitals, penetration, incest, rape, sodomy, indecent exposure, and exploitation through prostitution or the production of pornographic materials and potentially even exposure to pornographic matter.

■ **Emotional abuse**. Any pattern of behavior that impairs a child's emotional development or sense of self-worth is considered emotional abuse. This may include constant criticism, threats, or rejection, as well as withholding love, support, or guidance. Emotional abuse is often difficult to prove, although it is almost always present when other forms are identified.

When most people think about child abuse, images of extreme physical harm or sexual abuse may come to mind. It doesn't take

an obvious ordeal to damage a young child's psyche. Just as there are degrees of maltreatment, there are degrees of trauma. After spending decades listening to *Loveline* callers sharing their stories, I'm convinced that varying degrees of childhood trauma, the kind of maltreatment that's routinely dismissed as "discipline," or brushed off as "everyone's family has issues," are at the root of the acting-out of many teens and young adults today.

When these teens tell their stories, their thought process is characteristic of that of a traumatized child. They are often locked into damaging repetition-compulsion behaviors, but believe that the pain they suffer is their fault, that they somehow have done something to deserve continued bad treatment.

One night, a young woman called in to *Loveline*. She was living with her boyfriend, but was very unhappy because their sex life had basically ceased to exist. She explained that her boyfriend was only interested in porn. He would watch Internet porn or rent videos, go to bed with the television or computer on, and generally ignore her. She was clearly frustrated by his behavior. My co-host that night tried to crack a joke: "Why don't you just make a porn video?" he asked. "That was the first thing I tried," the caller replied, in all seriousness.

At first glance, this may seem like the stance of a victim, but it's actually a very grandiose position. Rather than risk revealing that her boyfriend might actually want to cause her pain or harm by rejecting her—an unacceptably shattering possibility—she opted for a grandiose gesture that allowed her an illusion of control over the situation, at the cost of her self-worth.

All people who have been emotionally traumatized suffer deep feelings of loss. Narcissists devote their energy and defenses into avoiding these feelings of loss and emptiness. In extreme cases, their avoidance strategies can involve trying to mute the feelings

with sex, alcohol, or drugs. In the case of our current climate of fascination with celebrity, the depth of emotion and amount of energy that today's young people pour into relationships with celebrities may be one way they attempt to fill the internal emptiness that is the legacy of emotional trauma.

■ ■ ■

Two theories of adolescent psychology—the imaginary audience theory and the personal fable theory—are particularly relevant in explaining the allure of celebrity culture for tweens and teens.

Psychologist David Elkind introduced these two theories in a 1967 paper on adolescents and egocentrism. He suggested that adolescents exist in an empathetically compromised state of egocentrism, and that typical teens live their lives as though they were on a grand stage in front of an attentive audience. Because every action is so important to them, these teens assume that their actions are of equal interest and importance to all those around them, that they are performing before a constant imaginary audience. The personal fable theory describes a belief on the part of the adolescent that he or she is unique and special, and that when it comes to pursuing his or her destiny, the conventional rules don't apply. In theory, most teens grow out of these dramatic, egocentric stages, as they successfully negotiate a separation from their parents and emerge with unique identities as mature adults. Notice the similarities with the narcissistic traits we've discussed throughout this book: Just as trauma can cause regression, or make a person become stuck in a narcissistic stage of development early in life, the teen years have become another window of development linked to prominent narcissistic features, and many are not making it through unscathed.

In his book *Fame Junkies*, Jake Halpern examines these theories in the context of modern pop culture saturation and concludes

that the notion that fame is accessible may lead teens to prolong their dependence on these delusions of grandeur beyond whatever developmental usefulness they may have had. For a generation of kids who have grown up with video cameras recording their every move, the spotlight seems like a comfortable and desirable place to be, and MySpace, YouTube, *American Idol,* and *Project Runway* all hold the promise of fulfillment for teens searching for an audience in the belief that they are destined for greatness.

Daniel Lapsley, a psychologist at Ball State University, implies that these daydreams or fantasies may be dangerous not because they'll leave teens with overly developed egos, but because they'll lead them to develop narcissistic personalities, a far more dangerous result. "The danger is that if these adolescents don't curb all this daydreaming with a healthy dose of reality, they could end up in relationships that are manipulative or exploitative," Lapsley contends. "After spending so much time in front of an imaginary audience, they might ultimately only be interested in forming relationships that serve their need to be admired, instead of forming ones that authentically engage other people."

Fame allows people to act out in ways that are exciting, dramatic, and rebellious. To the impressionable teen seeking a model for establishing autonomy and selfhood, such a dysfunctional strategy can have a perverse appeal. Consider Amy Winehouse: As a five-time Grammy winner she should be famous for her artistry alone, but her tabloid popularity currently rests on the fact that she abuses drugs and alcohol, cuts herself, has been arrested for public brawls, visits her husband in jail, and generally seems bent on self-destruction. Her parents hover in the background, willing but apparently powerless to help. Winehouse's fame appears to allow her to do whatever she wants, exempt from social conventions and, apparently, even legal consequences.

Following such exploits gives some teens a socially acceptable means of arousal, which they can use as a way of regulating the turmoil of emotions they experience daily. Others identify with the behavior, or find vindication for their own. In short, for most teens, and many adults, immersion in the minutiae of celebrity culture provides arousal and escape, a response that feels good in the moment but must be constantly fed.

It's interesting to note that this teen desire for titillating celebrity news is not a new phenomenon. Teens in the 1950s, '60s, and '70s looked to magazines like *16* and *Tiger Beat* to stimulate their own fantasies, absorbing a steady diet of alluring headlines: SCOTT'S JUST LIKE YOU! LEIF: THE RIGHT WAY TO MEET HIM! and SHAUN: BE THE GIRL WHO UNDERSTANDS HIM BEST! (That's Scott Baio, Leif Garrett, and Shaun Cassidy, for those too young to remember.) Like most feel-good substances of the past fifty years, it's not necessarily the drug itself that has changed. For vulnerable teens hooked on the seductive power of fame, it's the new formulation and ready availability of the drug that has increased its damaging effects.

■ ■ ■

Between TV, radio, magazines, and the Internet, celebrity gossip is unavoidable. Tweens and teens are estimated to absorb more than six hours of media exposure every day, with tweens spending 45 percent of their time watching TV and 14 percent online. Teens spend about 25 percent of their time on the Internet and an unbelievable 50 percent of their time watching television. And even the most passive, nontelevision-watching, computer-illiterate preteen or teen can't avoid the gauntlet of glossy magazines at the checkout counters in grocery or department stores.

As any parent of teenagers knows firsthand, most teens *aren't* passive when it comes to getting what they crave. And each gen-

eration has greater access to, and more mastery of, the increasingly sophisticated range of media outlets. Today it's pretty much impossible to prevent a preteen or teen from absorbing the celebrity gossip, and other, more salacious images, that dominate television, the Internet, and magazines. Teens who follow the celebrity-dominated media aren't satisfied just to model themselves after the famous people they admire. They want to participate. As a reality TV producer has told us, in a world where fame is just an *American Idol* audition or YouTube video away, many kids watch celebrities just so they'll know how to act when it's their turn.

Permissive parenting and society's normalization of unhealthy behavior compound the problem of this fascination with celebrity behavior. Teens may get ideas as to how to conduct themselves like celebrities from the media, but their narcissistic traits really flourish when their family is reluctant to impose moral standards or share value judgments on these unhealthy behaviors.

■ ■ ■

As recently as a century ago, the group of people who had the power to influence an adolescent's social development was relatively limited, including their relatives, peers, neighbors, and teachers, with parents having the highest influence of all. As one British study from 2001 reveals, however, the explosion of the mass media has changed this picture drastically. Several recent polls confirm that the behavior of media figures and celebrities is overtaking the influence of more traditional role models. Consider just a few of the many statistics that define this disturbing trend.

■ Thirty-six percent of teens polled still believe that talent is a more important factor in becoming famous than per-

sonality, but a nearly equal number, 32 percent, believe that personality outweighs talent.

- Teens admit to copying celebrity tattoos and body piercings.

- When celebrities lose weight, more than 70 percent of teenagers say they're influenced to do the same.

- Some 20 percent of college students nationwide regularly rely on prescription stimulants, such as Adderall, as study aids.

- Fifty-one percent of eighteen-to-twenty-five-year-olds said that being famous was their generation's most important or second most important life goal.

- Young people are nearly twice as likely to admire an entertainer (14 percent) as they are a political leader (8 percent).

- When given the choice of becoming stronger, smarter, famous, or more beautiful, boys chose fame almost as often as they chose intelligence, and girls chose it more often.

- Teenagers who regularly watch celebrity-focused TV shows are more likely to believe that they themselves will someday become famous. The same trend appears to be true for teenagers that read celebrity-focused magazines.

These statistics demonstrate how heavily influenced tweens and teens are by celebrity culture, a fact that's all the more disturbing when you contemplate the kinds of celebrity behavior those teens are observing on a daily basis. In the time it took us to research and

write this book, fifteen-year-old Jamie Lynn Spears got pregnant and was shipped off to Louisiana, even as her parents focused on their struggle to control her twenty-six-year-old sister (who had her first child at age twenty-three and her second a year later). Fifteen-year-old Miley Cyrus went through a full cycle of celebrity scandal, weathering the posting of online provocative photos and the media firestorm over her *Vanity Fair* shoot. And Vanessa Hudgens's nude Internet photos caused a momentary sensation, but failed to derail her girl-next-door career.

Such scandals surface, break, then quickly disappear from the manufactured face of celebrity, and each time they do, the bar of age-appropriate behavior slips a little lower. The young women exhibiting these types of behavior are the idols of a generation of ten-, eleven-, and twelve-year-olds. And parents everywhere fear that the teenage girl next door of today or tomorrow may not be so different from Hudgens in what she chooses to share in cyberspace.

Young girls face a particularly insidious danger from immersion in the world of celebrity culture. As Rosalind Wiseman points out in her book *Queen Bees and Wannabes*, girls suffer a decrease in self-esteem as they enter adolescence, around the time that gossiping about celebrities becomes a way of trading cultural information, values, and judgments with their peers. As Wiseman explains, "Girls have strict social hierarchies based on what our culture tells us about what constitutes ideal femininity. At no time in your daughter's life is it more important for her to fit these elusive girl standards than in adolescence. . . . Your daughter gets daily lessons about what's sexy (read *in*) from her friends. She isn't watching MTV or reading quizzes in teen magazines by herself. She processes this information with and through her friends."

Boys aren't exempt from looking to celebrities as a way to de-

fine their masculinity, though the dangers may not be as immediately obvious, except perhaps in the world of sports, where idols may casually admit to steroid use to enhance their performance. It's increasingly recognized that boys, as well as girls, suffer from obsession with body image. In his book *Real Boys' Voices*, William Pollack talks about society's expectations of masculinity, which lead adolescent boys to engage in "reckless or hurtful acts of bravado, or showing that they can handle physical and emotional trauma without uttering a word or conveying a single emotion. For a young boy trying to forge his own path, this pressure to fulfill traditional rules about masculinity can often feel overwhelming. It can lead him to tease, bully, or abuse others. It can cause him to make mistakes in how he treats girls and young women and become compulsive about seeking out sex. It can push him to drink alcohol and take drugs. It can prod him forward toward depression. . . . it may even lead him to frightful, sometimes lethal acts of aggression and violence. In almost all cases it makes him want to limit the range of his personal expression or silence his genuine inner voice entirely."

While males don't consume tabloid gossip as avidly as females, when boys do search for male role models in the mirror of celebrity culture, what do they see? The sports figures who appear in the tabloids usually do so because they're married to actresses or other celebrities. Or they're stars in extreme sports, where aggression is valued and bodily safety is devalued. Other tabloid staples include bad boys like Johnny Knoxville and Steve-O of *Jackass*, and hard-partying musicians. The male figures who get attention in celebrity media often embody the very traits Pollack warns against.

Today, as the multimedia conglomerates work harder and harder to spread awareness of their brands in every aspect of our culture, teenagers have more ways than ever to fuel their grandiose

daydreams and intensify their parasocial relationships with their idols. When you can wear or own all kinds of things endorsed by your favorite celebrity, it's that much easier to believe you can *become* that star. And it's not just the *Hannah Montana* backpack-and-lunchbox crowd that's susceptible to these marketing strategies. The Web site for *The Hills,* for example, showcases plenty of ways young adults can model their lives after the show's stars. They can "Get the *Hills* Look" in the shopping section, watch streaming video of the show using a "Shopisode" feature that highlights expensive wardrobe items available for sale on the site. They can search more than three hundred apparel brands that have appeared on the show (Click on "Catherine Malandrino" and you're taken directly to a $500 minidress as seen on Episode 326, "A Date with the Past"). Or they can enter the "Make Me a *Hills* Girl" sweepstakes, where aspiring stars can post seductive photos or videos of themselves. They can even log in to "chat" with the stars directly.

The merchandising of celebrity creates a vicious cycle of narcissistic synergy. Celebrities feed their narcissistic need to be perceived as successful by licensing their names to manufacturers for new lines of clothing, accessories, or perfume. The companies use celebrities as spokespeople, or as highly visible display racks for their products, helping them attract the more than $190 billion in spending power of the twelve-to-seventeen-year-old market. And the tweens and teens? They spend their money (or their parents' money) in pursuit of external validation of their own coolness.

■ ■ ■

The media is also fueling the tendency of narcissistic teenagers to create a pseudo-self, which they project out to others in hopes of attracting the steady stream of admiration and desire they crave. Inspired by projections of celebrity glamour, and facilitated by

sites like YouTube, MySpace, and Facebook, adolescents have mastered the art of the pseudo-self. Tweens and teens now create avatars, shoot glamorous or edgy self-portraits to post on their MySpace pages, or art direct lip-synching videos on YouTube.

In a recent episode called "Growing Up Online," the PBS show *Frontline* profiled Jessica, a fourteen-year-old from New Jersey who created the persona of online "Autumn Edow." Doing her own makeup, choosing her own outfits, and art directing (and often taking) her photos, Jessica created a pseudo-self: Autumn, a goth model and artist who looked much older than a teenager and had a portfolio of lingerie shots and provocative poses. On camera Jessica admits, "I didn't want to be known as 'Jess.' That was the last thing that I ever wanted, because all it did was remind me of the girl who had no friends. I wanted to be the total opposite."

Autumn became a MySpace sensation, and soon Jess was on the computer "all day" replying to commenters who told her she was "gorgeous." Jess says, "I didn't feel like myself, but I liked the fact I didn't feel like myself. I felt like someone completely different. I felt like I was famous."

When the principal at Jess's school got wind of Jess's profile, he contacted her parents, who forced her to take it down. Fighting back tears, Jess explains how she felt when she had to delete the photos of her as Autumn: "I was just completely erased from that whole world. . . . If you have something that's that meaningful to you, having it taken away is, like, your worst nightmare."

This feeling of loss of self is common to teens, but it's especially wrenching when what's being taken away is the only self you feel connected to. For teens with high levels of narcissism, genuine emotions often feel less real than the consciously created qualities of the pseudo-self. And when the pseudo-self is exposed or lost, the real teenager panics at the thought of people glimpsing the

emptiness of their true emotional world. When this happens, they lash out, masking shame with aggression. Reentering the real world, and reestablishing a connection to their own spontaneous emotions, can be too alarming a prospect for these teens to contemplate. Instead they seek whatever other solution our culture offers—most commonly drugs, alcohol, sex, or obsession with body image—all of which too often become the next problem.

■ ■ ■

Today's teenagers, then, are more likely to have suffered childhood traumas than at any time in recent history. They are intensely drawn to celebrity, often in unhealthy ways. And they are arguably at a greater risk than previous generations of submitting to the bad influences of celebrity culture. Given all that, how narcissistic can we expect future generations of young people to be?

Jean Twenge, a professor of psychology at San Diego State University and author of the book *Generation Me: Why Today's Young Americans are More Confident, Assertive, Entitled—And More Miserable than Ever Before*, has closely studied children raised in the cultural mainstream of the self-esteem movement, the generation of Americans born after 1970. She characterizes this "Generation Me" as unapologetically focused on the individual, with unprecedented freedom to pursue what they believe will make them happy.

Twenge and her colleagues examined the NPI scores of more than 16,000 college students nationwide over the twenty-four-year period between 1982 and 2006. Her results showed that the average NPI score among college students increased from 15.06 (roughly equal to the overall population's score of 15.3) to 17.29 (which is approaching our celebrity study mean score of 17.84) during that period.

Those results confirm the conclusion Mark and I reached in

the study of undergraduate students we performed just after our celebrity study. The NPI score of this group as a whole was 18.83, almost 6 percent *higher* than the average score of the celebrities we surveyed, and 12 percent higher than the MBA students' average score of 16.8. The undergraduates had the highest scores in entitlement, exploitativeness, and authority, higher than either the celebrity or the MBA groups previously surveyed.

Increased levels of narcissism among adolescents today don't necessarily mean we're in for an explosion in the number of reality stars or a new wave of young celebrities. However, these teens are at considerable risk of becoming developmentally stalled, entering adulthood locked into behavior that is triggered by their unhealthy levels of narcissism. This generation may have a harder time forming real relationships. They may favor self-promotion over helping others. And their attitudes, beliefs, and constant need for attention may make them difficult, if not impossible, to be around.

■ ■ ■

There are five main ways in which unhealthy narcissism is expressed in teens and young adults. If your child exhibits excessive behavior in any of these areas, it may be reason for concern.

Victimizing or bullying. A study by researchers at San Diego State University and the University of Georgia reveals that people with narcissistic personalities who experience social rejection are more aggressive than those who are less self-absorbed, a finding that may help explain why some teens resort to violence while others do not. Remember, a narcissist suffers from an extreme lack of self-worth; he is invested in projecting an idealized version of himself to the world. If the worth of this pseudo-self is questioned, the narcissist may resort to extreme behaviors to avoid the shame this

provokes. If you have a teenage son or daughter who consistently responds to situations of social uncertainty with bullying or aggressive behavior, you may want to consider whether these responses stem from inner feelings of self-loathing.

Hypersexuality. In the world of adolescence, genuine interpersonal contact is often supplanted by the empty arousal of sexuality. Teenagers focus their desires on either strictly sexual imagery involving perfect external physical features or outlandish behavior that conveys strength and fertility. Such displays serve the adolescent predisposition to narcissism well, encouraging the teenage inclination to avoid closeness and rely on strategies that help manage emptiness and unpleasant emotion. And, like the drugs their peers will hand them, these narcissistic strategies will work at first, but soon ensnare them in an addictive cycle, in which they come to need this particular arousal to regulate their emotions. In truth, any destructive expression of sexuality should be carefully examined. Not only can sexual acting-out be a sign of depression, it's also often linked with drug and alcohol use, regardless of whether the teen in question has other narcissistic personality issues.

Today's hookup culture provides a perfect example of the ideal narcissistic relationship. The Independent Women's Forum interviewed college women throughout the country and discovered that they characterized themselves as ambivalent to unhappy about their social lives on campuses. College-age women reported that they had only three options in their social landscapes: They could become "joined at the hip," in a rapidly developing boyfriend/ girlfriend relationship where two partners are thrust together with little or no time to get to know each other. They could become so-called friends with benefits, a pair who consider themselves friends but occasionally also have sex, a type of relationship that

always ends in disaster when one partner develops feelings the other can't match. They can engage in *hooking up*, physical encounters with people they might not know or know well. The actual definition of the term is loose; it can mean anything from kissing to sex. Two things are almost universally true of hooking up: the partners expect (or say they expect) nothing further to come of the encounter, and, especially among college students, the partners are usually intoxicated when the hookup occurs.

All three of these types of "romantic relationships" explicitly exclude any genuine intimacy. None of them involves building a genuine understanding of another person, or even oneself, in an interpersonal romantic context. Rather, these relationships are all designed merely to facilitate attraction and arousal, and to satisfy the primitive drive of sexual desire. This kind of emotionally vacant social interaction, which offers a solution for regulating primitive urges, is an ideal construct for narcissists.

Hypersexuality is also occurring with increasing frequency among younger teens and even preteens who eagerly imitate their favorite teen stars. These celebrities, often in their late teens, may initially tone down their own sexuality to preserve a tamer persona for a younger audience. However, in their private lives (and the more famous the celebrity, the less private their lives can be), these celebrities often engage in adult behaviors, even beyond those appropriate for their age. When these types of behaviors—drinking, using drugs, dressing provocatively, engaging in a string of brief relationships—surface in the entertainment media, young fans may be enticed by the behavior and begin looking for ways to mirror it back in their own lives.

Body image. Multiple piercings, tattoos, and eating disorders are all signs that a teen is distanced from his or her feelings or emotions.

Any teen who sets out to change his or her appearance is trying to exert control over his or her body. Teens who dramatically alter their looks typically become very defensive when questioned about their body art. They hide behind predictable rationalizations ("Don't you understand that this is the oldest form of artistic expression?"), claim they "just like how it looks," or eventually dismiss the choice as unimportant ("Well, I was just bored").

These are all fantastically disconnected explanations, and that's understandable: These teens really have no idea why they do what they do. They are motivated by primitive impulses that draw them to such choices, and often know little more than that they're gratified by the results. When I point out that individuals who submit themselves to particularly aggressive piercings, or total body tattooing, usually have a history of childhood physical abuse, highly narcissistic teens often ask, "Who doesn't?"

Substance abuse, hypersexuality, aggression, self-mutilation, cutting, and eating disorders are all primitive strategies teens use to regulate their emotions, highly arousing behaviors that give the individual a momentary sense of control. People who employ these behaviors would rather destroy themselves than trust and be vulnerable with another person. Because these behaviors have such dangerous repercussions, they demand that both the behavior itself, and the compulsion that underlies it, be addressed. Today, some psychiatrists even prescribe endorphin blockers to dampen the euphoric arousal associated with these types of behavior.

Alcohol or drug abuse. Most teens are well aware that drug and alcohol abuse is not healthy. They've spent years being exhorted by educators and parents to "Just say no." And yet, drug and alcohol use appears to be an acceptable, even central, part of life for celebrities of all ages, even, we now know, child stars. When it comes to

experimenting with drugs and alcohol, teens today receive a host of mixed messages that have an inestimable influence on their own opinions.

Normalizing substance use by teenagers is a huge mistake. If your teen is using drugs or alcohol at all, you should consider it a serious problem. Dismissing drug or alcohol use in teenagers by saying, "Oh, kids will always experiment—that's what they do," paves the way for vulnerable individuals to develop full-fledged addictions.

Every parent needs to understand that just because a behavior is common among adolescents doesn't mean it should be acceptable. Parents of young drivers don't condone speeding, for example, or driving without a seatbelt. Many parents acknowledge that drug and alcohol use are common among teens, without ever admitting that their own children may be engaged in this behavior. Adolescents go to great lengths to hide problematic behavior. If you have discovered that your child is drinking or using drugs, you should consider it a very serious problem, no matter whether your child tells you "I just party on the weekends" or baits you by asking "Didn't you ever do anything wrong when you were a teenager?"

Substance abuse is a very serious issue in teens. It is common, but it should not be considered normal. It's important for parents to realize that most of the common emotionally or physically damaging events in an adolescent's life—unwanted sexual contact, auto accidents, assaults—are alcohol- or drug-related. Even occasional use of supposedly milder substances like alcohol and pot are troubling, as they may interfere with the delicate process of brain development in adolescence.

Self-harming/acting out. In adolescence, a time when emotional pain and unregulated emotions predominate, aggression is never

far behind, and in a culture in which Ultimate Fighting and violent video and online games are considered acceptable forms of entertainment, it has only become glorified. Much has been made of the potential for video games to encourage violence, but one fact that has gotten less discussion is that adolescent males are usually highly rewarded for outrageous, often violent antics. Some believe that males who engage in death-defying feats are broadcasting their genetic superiority to an audience of available females. By this token, if you can live through a potentially dangerous stunt—like those on *Jackass*, for instance—you must be suited for survival. As a medical professional, I'd say you're simply lucky.

■ ■ ■

One thing parents and influential adults must realize is that they have a responsibility not to normalize these behaviors for their teenagers. When you say "She just got a little drunk," or "All teenage kids have sex," or "A little pot never hurt me when I was young," or "It's natural for kids to be a little rebellious," you're normalizing their behavior, denying its dangerous implications and potentially devastating consequences.

I first realized how fully our culture has accepted these behaviors when I was a first-year resident completing an internship at an adolescent psychiatric unit. One day, I came across what appeared to be a list of typical teenage behaviors: sex before the age of eighteen, experimenting with drugs, having more than one partner. In fact, the list had been designed to help doctors-in-training recognize pathologies in our teenage patients.

As parents, we must monitor such behaviors constantly, and remain aware not just of how dangerous they are, but of the many teen-directed cultural messages that tend to encourage them. Your teen doesn't have to come home with a tongue piercing, or get ar-

rested for criminal behavior, for you to be concerned about his welfare. The signs of unhealthy levels of narcissism—the kind that can lock an adolescent into dangerous and detrimental patterns—can be subtle and difficult to spot. As parents you must be vigilant in watching out for signs of bullying, victimization, exploitation by (or of) their peers, impulsive violence, premature sexual behaviors, substance use, and depression. Narcissism doesn't necessarily explain these behaviors, but narcissistic traits can interfere with appropriate solutions and make the problems more dangerous.

■ ■ ■

We know that an increase in trauma is linked to an increase in narcissism, and we know that teens are extremely vulnerable to influences that can stimulate their narcissistic traits. Adolescence is the last chance for parents and other influential adults to steer their children toward empathetic engagement with the world around them, and to help teens channel their narcissism toward healthy outlets. As children grow older, this task of parenting becomes more challenging, especially today, when celebrities may actually have more influence over a child's burgeoning narcissism than the parents do.

Parents need to stop brushing off their teenagers' unhealthy behavior and start measuring it against what is healthy. Unfortunately, before they can recognize appropriate, healthy behavior, many parents will have to confront their own narcissistic traits. Rather than simply trying to control their teenagers (something no generation of parents has ever been able to achieve), today's parents must first look to themselves, and their own parenting techniques, to understand how they may be contributing to the generational legacy of narcissism.

Parenting to Prevent Narcissism

Mom! Mom! It's not right. Mom!
——*Paris Hilton on being sentenced to jail for drunk driving.*

People say: "Oh she's spoil[ed], she's this, she's that." But until you've walked in someone's shoes for many miles, don't make a judgment call. . . . life's been comfortable for Paris and jail was probably tougher on her than it would be on, let's say, an everyday person.
——*Kathy Hilton, explaining why it was unfair
for Paris to receive such a harsh sentence.*

She is my best friend, she is my life, she is my sleeping partner. It's just me and all the animals.
——*Melissa "Rocky" Braselle
(Hayley Sanchez's mother and contestant on I Know My Kid's a Star)*

My mom drives me up the wall! I don't care if I'm uncomfortable, I just wanna be rich and famous. I don't care if I die, I just wanna be rich and famous.
——*Hayley Sanchez (Rocky's nine-year-old daughter)*

Teenagers aren't the only ones who are confused by the mixed messages of celebrity culture. Parents, too, are vulnerable to the cultural messages about childrearing that are promoted by the celebrity media. Being a parent is hard enough; on a bad day, even the most self-assured among us question our abilities to get it right. Then, when a seemingly average father like Mitchell Winehouse speculates that his long-term affair and subsequent divorce

may be the reasons his daughter Amy is such a mess, or when an elementary-schoolteacher mom and a working-class dad in a small town in Louisiana manage to raise not one but two daughters whose names are synonymous with *celebrity train wreck*, it invites parents to wonder just how damaging our missteps can be.

In Mark's work at USC, and mine on *Loveline*, we both have an inside view of the lives of teens. We both hear regularly, and from the source, about the problems, frustrations, concerns, and fears that today's teens and young adults grapple with. And, as parents, we worry about confronting those same issues as we raise teenage children in celebrity-saturated Southern California. We both know how stressful it can be to strive to raise secure, confident, emotionally healthy young adults.

■ ■ ■

How you were raised has a direct effect on how you raise your children. And the parenting techniques of the boomer generation, now raising their own families, will determine whether the epidemic of cultural narcissism will continue or begin to reverse course.

Jean Twenge and her colleagues have spent a great deal of time studying both the boomers and their offspring, whom she terms *Generation Me*. The baby-boomer generation (by Twenge's definition, those who grew up in the 1950s, '60s, and '70s) came of age actively in search of self-knowledge and self-fulfillment. Intent on shaking off the repressive mantle of their parents' generation, they marched, and protested, and fought to realize their needs and desires. Yet, hidden in their desire to make a difference, was a grandiose belief that they actually knew something special that they were going to impress upon the world. As parents, they've proven equally intransigent and difficult to advise; no surprise, given their

lifelong conviction that they knew what was good for the world. They have translated their introspection and desire for a more perfect world into a legacy of intense individualism and complacent self-importance for their children.

The boomer parents' insistence on instilling a sense of specialness in their children, while maintaining their own right to pursue the self-interests they struggled to achieve, is proving a double-edged sword. In *The Culture of Narcissism*, Christopher Lasch warned that "the modern parent's attempt to make children feel loved and wanted does not conceal an underlying coolness—the remoteness of those who have little to pass on to the next generation and who in any case give priority to their own right to self-fulfillment."

In his book *Arrested Adulthood: The Changing Nature of Maturity*, sociologist James Côté points out that each successive generation in the twentieth century pushed the boundaries of permissible behavior out further and further from those of their parents' generation. The sense of entitlement, too, seems to have increased in similar fashion from each generation to the next. "If the parents of Baby Boomers produced a generation of more extreme cultural narcissists" than the last, Côté points out, "one has to wonder what personality characteristics Baby Boomers as parents have nurtured in their children."

No other generation has fought aging and clung to the illusion of youth as tenaciously as the later cohort of boomers. This refusal to grow old (or, some might argue, to grow up) has had a detrimental effect on the family structure. The celebrity families that populate the world of reality television and tabloid gossip—the Lohans, the Spearses, the Simpsons—demonstrate this point vividly. Their family structures reflect the worst-case scenarios of what happens when children have parents who act like adolescents themselves.

When a mother or father (or both) abdicate responsibility for providing structure and guidance for their child, usually in favor of being their child's best friend or gratifying their child's desires, that child is prematurely forced into an adult role, even when he has no role model available to teach him responsible adult behavior.

The fact that you don't go out clubbing with your fifteen-year-old daughter, or share drugs with your college-age son, or blatantly exploit your children to gratify your own selfish needs, doesn't mean you're not encouraging the development of narcissistic traits in your child. As a responsible parent, you still need to look at yourself, and your relationship with your children, to see if you may be putting them at risk for heightened narcissistic tendencies. Through your personal behavior, and/or your parenting style, you may be modeling and encouraging narcissistic traits, behavior you might not even recognize as such, so common (and, some might even argue, useful) have they become in culture today.

■ ■ ■

No parent consciously sets out to raise a narcissist but, whenever a child becomes responsible for meeting the needs of the parents, the conditions for a potentially narcissistic dynamic are in place. Sometimes, these parental needs can be as explicit as those shown in the widely circulated video of an intoxicated David Hasselhoff, in which his daughter pleads with him not to drink so he'll be sober when he shows up for work the next day. They can be as blatant as those of the stage parents on *I Know My Kid's a Star*, who serve their children up as celebrities-in-the-making to fulfill their own frustrated fantasies of stardom. They can be as distressing as Alec Baldwin's rage-filled rant at his eleven-year-old daughter, who failed to answer his arranged phone call, or as commonplace as the heightened expectations that drive so many young athletes to push

beyond their limits on the soccer or baseball field, or in the dance or gymnastics studio, lest they disappoint their anxiety-ridden parents.

When a child cannot meet these parental needs or expectations, he or she is likely to feel inadequate, like a failure, and to fear that rage or abandonment may not be far behind. Children who are put in these situations regularly learn not to trust their parents. Consciously or not, they come to believe that their primary purpose is to satisfy their parents' dreams of success or gratification, and this hinders their ability to develop empathetic responses toward others. Unable to recognize their own wants or needs, they tend to externalize their emotions and develop adaptive strategies for satisfying them, strategies that are almost always narcissistic in nature.

Hollywood history abounds with stories of classically dysfunctional families in which parents with highly narcissistic traits, often combined with borderline personality disorders or alcohol and drug abuse, raised children with similar dysfunctions. The family histories of the Barrymores, the Downeys, and the Sheens all illustrate how harmful behavior can be handed down and amplified from generation to generation. And while these family sagas have played out in the limelight, there are many families in America where parents struggle with the same types of issues, and children suffer the same types of emotional wounds.

Families don't have to be so visibly dysfunctional to pass down a generational legacy of narcissistic traits. Stephanie Donaldson-Pressman and Robert M. Pressman, family therapists who specialize in the diagnosis and treatment of the narcissistic family, describe a much more common family dynamic. In *covertly* narcissistic families, the children report feeling as if the parents "just aren't there." These families appear to be healthy, normally functioning units,

but the parents aren't focused on meeting the emotional needs of their children. Instead of providing a supportive, nurturing environment, these parents present their children with a mirror of their own needs and expect the children to respond. The child, in these circumstances, becomes an extension of the parents. These parents may compulsively look after the child's activities and academics, but not offer much in the way of empathic attunement to the child's needs as he or she struggles with tasks. They show little interest in eliciting genuine, spontaneous, creative expression from the child, instead steering him toward making sure their own narcissistic needs are met.

In such a skewed arrangement, the child learns that the only way to get approval is to meet the parents' needs; otherwise he risks emotional abandonment, or worse. Such relationships often fall into one of two varieties: When a child's parents are emotionally unavailable, he learns that feelings just don't matter. On the other hand, when his parents are *unpredictable* in their expressions of affection, or offer only intermittent reinforcement, the child remains hooked in to the relationship, and can become deeply invested in seeking at least superficial approval.

Narcissists look to others for validation because they don't experience their own feelings in a meaningful way. They are compulsively driven to attract attention and admiration from those around them, in order to pump themselves up and compensate for the deep emptiness that results from the lack of a true sense of self.

One of the most common scenarios that triggers this unavailable parent-narcissistic child dynamic is divorce. In the aftermath of a divorce, many parents are emotionally and even physically unavailable; others may try to manage their own guilt by over-gratifying their children. Either situation can be traumatizing for the child, who may conclude that the split is somehow his fault

and connect his parents' behavior to his grandiose sense of blame for the breakup of the family.

In talking with us about her childhood, actress Julia Ormond spoke with insight about the trauma she felt over her parents' divorce when she was a young child and how it affected her choice of career: "My parents divorced when I was four," she remembered. "[Divorce] was still fairly stigmatized in England at the time, which felt isolating at school. I think there's a desire in children to create an alternative image of their selves; their true selves having taken in blame somehow. After all, how can their parents be at fault? I had a fantasy that if I was a boy, that things would have worked out differently. I have found it therapeutic to act and deal with life issues through a fictional and imaginative process."

No child develops a fully formed sense of self automatically. Children must learn how to meet their *own* needs, not develop an externalized sense of self by being expected to meet the needs of others. To develop this critical social and emotional skill, children must be able to develop trust in their relationships with others; they cannot flourish in an environment where they are made to feel empty, ashamed, or constantly obliged to meet someone else's needs at a critical time in their development.

In a healthy situation, parents accept responsibility for meeting a variety of their children's needs; they get their own needs met by themselves, each other, and/or other suitable adults. In a narcissistic family, a child's sense of self is sacrificed to the parents' needs.

■ ■ ■

Without a doubt, raising a teenager in today's world involves a set of challenges that can unnerve even the most diligent and aware parent. Whether you're parenting a toddler or a teen, the key thing

to remember is that you're dealing with an individual who seeks out idealized role models, nurtures grandiose fantasies, and often behaves as if he or she is omnipotent. An individual with this mindset can be demanding, capricious, and frustrating. Nevertheless, as powerful as a toddler or a teenager feels, or feels he's entitled to be, your job as a parent is to appropriately frustrate, not enable, their grandiose posturings. Remember, a grandiose sense of self is normal for a young child; it should be neither crushed nor overly supported. As a parent, your job is merely to be present, to show that you appreciate your child's experience as he struggles to manage reality on reality's terms.

As we saw in the previous chapter, teens lack the rational, empathetic power that comes with a fully developed prefrontal cortex. Since this important part of the adolescent brain effectively goes off-line for rewiring during adolescence, the job of helping teens identify and contain their emotions falls to the parent. If you have teenage kids, think of yourself as a kind of satellite central nervous system during these years, as you did when your child was younger. In developmental terms, teenagers are like toddlers on steroids. Remember when your first child began stepping beyond his or her fusion with you as a parent, and exploring the world independently? Remember how stubborn he could be, or how spectacular her tantrums were when you were helping her manage her emotions? Remember what a breakthrough it was when he or she learned to trust in exchanges with others? All those lessons are useful to recall when you're raising an adolescent.

A parent who responds in a favorable and empathic way to her child during these critical early years imbues in that child a strong sense of self-esteem. When your child was little, you can probably remember the happiness you felt at his or her first real smile or laugh, or the joy he or she experienced at sharing a triumph with

you. The joy you felt enhanced the joy your child felt, and it was reflected back at you. Over time, as your communication developed, you fostered your child's self-esteem and expectation of joy in a relationship.

Though at first your young child viewed you as an idealized figure, you also helped him to develop a realistic perspective, and to trust his ability to solve problems on his own. This meant allowing him to experience disappointment and frustration without stepping in to solve the problem for him, while allowing him to return to you for emotional refueling. Raising an emotionally healthy teenager requires that same kind of balancing act and, even in an optimal family structure, it can seem daunting. Laying down the law for an unruly child is never easy and the outbursts of wrath that follow can be painful. The important thing to remember is that it's not about you. (This can be tough for a narcissistic parent to swallow, since *everything* is about them.)

Furthermore, a parent's ability to engage with her child during this important developmental window can be derailed today by any number of factors. Divorce, overwork, illness, personal problems such as addiction, ambivalence about having children, or issues left from their own childhood—any of these can strain a parent's vigilance. In early childhood, such lapses can open the door for the child to begin developing the traits of primary narcissism. In adolescence, parental unavailability allows the traits of secondary narcissism to flourish. Though our culture often suggests, not unreasonably, that teens should be given space to explore their newfound autonomy, the truth is that vigilance and guidance at this stage are essential. Teens may look like adults, but I can assure you they're not.

The narcissistic impulses of teens are generally reinforced by parents in one of two ways. When parents are overprotective, it

signals to their children that they need to be rescued from unpleasant feelings when, in truth, it's usually the parents who can't tolerate the pain of seeing their children in a distressing situation. The parents then protect their own feelings by protecting the child, and the adolescent concludes that he's unable to handle normal feelings of pain or frustration on his own. On the other hand, sometimes parents become overwhelmed, angry, or frightened when confronted by their child's emotions. Such displays can cause the child to become stuck developmentally, as he learns to ignore his or her own emotions in order to focus on managing the emotions of the adults around him or her. Or the parents' overreaction may cause the child to be paralyzed by anxiety, and prevent him from wanting to explore the world on his own.

Either way, when parents prevent their child from truly experiencing his own emotions, it reinforces the child's narcissistic impulse to turn to others to bolster his sense of self, instead of experiencing his own feelings in a meaningful way. People who lack a complete sense of self depend on others to pump them up and make them feel okay. And from YouTube to *American Idol* to Paris Hilton, the media stratosphere is full of role models for this kind of narcissistic shortcut to self-esteem.

■ ■ ■

Three particular parenting styles have been associated with the development of highly narcissistic traits in adolescents and young adults. All three of these approaches are characterized by a lack of appropriate boundary between parent and child, a dynamic that appears to be on the increase in modern parenting. Even if you believe you have a healthy approach to raising your child, examine these three categories and ask yourself which of the three feels closest to your parenting style. In moderation, none of these styles

necessarily leads to the amplification of narcissism in children. When one particular parenting style becomes extreme, however, it can lead to serious problems.

Blatantly lenient, indulgent, and permissive. Parents who give their child too much freedom, who look the other way when the child acts out, and who blame others when the child gets in trouble, are parenting from one of three positions:

- *Lack of interest:* They can't be bothered to invest emotional or physical time with their child.

- *Self-interest:* They will not risk second-guessing their child's behavior because his achievements or career benefits the family (financially or otherwise).

- *Narcissism:* The parents teach the child that he is superior to others and entitled to special treatment, regardless of his behavior.

When parents employ any of these behavior styles, the potential damage to the child is twofold: Not only will the child's development be hampered by the insufficient parenting, but the style itself will be learned and even mimicked by the child, amplifying any characteristics of the narcissistic self in the next generation.

In an appearance on Nancy Grace's talk show, Hilton family biographer Jerry Oppenheimer laid out evidence that Paris Hilton's mother, Kathy, subscribes to this lenient parenting style. Describing the sense of entitlement Paris displayed from the point of her arrest in 2007 through her appeal and sentencing, Oppenheimer said, "She comes from a family that for decades has felt they're above the law. A few years ago, her mother, Kathy Hilton,

made a statement that clearly underscores the jam Paris is in now and the kind of life she's led since her early teens. And those words were, 'My daughters are stars, and stars may do anything they please.' And Paris grew up with this—inherited this Hilton arrogance, her false sense of privilege, her narcissistic ambition from being the center of attention, [which she] inherited from her mother and her maternal grandmother and from the Hilton side." On the same show, psychotherapist Mark Hillman concurred, citing Paris's "grandiose sense of her own self-importance" as one of the "classic . . . diagnostic criteria for a narcissistic personality disorder."

Gratifying your child's every need, whether to compensate for your own guilt, or because you cannot tolerate the idea that others might judge *you* for having an unhappy or unsatisfied child, will only fuel your child's sense of entitlement and grandiosity. A child raised in a blatantly lenient, overindulgent atmosphere will emerge as an adult with an over-inflated sense of self-sufficiency, without the skills to back it up. Adults with these traits tend to think *I deserve certain things and I expect others to take care of them for me.* It's no wonder the celebrity lifestyle is so appealing to a generation raised with these expectations, although they inevitably lead to pain and disillusionment.

Enmeshed and manipulative. Enmeshed and manipulative parents often see themselves as intensely loving and protective, but they selfishly undermine their child's development of an independent sense of self by allowing their identity as a parent to become completely enmeshed in their child's life. This narcissistic use of the child to satisfy the parent's selfish motives causes narcissism to develop in the child. Unwilling to sacrifice the identity they have developed in relation to their child, the enmeshed parent never

allows the child to experience the failures or frustrations that allow any child to break away from his parents psychologically. As a result, the child becomes narcissistically dependent on external sources of guidance and feedback.

In a variation on this theme, some parents become emotionally fused with their children. Such a parent can experience depression or panic if the child tries to break free from the idealized narcissistic shell he lives in. It's not that the child is incompetent to do so (though the parent's reactions may cause the child to feel this way). It's just that the parent sees any change or break in the relationship as abandonment. The parent's issues thus become the responsibility of the child.

For examples of such fused parent-child relationships, one need look no further than the many celebrity stage mothers and fathers who have tied their own careers and identities so closely to the successes of their children. Jessica and Ashlee Simpson are managed by their father, Lindsay and Ali Lohan by their mother, and shows like *I Know My Kid's a Star* are populated with dozens more examples, all of them exploited by the shows for their dramatic value.

From 2004 to 2006, about two million viewers tuned in to E! each season to watch as superenmeshed mother Lisa Gastineau and her daughter, Brittny, navigated their social lives, career choices, and dating prospects while living together in New York. Lisa's identity was so tied to Brittny's that, in one episode, as the two were discussing plans for Brittny's upcoming birthday party, Lisa refused to let her daughter reveal how old she was. Lisa referred to it as a "Gastineau rule: Never tell your real age." As talent scout Jimmy, another character on the show, wryly noted, Lisa wasn't worried about her daughter being perceived as older. The real problem was that "the older Brittny gets, the older Lisa gets."

In the enmeshed and manipulative style of parenting, as in the blatantly lenient, indulgent, and permissive style, parents defend their total involvement with their children's lives as the result of being their child's "best friend." But parents aren't meant to be their children's friends. Parents must set boundaries, impose rules, mete out discipline, and expect accountability for their children's actions. I see too many parents who aren't willing to set limits for their children because they're afraid their children won't like them, or because their own identity and success is so enmeshed with that of their child. Sadly, these parents are in crisis themselves, and they are the root cause of the development of unhealthy narcissism in their children.

Though such parents protest that they have the best intentions, becoming enmeshed in a child's life offers no real guarantees that that child will view his parents as loving and dependable friends. A 1998 study published in the *Journal of Personality Assessment* looked at the associations between celebrity, parental attachment, and adult adjustment among seventy-four former child TV and film performers. As adults, former young performers whose parents served as their professional managers viewed their mothers as less caring and more overcontrolling than did performers whose parents were not their managers.

As parents, you must remember that the journey from childhood through adolescence is a journey to autonomy. To prevent your children from developing heightened secondary narcissism, and to help them develop strong self-esteem and emotional health, it's important to help them build independence and self-sufficiency. If you attempt to protect your child from every risk, he will grow up with no strong sense of autonomy. At worst he may never really develop a sense of self, having continuously suppressed his own

wishes in favor of fulfilling your parental expectations. This won't be recalled fondly as the child grows older.

Unloving and strict. Not all showbiz parents are overly permissive and intent on being their children's friend. For years, Joe Jackson micromanaged the career of his sons, who sang professionally as the Jackson Five, using psychological and physical abuse until they finally fired him in the 1980s. Jackson saw nothing wrong with his tyrannical, abusive treatment of his family. "You have to be strict with kids," he said. "There's nothing wrong with punishment as long as you know how to punish." As for the effects of his parenting approach, the Jackson children's adult lives say it all. From Judy Garland to Brian Wilson and his brothers to Tori Spelling, unhappy childhoods at the hands of strict and emotionally withholding parents are common in show business, and they leave wounds that can take a lifetime to heal.

Psychologist Otto Kernberg suggests that narcissism can develop when a child's sense of self is shaped by a parent who is cold and hard, but nevertheless regards his or her child as gifted or special. Kernberg observes that narcissistic children "often occupy a pivotal point in their family structure, such as being the only child, or the only 'brilliant' child, or the one who is supposed to fulfill family aspirations." In a strict and unloving parent/child dynamic, the parent often uses the child for vicarious fulfillment of his or her own aspirations. Such parents often neglect to provide emotional support, depending instead on their high expectations and harsh demands to compel the child to behave as the parent wishes. Since Kernberg first observed this pattern decades ago, modern American culture has come up with more variations on the theme than he could have imagined.

Children who grow up in a household with cold, distant, and strict parents crave attention so desperately that they are at high risk for exploitation or abusive relationships as adults. They perceive any potentially exploitative partner as strong and capable of protecting them, only to fall, often repeatedly, into cycles of abuse. Highly narcissistic individuals may also seek this kind of attention by acting out in an extreme fashion, behavior that's driven by the notion that any kind of attention is good attention, and reinforced by repetition compulsion arising out of past traumas.

Dealing with a truly narcissistic child is very difficult, as such children are not interested in changing at all. The same thing can be said of dealing with narcissistic parents. Many parents leap to the conclusion that any problem their child experiences must be due to some external source; that itself is a sign of narcissism on the parent's part. If your child isn't behaving, are you blaming it on the school? On his peers? On the media? One of the hardest things for parents to do is to look in the mirror and wonder whether their own parenting techniques might be responsible for their child's bad behavior. Narcissism is only one of many personality disorders handed down from generation to generation, with each new installment amplifying its effect. Take a look at your children. Then look back to their grandparents, and ask yourself: Is your parenting style a reaction to how you were raised? Are you overly strict or overly permissive because you had strict and distant parents? Are you reacting to an emotionally distant upbringing by being overly enmeshed in your children's lives? Or, worst of all, do you feel justified in acting abusively toward your children because that's how you were raised? If you answered yes to any of these questions, you're probably passing on narcissistic traits to your children.

As parents, we should all remember that we're responsible not

only for shaping our children's lives, but for modeling the kinds of positive childrearing behavior we wish to pass on to the next generation, and the next after that.

■ ■ ■

In a time when the prospect of hard work has a bad rap among tweens and teens, narcissistic parents may not understand how to instill self-discipline and self-control in their children. The baby boomers felt an overwhelming need for external validation that led them to bury themselves in their work. They thrived on developing competency and were often tagged as overachievers. This need for total approval and support made them a generation of workaholics and millionaires. Today, these same boomers have begun to feel they toiled too hard, and made too many sacrifices in their quest for success, ignoring what research has shown again and again, which is that real happiness comes from important relationships. As a result, they are turning to every type of self-help program they can find, from spiritual gurus promising "The Secret" to happiness, to diet books, fitness plans, and cosmetic surgeries, to help them look and feel younger.

As a recent article in *Smart Money* pointed out, more and more Americans are spending thousands of dollars on antiaging strategies, hoping that miracle drugs will be developed in their lifetimes to prolong their lives indefinitely. One woman in the article was quoted as saying that she hopes to live to at least 116. Madison Avenue's insistence that "sixty is the new fifty," "fifty is the new forty," and so on, is aimed squarely at these overachievers, who cling to the belief that there's still hope for another shot at life.

Even as they seek to reinvent themselves, many boomers are intent on making their children's lives better and easier than the ones they led. Why should their children have to work as hard as

they did? While most boomers acknowledge that they never won trophies just for showing up, and that nothing was ever handed to them on a platter, they seem to turn a blind eye when it comes to their own kids. Behind this ambivalence is the realization that all their successes haven't helped them find true meaning in life; in fact, they've often left them with a feeling of emptiness. Seeing your children struggle can be painful, but navigating a challenge is a main source of true personal learning and growth. When we reward our children for not really doing anything, they develop the mindset that being successful is quite easy, and come to believe they're entitled to have whatever they want.

In the comedy *Meet the Fockers*, Gaylord "Greg" Focker has become engaged to Pam Byrnes. Both sets of parents are now meeting for the first time at the Focker family home in Florida. Bernie, Greg's father, shows his guests the "Wall of Gaylord," a shrine of sorts displaying the ribbons and plaques and trophies that Greg has won. At first, Pam's father, Jack, is impressed, until he gets closer and reads the inscription on the first award. "I didn't know they made ninth place ribbons," Jack says sardonically. Bernie responds proudly, "Oh, Jack, they got them all the way up to tenth place."

It's a scene that could be played out in households anywhere in America today. Ray Baumeister, a psychology professor at Florida State, has pointed to the explosion of trophies as a result of the self-esteem movement that began in the 1970s. This movement was largely the result of boomer parents hoping to raise more successful kids; unable to maintain boundaries with their children, the parents couldn't tolerate their children's disappointment at not winning, and invented more and more awards to ensure that everyone walked away with some kind of reward for showing up. What these parents failed to understand is that constantly being

proclaimed a winner deprives children of the opportunity to understand and experience the world realistically and to learn to tolerate failure and frustration. "The trophies should go to the winners," Baumeister says. "Self-esteem does not lead to success in life. Self-discipline and self-control do, and sports can help teach those."

It's that same entitled mindset that leads children today to see reality shows, YouTube videos, and the like as potential shortcuts to fame and success. Children who are the product of narcissistic parenting are at much greater risk of having toxically heightened narcissistic traits: They're likely to have low empathy, excessive ambition, strong feelings of grandiosity, and an inordinate need for praise and tribute from others. These individuals experience pleasure only in the presence of admiration, and modern celebrity culture dangles the prospect of attaining all the admiration in the world, without putting in any more hard work than Paris Hilton does before heading out to greet the paparazzi.

■ ■ ■

Who could appear more idealized, to a teenager, than another young adult who lives a life of total freedom from parental authority, with unlimited funds and complete power over those who surround him? In the normal developmental arc of adolescence, the young man or woman normally turns away from his parents as idealized objects, and toward someone or something that feels bigger than oneself. Today, when teenagers appear almost universally fascinated with celebrity lifestyle, a highly visible or famous star is a natural object for such idealization. However, the changing landscape of access to celebrities, combined with this generation's narcissistic drift, may make this psychological process potentially destructive.

In the article "Adolescent Psychology and the Media," therapist Jared Maloff quotes a 1995 University of Maryland study examining the idealization of celebrities among children from ages ten to seventeen. The results of the study indicated that the highest degree of idealization and modeling occurred among ten- and eleven-year-olds, although it was present in all demographics. As children begin to realize that their parents aren't infallible, they turn to celebrities to fill the void. Thanks to the entertainment industry and the Internet, Maloff notes, preteens and teens "can easily discover what parties their favorite young celebrity attended last night, what they drank, ingested, inhaled, or injected, and who they spent the night with. The celebrity party lifestyle is of course nothing new to the average person's awareness, but the video, photos and detailed blogs of each celebrity's own egocentric gratification of his or her own needs through sex, drugs, or alcohol are novel."

Maloff points out that such behavior is often consequence-free for the celebrities themselves, who are protected by their wealth and mystique. However, the average adolescent, who may enjoy feelings of invincibility, while lacking the higher reasoning function of the prefrontal cortex, will be helpless to protect himself from the very real fallout of emulating his idols' risky behavior.

As a child's need to please himself and his peers increases, his need to please you, his parents, decreases. In a healthy family, his parents will continue to meet his needs for both differentiation and emotional fulfillment. In a narcissistic family, however, the parents will view the child as selfish, conclude that he's acting intentionally to thwart them, and perpetuate the cycle indefinitely.

■ ■ ■

In the context of childrearing, it bears repeating: Narcissism is not all bad. A healthy balance of narcissistic traits can propel a person

to great success. Your mission as a parent should be to help your child develop the self-esteem and empathy that will enhance his real relationships with others, while helping him positively channel certain narcissistic traits. Here are some things to be aware of when confronting challenging situations with your preteen or teen:

■ *Resist the urge to activate your own narcissistic qualities.* If you react to the pain in your child by rushing to protect him, so that you can avoid feeling pain or shame yourself, you'll only teach him that he needs to be saved. If the only reason you want your child to feel gratified and happy is so that you can feel good about yourself, you won't raise an emotionally healthy child.

■ *Appreciate your influence.* A study by Brigham Young University family scientist Laura Walker has shown that the more parents are aware of what's going on in their children's lives at college, the less often the children tend to engage in risky behaviors. Students were less likely to do drugs or engage in risky sex if their fathers were looped in on their lives, students were less likely to drink alcohol when their mothers knew about their behavior, and students who were generally closer to their mothers were less likely to be involved in any of the three risk behavior categories studied: drugs, alcohol, and risky sexual activity.

■ *Maintain your authority.* Establish and hold boundaries. Remember, you're the one with the fully functioning brain circuitry. Don't make the mistake of sharing your youthful indiscretions as a bonding experience or cautionary tale. I have told this to thousands and thousands of parents:

When you share stories of your youthful misdeeds with your children, you're giving them a license to pick up where you left off. Too much disclosure can undermine your authority. Never lie to your child; just don't reveal what you don't have to. Instead, use the media, especially the celebrity media, as a vehicle to stimulate discussions about drugs, sex, or alcohol.

■ *Establish clear household values*. Lead by example. Teach your children to value relationships as well as accomplishments. Share moral, spiritual, and emotional values, and talk about how you believe they contribute to health and happiness.

■ *Let kids be kids*. Don't overconfide: That tends to shift roles, and can lead to a narcissistic family dynamic, with the child taking responsibility for meeting the parents' needs. Children should develop their own friendships with their peers; they don't need you to be their friend. They *do* need you to be their parent, which means maintaining appropriate boundaries while being fully present and loving. It can be exhausting to enforce limits on your children's behavior, but it's important not to take the easy way out and gratify their every whim, until you're treating your children like adults or, even more destructive, until they've assumed the upper hand in the relationship.

■ *Don't avoid the topic*. If you're the parent of a tween, teen, or young adult, you've already got at least a passing familiarity with narcissistic behavior. Teens, like infants, are narcissistic by definition. You shouldn't worry just because your teen seems self-absorbed, somewhat moody,

expects frequent praise, or has occasional fantasies that seem grandiose to you. These are all a normal part of the developmental process, and as a parent you can play an important role in helping your teen navigate this stage of life.

What *can* spell trouble is if your child seems to be manifesting steadily *increasing* signs of any of the tendencies above, or if you notice that he or she demonstrates several of the following behaviors: a distorted sense of reality; poor impulse control; a low tolerance for frustration; poor ego boundaries; a need for control; a tendency to deny uncomfortable feelings; a tendency to manipulate the people around him or her by idealizing them when they offer what he or she needs, and devaluing them when they frustrate him or her; or excessive tantrums or outbursts of rage. If your child is showing many of these signs, you may be dealing with a child whose narcissism is nearing disorder levels. Remember, too, that traumatic events in early childhood trigger rigidly narcissistic behaviors to emerge as coping mechanisms. If you know that your child has experienced some degree of trauma, you should seek professional help for her, and perhaps for your family as a whole.

In adolescence, when narcissism is quite evident, all children experience challenges involving their relationships with others, including with peers at school. Pay attention to your child's interaction within the family and with friends. If you notice a lack of empathy, for example, or a tendency to exploit oneself and others, or a strong self-preoccupation, start by talking to your child about it. But don't be surprised if the response you get is not positive. Many children, whatever their levels of narcissism at that

stage, will fail to acknowledge that any problem exists; they may even react violently to what they perceive as unfair criticism from you. If you feel you're unable to communicate effectively with your child, or feel unsure about setting limits and boundaries, I recommend that you and your child talk to a professional counselor who specializes in treating adolescents. Remember that asking for professional help is no reflection on you as a parent. (In fact, if you find you too easily interpret every aspect of your child's behavior as a reflection of your parenting skills, that may be a sign of narcissistic tendencies of your own.)

If your child exhibits normal levels of adolescent narcissism, but you worry that these tendencies are being amplified by exposure to particular elements of celebrity culture, you should talk with him or her about it in a way that communicates that you expect him or her to be responsible for managing such behavior. It's unrealistic just to hope that a child's narcissistic behaviors will go away if you hide that issue of *Star*, or forbid a particular channel on the TV. You can't prevent tweens or teens from knowing exactly what's going on with Lindsay or Angelina or Miley; they'll hear about it at school, read the magazine at the drugstore, or check TMZ on the Internet at the library. What you *can* do is talk with them about the serious consequences of such behavior, and provide appropriate roadblocks if your child starts acting out in similar ways. Above all, don't avoid the topic: If you do, you'll only be shirking your duty as a parent.

■ *Use celebrity media stories for productive conversation.* Celebrity media scandals can open the door for conversa-

tions with kids. Start talking with them about their favorite stars as early as ages eight to twelve, to pave the way for more substantial conversations later. Keep the conversation open; don't just talk, also ask them what they think. Follow up with open-ended questions: "Do you want to know anything else?" Respond in ways that reinforce family values and share your expectations as you talk about the consequences of celebrity behavior in real life. Explain why you think the behavior is inappropriate or disturbed, without blaming your child for being intrigued.

■ *Trust but verify.* The worst thing any parent can think, or say aloud, is, "not my kid." I have talked to too many kids who tell me "my parents have no idea . . ." If you're doing your job as a parent, you'll keep verifying that it's "not your kid," after all.

■ *Help your child connect with his real self.* On *Celebrity Rehab*, one of Mary Carey's biggest therapeutic breakthroughs came when she reconnected with her passion for dancing. It helped her to rediscover a very genuine piece of herself. Allow your children to find their passion, not the passion *you* wanted for them, by exposing them to a wide variety of experiences and people. Allowing them to face realistic challenges, being supportive (without rescuing them) when they struggle, and letting them get used to the dance of effort and frustration, are all critical to your child's developing self-esteem.

■ *Avoid overpraising.* Don't be overexuberant or offer false or inflated praise for whatever your child does. Instead, let your voice be part of a chorus of deserved praise for effort

and achievement. Co-opting your child's experience to nourish your pride is just another form of parental narcissism.

There's no denying that good parenting takes hard work. However, the effort is well worth it when you realize that, with help, teenagers can pass through the enhanced narcissism of those years with positive results. Parental involvement is key in helping adolescents develop healthy self-esteem, and helping them manage and channel their healthy levels of narcissistic traits productively.

Given the social circumstances we live in today, we're at serious risk of raising a generation that's more narcissistically driven than any in living memory. As parents, it's time for us to recognize that risk, and to take every measure we can to stop it. We must stop the legacy of unhealthy narcissism from being handed down to our children. And the way to begin is by looking in the mirror to assess our own personality traits and look for signs that changing our behavior will help change our society for the better.

Turning the Tide

On March 27, 2008, a well-known singer posted an extraordinary statement on his personal blog. Under the heading "FROM THE HEART," he offered a surprisingly thoughtful essay on the relationship between public images of celebrity and the dreams and fantasies of everyday people.

"What I'm about to write isn't about fame or success or celebrity or the media," he began. Rather, it was about what he perceived as rampant "self-consciousness" among young people, at levels "so high . . . that it's actually toxic."

He offered a few capsule portraits of the phenomenon he had in mind: The *American Idol* contestant who crows that he was "born ready to sing in front of the world," even as he trembles "so badly he can hardly breathe." The girl who'll "take a hundred photos until coming up with one she's happy with, which inevitably looks nothing like her . . . post one on her MySpace page and then write something like 'I don't give a f*ck what you think about me.'" The young man whose gossip blog "subsists on tearing other people down, [despite his] lifelong battle for acceptance as a gay man."

The writer even contributed a self-portrait—of someone who confronts the paparazzi with false bravado, "like he's Paul Newman," but who "leaves a 'reject' pile of clothes in his closet so high

that his cleaning lady can't figure out how one man can step into so many pairs of pants in a week."

What did these people have in common? They all "seem to know deep down that it's incredibly hard to be alive and interact with the world around us," but "try and cover it up at any cost," though many live constantly "on the edge of tears."

And what did he see as the reason for this widespread sorrow and insecurity? Perhaps, he suggested, it was the fact that "every one of us were told since birth that we were special," that "we were promised we could be anything that we wanted to be, if only we believed it"—and then grew up to confront "millions of other people who were told the exact same thing."

"And really? Really?" he concludes, "it turns out we're just not all that special, when you break it down. Beautifully unspectacular, actually."

Whether he knew it or not, this blogger had touched on all the core aspects of the Mirror Effect: the fixation on media images of celebrity; the attraction to shortcuts to fame such as MySpace and reality TV; the attempt to create an alluring pseudo-self; the moments when entitlement collides cruelly with reality, triggering a rush of panic; the descent into envy, with its temptation to tear down one's idols; the insecurity at the heart of the narcissistic personality; even the roots of the dysfunction in flawed parenting.

And who was the author of this perceptive portrait? It was singer-songwriter John Mayer, who posted it on his MySpace page while on a trip to Japan.

Even though Mayer's sentiments themselves could be viewed as somewhat grandiose, he may be the first artist to address the issue of narcissism among young people, including himself, explic-

itly. In his remarks, Mayer seems anxious to insist that he's really just like everyone else, though that may be an attempt to protect himself from people acting out aggressively against him.

When Mark and I first read this post, we were awed by how insightfully Mayer captured the narcissistic ethos of society today. Yet we also suspected that, no matter how well-intentioned his message was, it might be difficult to live up to in practice. Just over a month after he posted these words on his blog, Mayer's tabloid profile skyrocketed when he became involved in a romance with Jennifer Aniston. Tagged in the media as a serial dater of celebrities including Jessica Simpson and Jennifer Love Hewitt, Mayer had renewed his status as a player in the tabloid drama of young Hollywood.

Mayer might argue that he'd be dogged by the media no matter whom he dated, but, of course, the spotlight would be far less intense if he hadn't taken up with the most eligible woman in Hollywood. Basking in the narcissistic glow that surrounds Jennifer Aniston, one of the most watched celebrities on the planet, apparently provided John Mayer with some source of satisfaction.

Still, taken at face value, Mayer's message accurately captured the unhealthy narcissism we see today among celebrities and everyday people alike. As the media exploits the chaos on a minute-by-minute basis, America's youth are being seduced by what they see. And those with strong narcissistic tendencies are following the celebrities' lead.

Like an infectious agent, the Mirror Effect threatens to transmit the psychologically damaging traits of narcissism from the celebrities who model them to a generation of viewers who follow their every move, and mirror it back in their own behavior. Like any communicable disease, it infects the most vulnerable most

intensely, amplifying the force of the epidemic. For those who already harbor unhealthy narcissistic tendencies—individuals who suffered trauma in childhood and adolescents at a critical stage of development—the narcissistic projections served up by the media feed their dysfunctions, and encourage them to mirror the behavior back into society.

As narcissistic behavior becomes normalized, and certain undesirable traits become regarded as unexceptional, even individuals with little or no predisposition are at risk of being influenced by prolonged exposure to the rampant narcissism of celebrity. The nonstop soap opera of celebrity narcissistic behavior is causing envious members of society to act out their collective aggression on those who seem so perfect.

The cornerstones of healthy self-esteem and empathetic development, which are the family structure and the environment for healthy childrearing, are failing. Narcissists are having children and passing along the traits through abusive or exploitative parenting. If the Mirror Effect is unchecked, what will happen as narcissistic traits continue to be amplified, projected, then reflected out again?

The antidote to this is stable, emotionally meaningful human relations. However, these have been subsumed in our culture by the more arousing and addictive gratifications of entertainment news, which create huge profits for the corporate monoliths. People everywhere are gazing into the glassy surfaces of their televisions and computer monitors and glossy magazines, then gathering in groups to cluck about the latest gossip. These well-intentioned people become riveted to the exploits of the idealized creatures with whom they identify, until their admiration turns to envy, envy turns to aggression and righteous indignation, and, even, the impulse to sacrifice.

Among the most vulnerable members of the population, the nonstop celebrity soap opera creates a deep craving for fame. When that craving is denied, however, it activates aggression. If that seems hard to believe, go to any of the major gossip sites and read the comments after any item posted there. The vast majority of the comments are filled with anger and bile. Celebrity gossip has become a blood sport. Increasingly, this aggression is directed not just toward the celebrities featured in a given post, but also toward other commentators with different opinions. Our greatest fear is that such aggression might one day be redirected away from casual celebrity gossip and toward other social groups. That is how forces like racism, apartheid, and ethnic cleansing arise.

It will take widespread social change to reverse the ascendancy of these unhealthy narcissistic traits—entitlement, vanity, aggression, envy—in our culture. Without such change, these traits will transform generation after generation from caring, empathic human beings to self-promoting, ego-preoccupied aggressors who seek nothing more than targets for their rage, or occasions to gratify their grandiose fantasies of fame.

Fortunately, it is possible to change even major social trends. While it's extremely difficult for narcissists to change their behavior, it's by no means impossible. Narcissism does not have to mushroom into a toxic trait. Those with unhealthy narcissistic traits can use certain manageable strategies to seek a deeper understanding of themselves and their motivation. These simple behavioral changes are so basic as to be revolutionary.

If you believe you may harbor such traits yourself, making these changes will take conscious actions at first, but as you develop healthy psychological habits, and the experience of true, empathetic exchange replaces your narcissistic urges, they will come to feel effortless. According to Allan Schore, a UCLA expert in

neuropsychoanalysis and expert on the origins of personality disorders, such a change involves an integration of psychology and biology, of the mental and the physical. This, Schore says, can lead to a "paradigm shift" in the way we recognize conditions like narcissism in ourselves. "The essential thing seems to be that the patient[s] not only see their narcissism, and talk about it," he said, "but also that they have a physical experience of the emotion that underlies it—rage, shame, sadness, whatever it is."

■ ■ ■

The seven steps that follow offer simple techniques that anyone can use to begin to understand the motivations behind our narcissistic traits, and the empathetic responses that can overcome baser impulses like envy and aggression. If you learn to tune in to yourself and others, you may soon find that your own life is far more captivating than the glamorous lives reflected in the media mirrors.

1. STRIVE FOR INCREASED SELF-INSIGHT AND EMBRACE THE CONCEPT OF SOMETHING GREATER

Generally speaking, people don't change without some sort of spiritual awareness, life-altering experience, or systematic approach to changing their mindset. Research in the social sciences indicates how difficult it is for people to make even small changes to themselves, let alone more sweeping changes in how they function interpersonally and psychologically. Everyone tends to make sense of the world, and cope with it, through the lens of his or her own idiosyncratic experience. The self is, after all, what the brain is trying to sustain.

Once we accept that real change is difficult, the first step to

understanding how to change is to gain a deep sense of self-insight. You must be willing to ask, and truthfully answer, such questions as: Why am I the way I am? How did I get to this point? Who are my strongest influences? What do I believe in, and what do I stand for? Do I ever question these beliefs and my own motivations? Do I truly experience my emotions? Do I have difficulty appreciating the feelings of others? Am I a well-adjusted person, or do I know I have personality problems that I haven't addressed? Ultimately, what will I need to do in my life to achieve long-lasting happiness?

Narcissists often have a deep sense of emptiness and shame that they carry from early in life. They may have huge egos, but they have no self-esteem. Their grandiosity is merely the result of the enormous pain caused by their early-life trauma. Their psyche is stuck in an early developmental stage. The patterns of behavior they adapted to deal with traumatic events may have protected them in childhood but, in adulthood, they have become inappropriate and damaging.

Because such adaptive mechanisms are closely tied to survival instincts that emerged in what seemed at the time to be life-threatening circumstances, it can take a life-threatening event to break the pattern. Some people will cling to their defenses until their life is truly in danger, or until they incur major losses, particularly of important relationships.

Embracing the concept of something greater may involve a specific experience of God; it may or may not include an attachment to a religious community or faith. It can also involve a simple awareness that the world doesn't actually revolve around you. The basic element is faith: Faith that the sun will come up in the morning, that the laws of physics will continue to function as we have always known them, and, most important for the narcissist, that

people can be trusted, and that the world can be a good and safe place.

2. PRACTICE RIGOROUS HONESTY

Honesty is critical for two reasons. We need honesty to access our own genuine emotions, and to allow others to connect with the genuine, core elements of our true self. When you're not straight with others, it becomes easy not to be straight with yourself. This can obviously contribute to an unhealthy emotional existence, since chaos and stress are part and parcel of lying. One lie leads to a hundred, and soon a pathology has emerged.

Trust comes with honesty but, as we've seen, trusting others can be difficult for those with high levels of narcissistic traits. For such individuals it's all too easy to slip into a pseudo-self, or to become manipulative, in order to fulfill their narcissistic needs. The only antidote to such behavior is firm, inflexible reliance on the truth.

3. KEEP THINGS SIMPLE AND LIVE UP TO COMMITMENTS

This may sound like advice your great-grandma would have given you: "Live a simple life" and "Keep your promises." However, these two tenets actually serve as a meaningful foundation for developing emotional health. When you keep your life simple, you allow your most important relationships—most often friends and family—to give your life its meaning and purpose. Having such relationships gives people confidence in each other while quelling any feelings of alienation from the wider world.

Emotional dysfunction often has its roots in set behaviors people adhere to, unwilling or unable to give them up: behaviors such

as addiction, eating disorders, or dangerous acting out. Even when these strategies are no longer working for them, they still cling to them rigidly. Rather than change their lives, and risk some of the things they may consider important (such as their job or lifestyle), they narcissistically blame the world for not cooperating with their needs.

Living simply also means, in a very direct way, living up to your commitments. It's impossible to live a healthy life without keeping faith in the relationships and obligations in which you're invested. One problem in contemporary society is that we've become accustomed to the idea that everything is disposable; some extend this attitude toward relationships and even family, choosing to toss away their closest bonds if they fail to meet selfish needs. The reality is that most people with narcissistic dysfunction find themselves re-creating the same unsatisfying relationships again and again with different people. This repetition compulsion cycle can only be broken when you make a conscious choice to work through problems and honor your relationships.

4. SPEND TIME WITH A BROAD RANGE OF PEOPLE

Spending time with others is essential, not just for one's emotional health, but for the very nature of self and structure of our personality. We can only truly find ourselves through interaction with others in a social context. At the most fundamental level, we derive our sense of self only through awareness of others. Our lives should draw their meaning, and their greatest joys, from our interactions with others, but it's too easy in society today to focus too much of our energies on our own needs and desires, and to place only limited value on our personal relationships.

Americans value independence, industriousness, efficiency,

perseverance, and performance. We spend too little time in quiet conversation. Spending time with people you're closest to can be an important source of emotional nourishment. However, such relationships can be so deeply familiar that their ultimate value in enhancing our emotional landscape is limited. Spending all your time with the same five people does little to change your basic system of relating to others, and can be an outright obstacle to making significant changes in your life.

The opportunity for real change, particularly in how you experience yourself in relation to others, comes from spending time with people who *aren't* deeply familiar to you, and who are therefore more challenging to connect with. When I meet people who have made major changes in their behavior and sense of self, they often tell me that their willingness to change developed after spending a significant amount of time with someone new and different. Rather than repeatedly experiencing themselves as they always had, these people literally allowed themselves to be seen through a new pair of eyes.

The great benefit of broadening your circle of interaction is that it allows you to experience yourself in a new context, and quite likely across a wider range of emotions. Many people who have done this say that it allowed them finally to see themselves as they truly are, and that their habits of denial diminished; they gained new insight into their behavior and the impact it was having on others around them.

5. SHARE YOUR FEELINGS

People today often seem to assume that authority figures, or people with special knowledge, can somehow magically endow us with

the capacity for change. In search of easy answers, people in distress tend to turn to self-styled gurus for help, then sit back expecting the solution to be handed to them. Unfortunately, human nature isn't that simple. People don't change just because someone tells them to, or gives them permission to. It takes a flash of personal insight, or a conscious awareness of a particular need, for such a person to start moving toward change. Even once that change is made it can take persistent, committed effort to sustain.

Drug addicts don't stay in their disease simply because they're unaware of its consequences. They are *deeply* aware. They're also ashamed and guilty about the consequences of their using. But they can't stop. That's what makes it an addiction. If all I had to do was convince heroin addicts that what they were doing was unhealthy, or educate a bulimic young woman about the dangers the disease posed to her body, then every last one of my patients would instantly become physically and emotionally healthy, but that is not how human beings work. That kind of change must take place in the more primitive regions of our brains, where motivation is determined. Drives and feelings, not rational deliberations, are the engines that compel our behavioral patterns.

Although changing your thoughts can sometimes lead to changes in your feelings or demeanor, the most important way to gain entry to the primitive systems of motivation is to learn to access, and share, your feelings. You can't change yourself just by sitting alone and wishing it would happen. Unless and until it's challenged by another person, your primitive system will remain fixed within its usual paradigm. Together, two or more people relating, connecting, and communicating create an experience we call *intersubjectivity*. As one person has an emotional experience, the other receives it, appreciates it, and returns some version of the first

individual's emotions. This can take the form of nonverbal expressions, signaling an appreciation of one's emotional state. Or it might be a simple verbal acknowledgment, as basic as "me, too."

The capacity to access and express emotions, to trust that the person you're sharing with is present and available, and to accept their appreciation of your experience: These things, taken together, are transformative. Only by learning to tolerate emotional vulnerability, without allowing past experience or present expectations of abuse, shaming, or exploitation to color our feelings, can we grow and change.

6. LEARN TO APPRECIATE THE FEELINGS OF OTHERS

This is the flip side to learning to share your emotions with others: It's equally important to learn to maintain boundaries. When you're sharing stories with another person who's in distress, you must avoid being overcome by their emotional experience. It can be easy to confuse another's pain with our own, or to try to rescue that individual, to do something to make their pain stop.

While this is an altruistic impulse, rescue isn't always what a struggling person needs. Rescuing someone from a situation of his or her own making leaves that person forever dependent upon rescue, when all that person may have needed was emotional support while grappling with the situation.

Parents often make this mistake, particularly parents who have residual trauma from their own upbringing and are unable to tolerate seeing their child in distress. A child's distress can be unpleasant, of course, but when a parent suffers intolerable pain over that distress, that pain is actually the parent's, *not* the child's. This is one reason we see so much overpraising and overgratification of

children—because parents are especially anxious to quell their own distress.

The healthy posture, for parents or anyone else in such circumstances, is to learn to scrutinize what the other person is truly experiencing; to empathize deeply with that experience; to signal your appreciation for his feelings; and to remain available and present with that individual while he struggles to identify, tolerate, and regulate his emotions. This experience of empathic attunement, and the practice it will give you in maintaining boundaries, will have beneficial effects for you both.

7. BE OF SERVICE

The single most important recommendation on this list is to *be of service*. Simple, selfless acts of kindness and responsibility are an invaluable path toward engaging more constructively with the world around you. This doesn't mean making grandiose gestures, or promises to change the world. The efforts of Sean Penn, Angelina and Brad, Bono, and the like are commendable, but single-handedly attempting to turn the tide of global forces is no way to counter the sway of narcissism in your life; it's more likely to reinforce it.

The smallest acts—helping a stranger in need, or taking the time to really listen to someone else's problems, with no expectation of praise in return—will make you see the world a bit differently. One of my favorite examples comes from well-known LA disc jockey Adam Goldstein, also known as DJ AM. At the age of twenty-four, Adam was a mess: He was a cocaine addict, he weighed more than three hundred pounds, and was desperately unhappy. "I felt like my life was over," he told *Glamour* in January 2008. "So I went

into my living room, reached into a cabinet above my TV and grabbed my gun, a loaded .22. I sat back on my heels, cocked it and put it into my mouth. Then I squinted my eyes and said, '[f---] this.' I pulled the trigger. . . . The gun didn't go off. I thought, Are you kidding me? I'm such a [f---]ing failure I can't even kill myself? I dropped the gun and broke down."

Adam went into treatment and began the process of recovery from his addiction. One night, he was a guest on *Loveline,* and I noticed that he was wearing a very cool pair of shoes. When I complimented him on them, he immediately replied, "I'll get you a pair."

Against all protests, Adam dropped by the studio the next day with a pair of the shoes. When I continued to protest at his generosity, he explained that he was grateful to be able to do this, that simple acts of service were part of his recovery. And he thanked *me* for giving him the opportunity to practice one that day.

When Adam was recently injured in a tragic plane crash, my immediate impulse was to see if I could be of any help at the ICU in Georgia where he was being treated. Being the recipient of an act of selfless generosity makes it easier for you to offer the same. When we strive to serve, our ability to be humble, and to tolerate humility in the presence of others, becomes the primary task. That experience can help you find the great joy and reward of merely helping a fellow human being.

■ ■ ■

So, is there any good news in this survey of narcissism in our culture? Or has the celebrity-industrial complex written a death sentence for healthy human society?

We're optimistic. It's possible for human beings to change their behavior, to unlearn bad habits and develop new ones, to recog-

nize the potential damage we're doing to ourselves and act affirma-
tively to right it.

If you've been worried about the troubling behavior you see in
celebrity culture, we hope this book has illuminated some of the
issues behind that behavior, and helps you interpret it for yourself
and your family.

If you've been worried that your children or loved ones may be
influenced by those troubling behaviors—the dynamic we call the
Mirror Effect—we hope this book has helped you understand what
those types of behavior might mean, why your children might be
vulnerable to their effects, and how to change your own relation-
ship with them in order to address the problem.

And, if you're worried that you may have heightened narcis-
sistic traits of your own, we hope this book has helped you begin
to understand them better, put them in context, and offered you
hope for the future.

From our sociological and medical perspectives, Mark and I
are deeply troubled by the images of narcissistic behavior that
flood our culture today. We could be at the beginning of a pan-
demic of a personality style that was merely a footnote 150 years
ago. Narcissistic parents beget narcissistic children and, as boomer
parents pass the torch to a new generation, they are also handing
over a legacy of narcissistic dysfunction. The media has become
the conduit for the spread of narcissistic behaviors, like the mos-
quito for malaria, fleas for plague, or water for cholera. The sources
are all around you: your television, your computer monitor, the
magazines on your coffee table, classmates at your child's school.
They are feeding your children the most dangerous possible mes-
sages: telling them that heavy drinking, drug use, hypersexuality,
rampant entitlement, eating disorders, cosmetic surgery, and dan-
gerous acting-out behavior are all normal, glamorous, even valu-

able parts of human life, rather than extreme behaviors that need urgent correction.

We also have faith in the resilience of our present and future generations. With every ebb and flow of cultural trends, society as a whole tends to look back to healthier times, to pull forward what was good and right about our predecessors' attitudes and beliefs, and draw on their examples for guidance.

We all share certain narcissistic traits; the question is whether we manage them, or they dominate us. The challenge is to learn how to channel them not into grandiose fantasies, but into productive pursuits. No one has ever said it isn't fun, exciting, and flattering to be famous, but real, long-lasting happiness in life doesn't come from fame; it comes from achievement, and from our relationships with others.

There's nothing wrong with nurturing a dream that someday your achievements might *lead* to fame, that a widespread audience might recognize your talents and admire you as, let's say, an artist or performer. The good news about our media culture is that it has made it far easier for anyone in the world to have access to such an audience. However, there's a difference between striving for success as a performer and indulging in damaging narcissistic behavior in hopes of snagging the brass ring of celebrity. Those who become famous for doing outrageous or stupid things usually find that the initial high is short-lived, especially when there's nothing beneath the surface to sustain the fame, and that the costs far outweigh the rewards. Today's overnight sensation is tomorrow's punch line.

The Mirror Effect is a real and dangerous phenomenon in our culture. It traps people in a cycle of self-involvement, hobbling their ability to connect with others, and thus to understand themselves fully. We meet people every day who share our concern

about the problem, and want to help address it in their lives and the world at large. People are waking up to the emptiness that's at the core of the narcissistic celebrity lifestyle. And they're realizing that the place to start fighting the pandemic of narcissism is within our own lives, by learning to find nourishment and fulfillment in healthy, constructive ways, and by making commitments to real people, to real relationships, and to ourselves.

The Narcissistic Personality
Inventory (NPI)

Whenever we tell anyone about the NPI study we administered to celebrities while researching this book, their first question is: "Can I take the test?" The answer is yes. Before you do, however, you should understand a thing or two about how the test is structured and what it's intended to evaluate.

The most important thing to know is that the NPI is *not* a diagnostic instrument for a personality disorder. It will not tell you if you have narcissistic personality disorder; what this test documents is the taker's levels of various narcissistic traits.

You should also be aware that there is ongoing debate within the scientific community about the validity of measuring narcissism on the NPI or any other scale. Nor is everyone convinced that tests using this scale prove the existence of a trend toward increasing narcissism in our society. However, other studies have offered further independent evidence that the trend is increasing, and this conforms with our own experiences in the field.

Taking the NPI is in no way a substitute for a diagnostic workup by a trained professional. If you're experiencing symptoms such as

depression, anxiety, uncontrolled use of substances, or any other behaviors that affect your functioning, please see a professional. Symptoms that may seem psychiatric or psychological can actually be signs of a medical condition. In any such circumstances, always begin by having a thorough medical evaluation; if necessary, your doctor can then give you an appropriate referral to a mental health professional.

Narcissism has become such a pervasive issue today that it will be natural for most readers to identify with at least some of the issues discussed in the book and to wonder where they fall on the narcissism spectrum. Again, if you're having chronic feelings of emptiness, or difficulty with your interpersonal functioning, simply knowing where you are on this spectrum won't change things. Narcissism is the result of longstanding behavioral patterns that reflect fixed brain functioning. It requires a lot of motivation to change these patterns. In chapter 10, we suggest ways to start changing in a healthy direction, but these suggestions won't be enough for everyone, and you might need professional help to sustain whatever changes you make.

In taking this test, you'll notice that it's sometimes difficult to choose between the two choices offered to you. You may feel that neither, or both, apply. This is what social scientists call a *forced choice*. Although you may feel ambivalent about the choices available to you, the one you do choose has meaning. There are no time constraints for the evaluation, but you should take it in a single sitting, without asking anyone for help or clarification.

There's no such thing as a good or bad result on this test. Scoring high on the narcissism inventory, or high on any of the component categories, doesn't mean you have a disorder, or that you're a good or bad person. Narcissism is an adaptive strategy, one that can be useful in certain areas of human functioning. Narcissism

can be a source of immense creative energy that fuels an individual's need to make a difference in the world. It can certainly be important in extraordinarily dangerous or stressful careers, such as being a fighter pilot, for instance.

Narcissistic traits *are* often a liability when it comes to interpersonal functioning. When a narcissistic individual's emotions become unregulated, and the people around him or her don't comply with his or her needs, the going can get a little tough. If you can't quite empathize with the needs of others, conflict is inevitable. And narcissists tend to meet conflict with rigid unwillingness to change and an inability to see any perspective other than their own. Add in the aggressive reactive tendencies of a narcissist, and it's quite clear that an extremely narcissistic person, and those with whom he or she is involved, are headed for unpleasantness.

If you take this test and get a high score, *and* you're experiencing emotional distress or interpersonal conflict, you should consider seeking professional help. What do we mean by high? Remember that the average score for the population is 15.3. In statistics, we use a concept called a *standard deviation* to explain the spread of the scores are the mean, or average. One standard deviation above the mean accounts for 68 percent of the entire population; two standard deviations accounts for 95 percent of the population. In the general population NPI data, one standard deviation is equal to 6.8 points and two standard deviations are 13.6 points. Thus, if you took the survey and got a score that is two standard deviations above the mean, your total would be 29.9 (15.3 + 13.6). This means that you scored higher than 95 percent of the population that has taken the NPI.

Although we can't stress enough that this test alone is *not a screening tool and* not *specifically meant to uncover genuine pathology or need for treatment,* we do believe that knowledge of one's traits can

create opportunities for change. If you score 20 or higher on the test, it's highly likely that there will be one or two components on the inventory that are predominant in explaining your score. If you find that most or all of the answers that earned you points pertained to one or two specific personality traits, consider focusing some attention on these characteristics, which are likely, at the very least, to be dominant aspects of your personality.

Let's say your overall score is an 18, but your high score is largely the product of your higher results in the superiority category. You might consider monitoring this trait in your daily life by paying attention to your feelings of superiority, how you tend to express them, and what effect they seem to have on other people. Then, try to let go of your feelings of superiority, and see whether other feelings, such as fear or anger, emerge in their place. Own these feelings, but try to stay aware of what the other people in the conversation are experiencing in that moment. What are their motivations? Are their points of view in any way valid? Does acknowledging their feelings somehow make you feel diminished? (This is common; you might consider it the flip side of envy.) Understand that what you're experiencing is just your feelings; they don't necessarily reflect reality, or even what the other person is experiencing.

As you move past any of the feelings represented by the categories in the NPI, you'll generally experience a certain amount of anxiety or discomfort. You may feel vulnerable or even attacked by the other person with whom you're interacting. Hang on; usually, this will pass. However, be aware that any time you're dealing with narcissistic tendencies, aggression is always right around the corner. You may actually start feeling exactly the opposite of the feeling you're working on. For example, as you work on acknowledging your feelings of superiority, you may find feelings of inferiority

creeping in. You're not going to like these feelings, but stay with it. The object is to start creating a more realistic appraisal of reality without the distortions created by your narcissistic traits. The fact is that, no matter what you're feeling, you, your *self*, is neither superior nor inferior to the other person. Even if you're actually in a position of authority, your *feelings* are not superior to anyone else's. In reality, other people probably have some valid points and some feelings you could easily relate to if you gave them a chance. Slowly, you'll begin to develop the capacity to process interpersonal experiences more realistically and without triggering feelings of emptiness, envy, or rage.

Though there's no conclusive evidence in the area, we've seen people who are strongly motivated change their behaviors in areas like superiority simply by increasing their awareness of the trait and how it affects them and their relationships. Of course, such personal development requires a great deal of motivation and a willingness to change. And such change is difficult for those who are highly narcissistic because their narcissistic perceptions and interpretations of themselves allow no alternative explanation. Nevertheless, if you're concerned that you have narcissistic tendencies, and you've documented this quantitatively with the NPI, you would appear to possess at least the self-awareness necessary to effect real change.

Learning to identify and assess your feelings and motivations accurately may come more easily to people who have spent time in therapeutic counseling. Individuals who have been in therapy are often aware of their narcissistic traits and are able to moderate them in their personalities. You might be surprised by what your scores, or the scores of your friends, reflect. Even when we administered the test to celebrities we found some scores that might seem surprising.

After word of our study got around, the producers of Howard Stern's Sirius Radio show asked Mark to administer the NPI to Howard, Robin, and Artie Lange. When Mark called in to the show to discuss the results, he cautioned the cast that they might feel embarrassed if he revealed private information about their psychological makeup on the air.

Howard, of course, didn't see it that way at all. "No, you don't understand, [any of us] would be proud if we were the biggest narcissist on the show," he told Mark. If you've ever heard Howard on the radio, you might expect his narcissism score to be off the charts. In fact, when Mark revealed the scores, Howard's was a modest 15, actually slightly below the national average, and considerably below that of most of the celebrities we tested.

In contrast, his cohost Robin Quivers scored a 34, one of the highest of anyone we tested. And, indeed, Robin's reaction confirmed her highly narcissistic traits. First, she tried to defend her performance by complaining about the test: "I didn't know how to answer any of those questions." Then, she tried to deny the results: "Oh, stop it! That's ridiculous!" Then she tried to shift the blame to others: "You cheated! I think that you must have switched our tests." Underlying her response was a level of aggression typical of a narcissistic personality who has been provoked.

When Mark pointed out that Howard's score put him right in the average population in terms of narcissism, Stern immediately credited his years of therapy for his balanced performance. "I can tell you that therapy helped me, and I am way more together than all of you." (He couldn't resist getting in one last dig at Quivers, though: "So I won, and you lost. You're crazy and I'm not!")

You might be surprised to find that you score relatively high on the NPI's narcissistic scale, which doesn't necessarily mean you're in denial (others in your life can tell you whether you are),

but that you might not have the overt narcissistic characteristics we've been discussing.

If this is the case, you may have a personality style that James F. Masterson calls the *closet narcissist* and Elsa Ronningstam identifies as the *shy narcissist*. Narcissists who fit this profile may actually be very focused on other people, but have difficulty giving others' feelings the same importance as their own. This kind of narcissist is very sensitive to criticism or slights from others and will respond with harsh self-criticism. They may seem humble or unassuming and avoid being the center of attention. They may also feel guilt or shame for their ambitions or accomplishments, although they may relentlessly pursue them without genuine regard for others. They may also hide their strivings or accomplishments for fear of triggering envy in others. Closet narcissists know envy well; they suffer intensely from it, even as they fiercely disavow it. They can be difficult to identify, because they're not arrogant and openly aggressive, but may manifest their narcissistic traits with overattentiveness and exceeding vulnerability. Nevertheless, such narcissists suffer from a lack of self-esteem and a deep sense of shame; their attentiveness should not be taken for empathy, as it's as difficult for them to connect emotionally as it is for the classic narcissist.

My friend and longtime *Loveline* cohost Adam Carolla is a good example of this type of narcissistic personality. In fact, he openly identifies himself as a narcissist. However, when he found out about his high NPI results, he immediately protested: "Drew, how could that be? You know I hate to be the center of attention. No one talks about his accomplishments less than you or I."

And he's right. Full disclosure: I scored 16 on the NPI, and I do have some of the dynamic of the closet narcissist in my own personality. And, just as Howard Stern credited his years in therapy with his reduced narcissistic strivings, I, too, have done a great deal

of personal work in order to function effectively in my daily professional capacity in the field of mental health. For me, an accurate understanding and the ability to acknowledge my personality traits is essential to my ability to effectively help my patients.

Several of the celebrities from our study have graciously consented to allow us to publish their scores to give you some context in judging your own results. Understand that these results don't necessarily imply a need for treatment or change. However, if you're higher up the scale and wonder why your relationships never seem to work out, or you have difficulty with aggression, particularly if you have trauma in your childhood, check in with people in your life who genuinely care about you for an assessment of these results. Very narcissistic people are usually the last to be aware of the source of their troubles.

If you are having symptoms, regardless of whether you rate well above average on the NPI scale, there are plenty of mental health professionals out there who are well trained to help you. If your score is higher than thirty, I suggest you consider a professional assessment. Of course, even a score that high isn't a concrete sign that anything is direly wrong, and treatment is not mandated. Adam Carolla didn't run for help after hearing his result, and he has great success and satisfaction in his career, a stable relationship with a wonderful woman, and two beautiful kids (although, one day we'll have to talk to them about what it was like having Adam as their father).

Measuring yourself against the celebrities on our scale may be reassuring. You may find that your results are similar to those of someone you admire or for whom you have great affection. Remember, though, that your attraction to a celebrity may be an attraction to the pseudo-self that star puts forth, rather than to his or her true personality. Matching your favorite star's level of narcis-

sism shouldn't necessarily be reassuring; nor should it be considered a healthy goal.

The celebrities we surveyed were a diverse group of people, but they all shared one thing: the specific dynamic of narcissism. If you are having significant distress in your own life, and believe it may be linked to narcissistic tendencies in your personality, you can take solace in the fact that people on our list are working them out in ways that at least seem to allow them to thrive. But registering the same score as one of our celebrities doesn't mean you're likely to be as successful as that individual, or even that you're fundamentally similar people. It does mean you're struggling with a similar dynamic, but one that can manifest differently from person to person. Having read this book, you should understand that narcissism can be a significant liability. If your answers show a trend toward narcissism, it's up to you to understand your behavior and work to change in a healthy direction.

NARCISSISTIC PERSONALITY INVENTORY (NPI)

(as developed by Raskin and Terry, 1988)

1. **A.** I have a natural talent for influencing people.
 B. I am not good at influencing people.

2. **A.** Modesty doesn't become me.
 B. I am essentially a modest person.

3. **A.** I would do almost anything on a dare.
 B. I tend to be a fairly cautious person.

4. **A.** When people compliment me I sometimes get embarrassed.
 B. I know that I am good because everybody keeps telling me so.

5. **A.** The thought of ruling the world frightens the hell out of me.
 B. If I ruled the world it would be a better place.

6. **A.** I can usually talk my way out of anything.
 B. I try to accept the consequences of my behavior.

7. **A.** I prefer to blend in with the crowd.
 B. I like to be the center of attention.

8. **A.** I will be a success.
 B. I am not too concerned about success.

9. **A.** I am no better or worse than most people.
 B. I think I am a special person.

10. **A.** I am not sure if I would make a good leader.
 B. I see myself as a good leader.

11. **A.** I am assertive.
 B. I wish I were more assertive.

12. **A.** I like to have authority over other people.
 B. I don't mind following orders.

13. **A.** I find it easy to manipulate people.
 B. I don't like it when I find myself manipulating people.

14. **A.** I insist upon getting the respect that is due me.
 B. I usually get the respect that I deserve.

15. **A.** I don't particularly like to show off my body.
 B. I like to show off my body.

16. **A.** I can read people like a book.
 B. People are sometimes hard to understand.

17. **A.** If I feel competent I am willing to take responsibility for making decisions.
 B. I like to take responsibility for making decisions.

18. **A.** I just want to be reasonably happy.
 B. I want to amount to something in the eyes of the world.

19. **A.** My body is nothing special.
 B. I like to look at my body.

20. **A.** I try not to be a show off.
 B. I will usually show off if I get the chance.

21. **A.** I always know what I am doing.
 B. Sometimes I am not sure of what I am doing.

22. **A.** I sometimes depend on people to get things done.
 B. I rarely depend on anyone else to get things done.

23. **A.** Sometimes I tell good stories.
 B. Everybody likes to hear my stories.

24. **A.** I expect a great deal from other people.
 B. I like to do things for other people.

25. **A.** I will never be satisfied until I get all that I deserve.
 B. I take my satisfactions as they come.

26. **A.** Compliments embarrass me.
 B. I like to be complimented.

27. **A.** I have a strong will to power.
 B. Power for its own sake doesn't interest me.

28. **A.** I don't care about new fads and fashions.
 B. I like to start new fads and fashions.

29. **A.** I like to look at myself in the mirror.
 B. I am not particularly interested in looking at myself in the mirror.

30. **A.** I really like to be the center of attention.
 B. It makes me uncomfortable to be the center of attention.

31. **A.** I can live my life in any way I want to.
 B. People can't always live their lives in terms of what they want.

32. **A.** Being an authority doesn't mean that much to me.
 B. People always seem to recognize my authority.

33. **A.** I would prefer to be a leader.
 B. It makes little difference to me whether I am a leader or not.

34. **A.** I am going to be a great person.
 B. I hope I am going to be successful.

35. **A.** People sometimes believe what I tell them.
 B. I can make anybody believe anything I want them to.

36. **A.** I am a born leader.
 B. Leadership is a quality that takes a long time to develop.

37. **A.** I wish somebody would someday write my biography.
 B. I don't like people to pry into my life for any reason.

38. **A.** I get upset when people don't notice how I look when I go out in public.
 B. I don't mind blending into the crowd when I go out in public.

39. **A.** I am more capable than other people.
 B. There is a lot that I can learn from other people.

40. **A.** I am much like everybody else.
 B. I am an extraordinary person.

SCORING KEY

Assign one point for each response that matches the key.

1. A	**3.** A	**5.** B
2. A	**4.** B	**6.** A

7. B	19. B	31. A
8. A	20. B	32. B
9. B	21. A	33. A
10. B	22. B	34. A
11. A	23. B	35. B
12. A	24. A	36. A
13. A	25. A	37. A
14. A	26. B	38. A
15. B	27. A	39. A
16. A	28. B	40. B
17. B	29. A	
18. B	30. A	

THE SEVEN COMPONENT TRAITS BY QUESTION:

AUTHORITY: 1, 8, 10, 11, 12, 32, 33, 36

SELF-SUFFICIENCY: 17, 21, 22, 31, 34, 39

SUPERIORITY: 4, 9, 26, 37, 40

EXHIBITIONISM: 2, 3, 7, 20, 28, 30, 38

EXPLOITATIVENESS: 6, 13, 16, 23, 35

VANITY: 15, 19, 29

ENTITLEMENT: 5, 14, 18, 24, 25, 27

CELEBRITY NPI SCORES

Robin Quivers, radio personality	34
Pauly Shore, actor and comedian	28
Adam Carolla, TV and radio personality	28
Chelsea Handler, comedian and TV personality	21
Adrianne Curry, reality TV star	19
Bob Forrest, musician	19

Ron Jeremy, adult film actor 16
Dr. Drew Pinsky, TV and radio personality 16
Howard Stern, radio personality 15
Diora Baird, model and actress 11
Frankie Muniz, actor 10

ACKNOWLEDGMENTS

So many people have helped us complete this book. We are most grateful to Susan Pinsky, Jordan, Douglas, and Paulina Pinsky and Dr. Mort and Helene Pinsky and to Dr. Sarah E. Bonner, Nathaniel and Kaylee Young, and Dr. Sydney and Doreen Young for fully supporting this effort and for sacrificing so much time with us.

We are extremely indebted to our close collaborator and great friend, Jill Parsons Stern. Jill is a fellow traveler in the subject matter of this book, and her intelligence, creativity, incredible set of skills, and off-the-scale work ethic pushed us beyond what we ever thought we could accomplish. Heartfelt thanks, Jill.

We thank our agents Howard Lapides and Jackie Stern (The Core), Tina Bennett (Janklow & Nesbit Associates), and John Ferriter (William Morris), and our publicist Valerie Allen (Valerie Allen PR) for superb representation on this project.

Cal Morgan, our tireless editor at HarperCollins, understood our ideas for the book from the beginning and challenged us to

sharpen our thinking, and the staff at Harper, including Jonathan Burnham, Christina Boyd, Kevin Callahan, Nina Olmsted, Tina Andreadis, Shelby Meizlik, and Leslie Cohen, provided wonderful support. Thanks to all of you.

We acknowledge the first-class research assistance very ably provided by Dr. Sam Lee (University of Illinois at Chicago), Dr. Clara Chen (University of Illinois, Urbana-Champaign), Gerry Sadowski, Charles Vannatter, Megan McDermott, Lindsay Thomas, Neva Dominguez, Suzanne Ogden, Zöe Chance (Harvard), and Audrena Goodie.

In writing this book, we had many discussions with a wide array of people who gave us deep insight into the entertainment business and the nature of celebrity. We thank Julia Ormond, Jennifer Garner, Jeff Probst, Adam Carolla, Adrianne Curry, Lesley Goldman, Bob Saget, Stormy Daniels, Chris Dunn, Louise Pennell, Chelsea Handler, Frankie Muniz, Pauly Shore, Erin Gray, Enrico Colantoni, Kristen Bell, Fiona Horne, Shanna Moeckler, Meredith Baxter, Katie Stuart, Howard Stern, Robin Quivers, Jonathan Murray (Bunim-Murray), Bob Forrest, Tom La Grua (SAG), Carson Daly, Craig Ferguson, Diora Baird, Ron Jeremy, Dr. Keith Campbell (University of Georgia), Dr. Belisa Vranich, Dr. Alexei Vranich, Dr. Anita Elberse (Harvard), Dr. Deborah Gewertz (Amherst College), Peter Kurie (Princeton University), Dr. Debbie Then, Dr. George Foster (Stanford), Dr. James Gong (University of Illinois), and Dr. Wim Van der Stede (London School of Economics). We also thank Dr. Lynne Cooper and Dr. William Ickes at the *Journal of Research in Personality* for publishing our original study, and Jamie Kennedy and Michael Addis for including us in their film, *Heckler*. Thanks also to the many other celebrities and students who participated anonymously in our initial research study. Without you there would be no book.

Many others have opened doors for us and have provided support, including Mike Richardson (Dark Horse Entertainment), Brian Mulligan (Brooknol Associates), Dick Cook (Disney), Bruce Rosenblum (Warner Bros.), Sherry Lansing (Paramount), Laurie Younger (Disney-ABC Television), John Maata (CW Network), Ken Werner (Warner Bros.), Dick Rosenzweig (Playboy), Simon Anderson (Advance LA), Marty Kaplan (Norman Lear Center, USC), Fabian André (Bunim-Murray), John Connolly (while at AFTRA), Chris Prapha (Artists Independent Management), Mike Moz, and David Stern.

We would like to thank Norm Pattiz, Max Krasny, Ted Stryker, Anderson Cowan, Lauren Winer, and, especially, Ann Ingold at Westwood One Broadcasting and KROQ Infinity Broadcasting, Jeff Olde and Noah Pollack (VH1), Mort Janklow (Janklow & Nesbit), John Irwin and Damian Sullivan (Irwin Entertainment), the Marshall School of Business and the Keck School of Medicine at USC, the staff at Las Encinas Hospital and several generations of students in Mark's course, *Management and Organization of the Creative Industries*, with whom we tested many of our ideas.